Julia Margaret Cameron
1815~1879

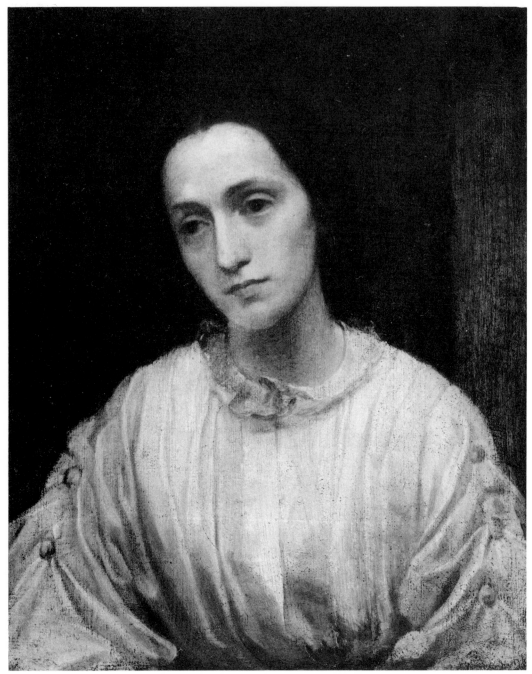

I.I

Mike Weaver

Julia Margaret Cameron
1815~1879

The Herbert Press

First published in Great Britain 1984
by The Herbert Press Ltd, 46 Northchurch Road, London N1 4EJ

Designed by Pauline Harrison

Printed and bound in Great Britain by
W. S. Cowell Ltd, Ipswich

British Library Cataloguing in Publication Data:

Weaver, Mike
Julia Margaret Cameron.
1. Cameron, Julia Margaret 2. Photography
—Portraits
I. Title
770'.092'4 TR680

ISBN 0 906969 35 2

The exhibition *Julia Margaret Cameron 1815 – 1879*
was selected by Mike Weaver and organized by
the John Hansard Gallery, The University, Southampton.
Exhibitions Officer Sara Selwood

Front cover illustration: *The Kiss of Peace* (no. 1.53)
Back cover illustration: *The Mountain Nymph Sweet Liberty* (no. 3.60)
Frontispiece: G. F. WATTS, *Julia Margaret Cameron* (no. 1.1)

Contents

Notes to the captions

Measurements are given in centimetres. Height precedes width.

Unless otherwise stated, all works are by Cameron, and are albumen prints.

Entries marked * are not illustrated.

All the titles and dates which appear in italics are either from inscriptions in Cameron's own hand on the print exhibited and illustrated, from the Fine Arts Registers, or from her inscriptions on other prints of the same image, in which case the source is acknowledged in brackets. Titles not in italics are working titles provided by the authors of the catalogue. Dates not in italics are also provided by the authors. Other sources are acknowledged in brackets. Dates from sources other than that of the given title are placed on a separate line.

Cameron first registered her work with the Fine Arts Registers of the Public Record Office on 30 May 1864. In many cases she inscribed the mounts of her photographs, 'From life Registered Copyright Julia Margaret Cameron'. We have omitted these details.

The Colnaghi blind stamp appears on many of Cameron's mounts. It reads, 'Registered Photograph Sold by Messrs. Colnaghi 14 Pall Mall East London'.

The following abbreviations have been used in the catalogue entries:

(Ford) Colin Ford, *The Cameron Collection. An Album of Photographs by Julia Margaret Cameron presented to Sir John Herschel,* London and New York, 1975.

(Mozley) Anita Ventura Mozley, catalogue to the exhibition, *'Mrs Cameron's photographs from the Life'*; Stanford University Museum of Art, 22 January – 10 March 1974.

(Gernsheim) Helmut Gernsheim, *Julia Margaret Cameron – Her Life and Photographic Work*, London 1975.

(George Eastman House) The International Museum of Photography – George Eastman House, Rochester, New York.

(Ovenden) Graham Ovenden, (Ed.), *A Victorian Album. Julia Margaret Cameron and Her Circle*, London 1975.

Preface and acknowledgements

This book is based on the catalogue for the exhibition of Julia Margaret Cameron's work organized by the John Hansard Gallery, the University, Southampton. The purpose of the exhibition was to present a major Victorian artist who used photography as her means of expression. Although all too often treated as an eccentric, Julia Margaret Cameron was at the very centre of Victorian life and thought. Like that of many of her contemporaries, this woman artist's work was based upon traditional Christian typology, a kind of biblical interpretation which relates the characters and events described in the Old Testament to those of the New. In the words of another traditionalist of the period, Anna Jameson, the aim of the exhibition was to present 'a kind of pictured drama in successive scenes'.

It would not have been possible to present this 'drama' without the inspiration, enthusiasm and research of Dr Mike Weaver who selected the exhibition. The John Hansard Gallery and the publishers are enormously indebted to him. Sara Selwood has provided invaluable assistance in selecting the photographs and contextual material and preparing the catalogue. Her chronology and the captions place Cameron's photographs within their historical context with special reference to the work of the Victorian critic, Anna Jameson.

We would also like to thank the private individuals and museums who so generously contributed to the exhibition and without whose participation neither the exhibition nor the book would have been possible: The Ashmolean Museum, Oxford; The Bodleian Library, Oxford; Mrs Angus Hewat; The Hon. Edmund Howard; The Fine Art Department, University of Leeds; Liverpool City Libraries; The National Gallery, London; The National Portrait Gallery, London; The Science Museum, London; The Victoria and Albert Museum, London; and The Library, Wellcome Institute for the History of Medicine, London. The Royal Photographic Society has willingly lent from its magnificent collection of prints. We are indebted to Lord Brain and Pamela Roberts of the Royal Photographic Society; and to Valerie Lloyd for much help and advice.

The exhibition *Julia Margaret Cameron 1815–1879* is being shown in the United Kingdom, Europe and New York (at the International Center of Photography) during 1984 and 1985. This has been made possible by the help of Michael Harrison of the Arts Council of Great Britain, and Julian Andrews and Brett Rogers of the British Council.

The book reproduces all the original Cameron prints shown in the exhibition and provides a more comprehensive survey of her work than anything yet published. Cameron met with innumerable technical difficulties in making contact prints from large wet collodion glass-plate negatives. These were developed in a make-shift darkroom and inevitably produced images which were frequently blemished by streaks and dust spots, but only

those with an over-developed taste for restoration will find her albumen prints too marred to be appreciated.

Albumen prints were printed on paper coated with egg-white and sensitized with silver nitrate. They could be toned to produce a colour range from brown to purple. Carbon prints, like those produced by the Autotype Company, were made by a photo-mechanical process in which a gelatin-coated paper was exposed to light under a negative. Those parts of the gelatin which had not hardened were then washed away, leaving a kind of transfer image. In the case of Cameron's 'carbons' this gelatin contained black, brown, or orange pigments. Retouching to enhance the continuous tone of this commercial process removed much of the unevenness characteristic of her albumen prints, but at the expense of their refulgence. When all is said and done, we can only be grateful that so many of her albumen prints have survived in our national collections.

BARRY BARKER
Director, John Hansard Gallery,
The University, Southampton.

A contextual chronology
by Sara Selwood

11 June 1815	Born Julia Margaret Pattle, Calcutta. Father, James Pattle, Official in the East India Company; mother, Adeline de l'Etang.	
1820		Keats, *Eve of St Agnes*
1832		Anna Jameson, *Characteristics of Women*
1833	The Society of Diffusion of Useful Knowledge is founded, to last until 1846. Charles Hay Cameron is one of its committee members.	
1834	Julia Margaret Pattle returns to Calcutta, after living with her grandmother at Versailles and having been educated in Europe.	Henry Taylor, *Philip van Artevelde*
1835	At the Cape of Good Hope she meets Charles Hay Cameron, a jurist and member of the law commission, Supreme Council of India.	C. H. Cameron, *On the Sublime and Beautiful*
1837		Tennyson, *St Agnes' Eve*
1838	Julia Margaret Pattle marries Charles Hay Cameron in Calcutta.	Curmer edition of Bernardin de St Pierre, *Paul et Virginie*
1839		Sir John Herschel uses 'hypo' to fix the photographic image
1840		Carlyle, *On Heroes and Hero-Worship*
1843–8	Mr Cameron serves as fourth member of the Council of India and President of the Council of Education. Cameron acts as hostess for Anglo-Indian society in Calcutta and does philanthropic work, including the organization of a relief fund for the Irish potato famine.	
1845		Sir Coutts Lindsay, *Alfred*

1847	Her translation of Bürger's *Leonore* is published with illustrations by Daniel Maclise.	Lord Lindsay, *Sketches of the History of Christian Art*
1848	Mr Cameron retires, and the family returns to England. They settle at Tunbridge Wells, where Cameron meets an old friend of her husband's, the poet and civil servant, Henry Taylor. She moves in the society based around her sister, Sarah Prinsep's salon at Little Holland House, Kensington, London, where she meets the painter, G. F. Watts.	Anna Jameson, *The Poetry of Sacred and Legendary Art* The Arundel Society, a society for promoting the knowledge of art, is founded.
1849		Henry Taylor, *The Virgin Widow*
1850	The Camerons move to East Sheen to be near the Taylors. They meet the Tennysons who live nearby at Richmond.	Anna Jameson, *Legends of the Monastic Orders*
1851		*The Great Exhibition*, Crystal Palace
1852		Anna Jameson, *Legends of the Madonna* Frederick Scott Archer develops the wet collodion method which Cameron was to use.
1853	Mr Cameron publishes *An Address to Parliament on the Duties of Great Britain to India in respect of the education of the natives, and their official employment.*	
1854–6		Coventry Patmore, *Angel in the House*
1855		Tennyson, *Maud*
1856		Sir John Gilbert's illustrated *Shakespeare* National Portrait Gallery founded
1857	The Camerons move to Ashburton Cottage, Putney Heath where Cameron takes Mary Ryan into her home.	Sir Coutts Lindsay, *Boadicea* The illustrated Moxon Edition of Tennyson's *Poems* The South Kensington Museum (later the Victoria and Albert) founded The Manchester Art Treasures exhibition, where Rejlander's photograph, *The Two Ways of Life,* is shown. Oxford Union Building decorated with Arthurian subjects by the Pre-Raphaelites including Val Prinsep, Cameron's nephew.
1858		Thomas Wright's new edition of *Morte d'Arthur*

1859	Cameron is recorded as being a member of the Arundel Society.	First Pre-Raphaelite exhibition Tennyson publishes four *Idylls of the King* (40,000 copies printed) C. Darwin, *The Origin of Species* Watts at work on frescos for Lincolns Inn Fields George Eliot, *Adam Bede* The illustrated literary magazine, *Once a Week* begins publication.
1860	While her husband and eldest sons are in Ceylon, seeing to the family coffee plantations, Cameron visits the Tennysons at their home in Freshwater, Isle of Wight. She buys two cottages, which she names 'Dimbola' after the Ceylon estate. The Camerons and the Tennysons become neighbours.	The illustrated literary magazines, *The Cornhill* and *Good Words* begin publication.
1862		New Copyright Act passed in Parliament Henry Taylor, *St Clement's Eve* International Exhibition, London
1863	During another of her husband's visits to Ceylon Cameron's daughter and son-in-law give her her first camera.	Watts painting Tennyson
1864	Cameron is now producing successful prints and has begun to present her friends with albums, for example the Watts album. She is elected member of the Photographic Societies of London and Scotland. Cameron enters into arrangement with Colnaghi, London, dealers for the printing and sale of photographs. She registers her photographs with the Fine Arts Registers of the Public Record Office, 1864–75.	Anna Jameson and Lady Eastlake, *The History of Our Lord* *The Parables of our Lord and Saviour Jesus Christ*, illustrated by J. E. Millais
1865	Awarded Bronze Medal, Berlin.	
1866	Awarded Gold medal, Berlin. Buys larger camera, which takes 12 × 15″ plates, fitted with a Dallmeyer Rapid Rectilinear lens, focal length 30″. She works with a wide open aperture, with exposure times of 3–7 minutes. Although the lens is designed for 16 × 20″ plates, she uses 12 × 15″ plates, and sometimes inscribes prints 'Not enlarged'. Hires Colnaghi's Gallery, London for an exhibition.	National Portrait Exhibition 1866–7

1867	Honourable Mention, Paris exhibition.	William Michael Rossetti, *Fine Art Chiefly Contemporary* Millais paints Sir Coutts Lindsay as *Jephthah*
1868	Hires German Gallery, London, for an exhibition. Receives payment from Darwin for her portraits of him. Failure of the coffee crop in Ceylon.	Coventry Patmore, *Odes* Watts painting Taylor and Carlyle
1869		John Stuart Mill, *On the Subjection of Women*
1873	Her daughter Julia dies. The Prinseps come to live with Watts in his new house, 'The Briary', at Freshwater.	
1874	Begins to write *Annals of my Glass House*. August: Starts making photographic illustrations for the Cabinet edition of Tennyson's works at the poet's own request. December: Publishes her own edition of the *Idylls of the King and Other Poems* with twelve illustrations.	*Female characters of Goethe, from the Original Drawings by William von Kaulbach*, 1874
1875	May: produces a second part of *Idylls of the King and Other Poems* in the same format as the first. She then brings out a third, miniature edition, based on the two earlier editions. Instructs the Autotype company to produce new negatives from 70 of her images, and print brown, red and black carbon prints from these. October: The Camerons return to Ceylon on the s.s. Mirzapore. They live near Kalutara. Cameron photographs the plantation workers.	
1876	September: Cameron's poem, 'On a Portrait' is published in *Macmillan's Magazine*.	
1878	The Camerons visit England briefly.	
26 January 1879	Cameron dies in Ceylon. Mr Cameron dies 8 May 1880.	

Julia Margaret Cameron
1815~1879

A feminine artist

It is remarkable that the greatest British pictorial photographer of the nineteenth century should have been a woman. John Stuart Mill had said that women could make a literature of their own only if they inhabited a different country from men, and never read men's books. Yet Julia Margaret Cameron entered the world of the Royal Academy and Salon painters with confidence. In photography she had found a medium, however, which was still unsure of its claims on art, and such models as existed for it were flouted by this woman whom men felt, at least at first, that they need not take seriously. They would have preferred her to have a sharper focus and narrower ambitions, but she gave them soft focus and large ambitions. They sniped at her technique, and they assumed she did not want pay or publication. Because she was a traditionalist in both art and religion she internalized her own social role within the conventional framework of relations between men and women. She remained for all her abundance of energy a feminine rather than a feminist artist. Born in 1815 in Calcutta, her values belonged to the early Victorian period.

On 1 February 1838 the Honourable Charles Hay Cameron, Acting Fourth Ordinary Member of the Supreme Council of India, married in Calcutta Julia Margaret Pattle, daughter of the second most Senior Merchant, or civil servant, in the East India Company. Cameron settled one hundred thousand Company's rupees (about ten thousand pounds) upon her, and Henry Thoby Prinsep, Secretary to the Government and later a Member of the Supreme Council, acted as a trustee of the marriage settlement. Charles was almost forty-three, and Julia twenty-three. Mr Cameron's rank was immediately below that of the governors, chief-justices, and bishops, and above everyone else. Ladies took precedence in society according to their husband's rank, so by 1843 when Charles took his permanent seat on the Council Julia was a person of colonial eminence. In 1848 Charles retired, and the family returned to England to make homes successively in Kent, London, and on the Isle of Wight.

Mrs Cameron was secure in her religious beliefs, and ruler of her own household. She had the six children which was the Victorian norm, and that she considered the domestic role a worthy one can be seen from the poem she wrote, 'On Receiving a Copy of Arthur Clough's Poems at Fresh Water Bay', c. 18 July 1862 (Writings, p. 154) It reflects religious misgivings which she did not share. Arthur Hugh Clough was a true sceptic – someone who had been drawn to the Oxford Movement and back to liberalism – and the Camerons understood his mixture of scornful humour and tender sympathy, which was how his sensibility expressed his doubts, 'the tender questionings of a wild unrest'. Mrs Cameron's worries were earthly ones about her family, and especially about her husband. She gave up her career as a photographer to follow her husband to Ceylon so he could die among his sons, although she had expressed a wish not to end her own days there,[1] where she died shortly before him in 1879. The story that her children gave her a camera to pacify her while he was away on an earlier trip is another of those many anecdotes which aim to rob her of her dignity as woman and artist, and have taken the place of criticism of her

work. From the time when Sir John Herschel had told her of his photographic researches of the late eighteen-thirties, she had been interested in the new medium. The large camera and the cumbersome wet-plate process were not toys for a neurotic woman to be kept busy with. Almost fifty, she was a mature woman of considerable learning and with a passionate interest in literature, drama, and art when she took up photography in a serious way in 1863.

Cameron belonged to that great generation of Victorian novelists (she attempted a novel herself), which included the Brontës and George Eliot. She was a pioneer professional, socially conditioned to remain an amateur but actually wanting publication under her own name. There was nothing pseudonymous about Julia Margaret Cameron. Unlike most of the novelists, she had her children, cared for her grand-children, and nursed their mothers. We have glimpses of her anxious about the sight of her son Ewen's eyes and looking, after nursing her daughter Julia, 'wretchedly aged, and quite broken down'.[2] The anecdotes attempt to turn her into a blue-stocking. She is depicted as obsessed with old-fashioned shawls, with fingers stained with chemicals (what do women know about science?). Inevitably, to photograph was to give up certain household chores, and to serve eggs and bacon three times a day because the servants were acting as models. Some have suggested it was all too much for poor Charles and other alleged 'victims', but there is no sign of conflict between them, rather a sense of deep and lasting relationship based on mutual admiration. She was the Mrs Gaskell of photography. She seems to have accepted maternity and marriage as high and holy offices, and lived an active life in which art relieved her from daily household cares. She was not an invalid, not repressed, and not inadequate. She was a nice-looking woman, who was a fine person. Her sisters, all younger than her, for all their famed beauty could not hold a candle to her. A Christian artist, she submitted her passions and her pride to the will of others and, above all, to God. If it were not so unfashionable, I would have called her a genius, a word which, like the Camerons, came out of the eighteenth century. If there is any doubt that she was a Christian woman, the letter which she wrote, 'in confidence', to her niece Adeline's husband, Henry Halford Vaughan, briefly Professor of Modern History at Oxford, gives the proof (*Writings*, p. 152). Such a letter, wrung from her heart in condolence, establishes her as a woman of deep religious and domestic feeling.

That her photographs should have reflected this religious faith and traditional sense of woman's place in the home is not at all surprising, given that she came to maturity in the eighteen-forties. In age she preceded the Pre-Raphaelite painters by almost a generation. Because she knew many of them we forget that she was not their contemporary, and that she began her career after theirs in the sixties with a sensibility formed prior to theirs. She never employed their highly finished and detailed style, and she avoided their more morbid themes. But she did share with them their desire to interpret the Bible in the typological manner. She, too, studied biblical types, and found personifications of them among her famous friends and domestic relations.

A biblical type may be said to represent a person or event in the Bible, who or which can be seen to correspond to other such types, or anti-types. For instance, King David is an anti-type of Christ. The comparison of such types involves not only biblical criticism or interpretation, but a Christian psychology. Infinite aspects of Christian behaviour can be observed by endless comparisons between such types. It is a serial process in which one type illustrates another with overtones of meaning accruing to the types as one is metamorphosed into another. Hitherto, Cameron's photographs have been seen as vaguely allegorical, but they are more properly described as typological or typical – illustrative in a profound, biblical sense.

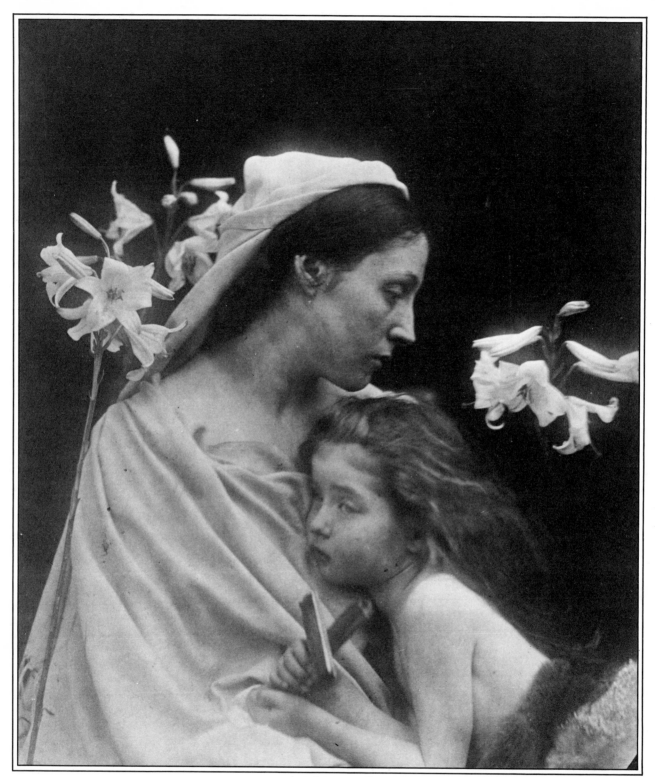

no. 1.5 (*see* page 28)

1·Sacred and typical

In presenting photographic illustrations printed by Negretti and Zambra of Raphael's Cartoons at Hampton Court in 1860, an editor in his introduction thought it might be necessary to remind his audience that Raphael was not a pre-Raphaelite.[3] This was the period when Raphael was the subject of a great revival supported by Prince Albert. He was mediated not only by means of photographs of the Cartoons, but by engravings by Raimondi, Desnoyers, Jesi, and Steinla.

Among the photographic portraits by Hill and Adamson are to be found Lady Eastlake (then Elizabeth Rigby) and Anna Jameson, who were both writers on art, and on Christian art in particular. Lady Eastlake was photographed variously as a lady of fashion, a *duenna* with a crucifix, and as a nun (fig. i). When Cameron photographed Lady Adelaide Talbot as a nun she contrived to have a cross of light fall upon her face (no. 2.18). These may be fancy portraits by which the conventional taste of the day is followed, but the religious foundation of that taste goes deep.

Anna Jameson (fig. ii) spent six years on her great work, in its first edition called *The Poetry of Sacred and Legendary Art* (1848). She played a very important part in bringing before the British public the fruits of German art-historical research on the Italian High Renaissance. She went on to produce further works in the series, *Legends of the Monastic Orders* (1850), *Legends of the Madonna* (1852), and *The History of Our Lord* (1864), which was substantially completed for her by Lady Eastlake after Jameson's death in 1860. Anna Jameson disavowed any drift towards Romanism in paying such attention to Catholic iconography: 'I hope it will be clearly understood that I have taken throughout the aesthetic and not the religious view of those productions of Art which in as far as they are informed with a true and earnest feeling, and steeped in that beauty which emanates from genius inspired by faith, may cease to be Religion, but cannot cease to be Poetry; and as poetry only have I considered them.'[4] Aubrey de Vere, the intimate friend of Cameron, was a poet who was a Catholic

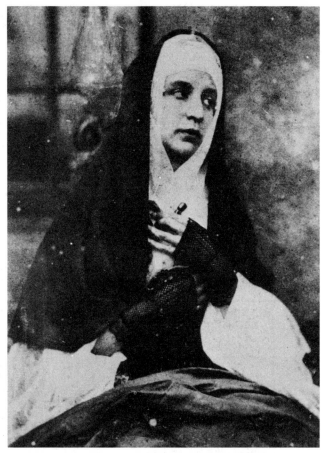

i. Hill and Adamson, *Lady Eastlake* (1809–93), *c.* 1845. (National Galleries of Scotland)

OPPOSITE
ii. Hill and Adamson, *Anna Jameson* (1794–1860), *c.* 1845. (National Galleries of Scotland)

convert. Accompanying Sir Henry Taylor on an Italian journey of 1844, he wrote passionately about Perugino, Pintorrichio, and Fra Angelico.[5] (There is a *Madonna and Child with the young St John* by Francia, now in the Ashmolean Museum in Oxford, which formerly belonged to Taylor.) What de Vere saw in early Italian painting was a fully developed Christian symbolism, firmly founded on the idea of the Incarnation. Cameron's membership of the Arundel Society, founded by Lord Lindsay (who had also written on Christian

Art), the Marquis of Lansdowne, and Ruskin, brought her into touch with both Italian and Northern painting.[6] Her friends Hunt and Watts were on its council for a time, and she herself was often in the South Kensington Museum where the Society had one of its outlets for its publications, and where Henry Cole, the director, accepted her photographs.

Sir Henry Layard, editor of the publications of the Arundel Society, gave an account of its progress in the *Quarterly Review* for 1858.[7] Like Samuel Rogers,[8] Layard thought that in the Elgin Marbles and Raphael Cartoons England possessed the greatest sculptures and pictures in the world. But he wanted to extend English taste to Italian fresco painting by commissioning copies in watercolours, which were reproduced as chromolithographs. The technique of fresco might well have been as interesting to Cameron as it was to Layard, because it required speed in execution (the wall had to be as damp as a wet-plate), simplicity of design, and breadth of effect. The Italian painters, in order to achieve this, 'frequently sacrificed detail and careful finish'. Any faultiness was brushed aside in recognition of the results – 'a reverent and almost holy rendering of sacred subjects, and a constant endeavour to embody moral beauty in graceful and lovely material forms, which appeal directly to our hearts and our imaginations, and make us almost pass over faults of execution.' For Layard, the only possible hero of English fresco painting at the time was the G. F. Watts of the *St George and the Dragon* in the House of Commons.

Cameron was no less Protestant and no more Catholic than the iconographers Jameson and Eastlake. She engaged Sir John Herschel on theological questions, writing to him about the Cambridge History Professor J. R. Seeley's *Ecco Homo: A Survey of the Life and Work of Jesus Christ* (1866), and getting a sternly conservative reply.[9] John Forbes White wrote that enormous success lay ahead for anyone who could bring Rembrandt's mastery to religious subjects. Delaroche, he thought, had shown signs of it.

Religious art was not dead, and the world was not dead to true religious art, 'if only the chord could be struck by a great master'.[10] Cameron, like Jameson, doubtless thought that Christian iconography should merge in photography in the way that Classical allusions were absorbed in Tennyson's poetry. Classical, Christian, and Arthurian elements might sit together at the same Round Table. So she put Sir John Herschel in the velvet cap of a German Nazarene painter even if he thought it was only the cap of a *Paterfamilias* (no. 3.24).

Cameron had friends of many shades of Anglican opinion. If Tennyson had religious doubts, his religious confidante Agnes Weld gave Charles Cameron a *Book of Common Prayer* which found its way into Tennyson's wife's library. If Sir Henry Taylor had even more doubts, his close friend de Vere was the close friend of Cardinal Newman and Cardinal Manning. Coventry Patmore, who reviewed Cameron's exhibition of 1866,[11] became a famous Catholic convert in 1864. A copy of his *Odes* (1868), poems of parental and marital love in a heightened style, has Cameron's name on the cover.[12] But Patmore complained of her photographs that figures from the life could not be composed in the manner of the masters without avoiding 'the effect of the "realistic" air which most of her groups persist in maintaining for themselves, after all has been done to bring them into the pure region of ideality'. The photographer Roger Fenton had felt the same about Rejlander's *Two Ways of Life*, but perhaps Patmore's resistance can also be explained in part by the questionable nature of her subjects. Salutations and Annunciations, 'after Giotto', and 'in the manner of Perugino', verged, perhaps, on sacrilege. Presumably he felt that literary Romanticism avoided dangers which photographic realism could not, dealing with living models.

Sir Charles Eastlake, Elizabeth's husband, had written in *Contributions to the Literature of the Fine Arts* (1848) that the subjects of the Old Testament were universally considered, in early Christian Art, to be types or models for the New Testament:

'The selection, or at least the treatment, of subjects for the Gospels, may have been regulated in some instances also by their assumed correspondence with certain prophecies; indeed, the circumstances alluded to in the predictions of the Old Testament are not unfrequently blended in pictures with the facts of the New.'[13] So if history may be said to span from the Creation to the Judgement Day, all the lives and events between are capable of typological interpretation. John the Baptist is the forerunner of Christ; Rachel, who opens the well so the sheep may drink, prefigures the Angel who rolls away the stone of the Sepulchre. This retro- and pro-spective way of thinking was practised by the Pre-Raphaelites in their narratives of Christian life under the Druids, but because Cameron was not concerned with realist narrative, her biblical references are so idealized and unspecified as to have been almost entirely overlooked.

William Michael Rossetti, in *Fine Art, Chiefly Contemporary* (1867), which Cameron gave to Tennyson, asked in his essay, 'The Externals of Sacred Art', 'whether the artistic feelings of a Protestant people of the nineteenth century are best met by a typical or by a narrative expression of religious subjects'.[14] In defining the tendency of the age as naturalistic he acknowledged that this favoured the narrative over the typical. Only the German Nazarene painter preferred the typological approach, which he described as follows: 'He aims, it may be, at the expression of some religious idea which the beholder is not disposed to receive; or, even if they are at one regarding the idea, he has embodied it under a form, and with a use of means, for which he is individually responsible. He has asserted in the process his own protestantism, or right of private judgement; and the more definitely and more originally the assertion is made, the less avenue he has opened for himself towards the con- victions and the acceptance of others.' This kind of artist selected and combined his own symbols whereas the narrative artist stuck closely to the Bible. Rossetti felt that typical, or typological, art had lost its attraction in a positivist age and that

people preferred direct facts to symbolic concep- tions, naturalist art to 'traditionalist' art. He was, of course, promoting the Pre-Raphaelite position, but Cameron did not share his views on sacred art. She was, in fact, the kind of traditionalist that Rossetti described and denounced;

The most usual or accepted model of the traditionalist is Raphael, in such compositions as cartoons. The traditionalist dresses his figures in blankets which were never worn, puts a bit of Judaism here for the 'charac- teristic' heads, a bit of Anglicism there (supposing him to be a Briton), a bit of classicism, and an entirety of nothingism. His whole composition becomes a subject such as never could have been in being, and which does not even ask to be genuinely credited.

But if we consider Rossetti's remarks in the light of Cameron, he was leaving out one important factor – that although a traditionalist or idealist, she worked from life, *d'après nature*, as she wrote on one print. She was a traditionalist in a new naturalistic medium, and Rossetti did concede that the person of genius or intense feeling could over- come traditionalist or Raphaelite limitations. In the end it was the religious spirit which mattered, the sacred essence rather than the realistic fact. One of the authors whom Cameron read was James Hin- ton, who wrote a poem, 'English Art', expressive of English artistic aspirations;

> I long for the great day when English Art
> Shall be the outcome of the English race,
> When every woman shall have Venus' face
> And the Madonna's beauty, and her heart.

When David Octavius Hill took up photography again in the late fifties, this time with Macglashon, he made three out of his fifteen albumen prints with engravings after Raphael in the background. Hill and Macglashon published a photograph of *The Sculptor of 'Sir Galahad, the Good Knight'*, with an engraving of Raphael's *Parnassus* in the back- ground (fig. iii). The picture is 'inscribed' to the Scottish religious painter, Sir Joseph Noel Paton.

The woman depicted has a Christian, Raphaelite air, the background is a Classical Raphaelite subject, and the title evokes the world of Arthurian chivalry. This kind of Christian pictorialism, in which sacred stories are all blended together as poetry, contributed not only to new directions in fine art photography but formed the basis of Cameron's sensibility.

The biblical quotation appended in Cameron's hand on one print of *The return 'after three days'* (no. 1.13),[15] 'Wist ye not your Father and I sought thee sorrowing?', suggests the Crucifixion as well as the Dispute among the Doctors. The flowers symbolize the Day Spring and the Sepulchre. That the child is neither twelve nor thirty-three is immaterial because the shadow of the cross fell upon Christ at his very birth. So Cameron does not treat the theme as Holman Hunt does, showing an adult figure with the shadow upon the wall. Instead, she shows a sleeping child, in several versions (nos. 1.7–1.9), hovered over by its mother in the manner of Guido Reni, or clutching a wooden-toy cross; or, in a combination print with three women which doubles as an Adoration and as the Three Marys at the Sepulchre. The three girls in *The return 'after three days'* are, then, also types for the three adoring and sorrowing Marys. The roses and lilies they offer symbolize a Passion of perfect purity in death as well as birth.

Cameron's floral symbolism is typical rather than narrative. The Madonna lily is an attribute of purity and the lily-of-the-valley signifies meekness. The palm as an attribute of St Agnes signifies the martyr's victory over pain and death, and jasmine can suggest divine hope or heavenly felicity. But in each case the attribute is more symbolic than allegorical, as in Watts' use of flowers. In Christian iconography the walled or trellised garden can signify the purity of the Virgin enclosed within it, and Paradise itself. The rose had long been considered the flower of Venus in Classical mythology but was incorporated into Christian symbolism, red roses for the martyrs and white for the saints. *The Rose bud garden of girls* theme (no.

iii. Hill and Macglashon, *The Sculptor of 'Sir Galahad, the Good Knight'*, c. 1861. (The Metropolitan Museum of Art, New York; David Hunter McAlpin Fund, 1946. 46.1.13)

2.5) in Cameron's work is, therefore, infinitely interpretable in terms of the sacred and the profane, divine and mortal love. Or, as Charles Cameron wrote; 'It is possible, therefore, by means of a metaphor, however trite, provided it has not lost its literal signification, to invest one thing with the moral attributes of another.'[16] The epithet rose-bud is exchanged between the girls and the garden so that they are both unsullied virgins and brides of the Canticles at the same time. The rose of Christendom is the type of maidenly purity as well as of heavenly bliss. This metaphorical transfer Mr Cameron considered in terms of words: 'By constant juxtaposition sounds become the signs of ideas, that is, become capable of exciting those ideas in the mind . . . by the judicious use of them a writer may accompany those ideas, which form the thread of his discourse, with a continuous

22

strain of emotion not very different from those strains which are produced by the succession of musical tones.'[17] The words he gave as examples, 'spring', 'summer', 'liberty', were sometimes used by his wife as titles for her pictures. It has been suggested that she appended titles on the spur of the moment, and that is why sometimes the titles differ. But she did this because she was concerned to suggest typical meaning rather than narrative fact. The lines from Tennyson's 'Maud';

> There has fallen a splendid tear
> From the passion-flower at the gate

produced more than one response from Cameron. In fact, the figure who momentarily expresses Maud in Cameron's the *Idylls of the King* (Part Two) and A Study for 'Maud' (no. 1.45) otherwise typifies the *Guinevere* (no. 2.16) and the *Angel at the Sepulchre* (no. 1.50).

If Cameron had difficulty at times in reconciling the sacred with the profane it was due to the anxieties of the day and her own passionate nature. Contrast two of her pictures, *Fervent in Prayer* and *Goodness* (nos. 1.10, 1.11). The first is of a Madonna and child, the second is very much Mary Hillier, doubtless bearing the *persona* of the Madonna but in charge of a half-draped child. These passionate Victorians, Tennyson, Patmore, and Cameron, sought to sublimate desire and to make desire sublime, both at the same time. They were as possessed by Cupid as they were devoted to Psyche, which is why Cameron's angels and cupids are interchangeable. There are versions of Cupid which evoke, variously, classical sensuality and Christian adoration, and there is none of the repression and prurience which dominates Lewis Carroll's vision of children. For Cameron sensuousness and holy sadness are not at all incompatible. Young Freddy Gould could impersonate Astyanax, a classical type of Christ, as well as Cupid. In many pictures the heroic, the sacrificial, and the erotic are successfully combined.

My GrandChild and *The Shadow of the Cross* are both titles for the image of the mother hovering over the child (nos. 1.8, 1.9). The Madonnas and children, which include the Child Baptist John, represent a sublime innocence; Jesus destined to die for mankind, John as witness to it. Jameson wrote that such 'church pictures', as she called them, 'might be multiplied among us with advantage to the young and the old. We need sometimes to be reminded of the sacredness of childhood.'[18] The idea of the Sacrifice lies behind the image of the Child Christ most of all when represented alone. He either indicates the Cross, or even lies upon it, as Jameson illustrated in paintings by Luini and Franceschini respectively.[19] John was considered by Jameson to be a special type in that he was the last of the prophets of the Old Testament and the first of the saints of the New. He bridged two worlds. He could also change sex, according to Cameron. When Florence Fisher was not plain Florence Fisher (no. 1.24), she could be *A Study of John the Baptist* (no. 1.25), just as a female could replace the biblical male *Angel at the Tomb* (no. 1.51).

It is in the same spirit of 'the last at the Cross, the first at the Tomb' that women, and girls like Florence Fisher, can reject the role forced upon them in the Garden of Eden where Eve was responsible for the Fall, by announcing the Saviour and being the first to recognize Him after the Resurrection. The possibilities of a theological feminism were not lost on Cameron. The subjects of The Women at the Sepulchre, The Angel at the Tomb, Mary Magdalene in the Garden, and The Three Marys put women in the position of witnesses charged with the task of bringing men to the faith. This, at least, was Jameson's view.

The basic type which the sitter called Cyllene Wilson impersonates is Mary Magdalene, of whom *Ophelia* and the *Angel at the Sepulchre* are types, as well as *Gretchen* (from *Faust*) and *The May Queen*, who are related to the Leonora of Bürger's poem, which Cameron translated (*Writings*, p. 146). Leonora, whose love has gone to the wars, fears him dead, and imprecates against heaven. Her mother tells her to pray, but she will not kiss the rod, cannot endure and judges God. Her mother

tries to console her by suggesting she becomes the bride of Christ. It is to this type of the impenitent, unreconciled maiden that Death makes his appearance in the person of the lover. The Romantic themes of sex, death, and religion are essential to these types of fallen women. But in Cameron's photographs, unlike in Bürger's poem, these sinners are metamorphosed into saints.

Whether Cameron derived her *Beatrice* (nos. 1.46, 1.47) from Hawthorne's novel *The Marble Faun* (1860) or from the original, the painting then attributed to Guido Reni, this woman who committed incest with her father and conspired to kill him combines sin with grief, carnal knowledge with selfless austerity. Sorrow is made beautiful in Cameron's photographs because it combines innocent sensuousness with dark experience. In one image, *Call and I Follow* (nos. 1.54, 1.55), it is difficult to judge whether the model is Hillier or Wilson yet we feel she belongs among the Magdalenes rather than with the Madonnas. The head-drapery forms a dark nimbus, as opposed to the light-coloured drapery of *The Dream* (no. 1.52), and the uplifted head is filled with religious yearning. On another version, *The Angel at the Tomb* (no. 1.51), where the light strikes the hair so wonderfully, Cameron added a quotation, 'God's glory smote her on the face', and then a footnote, 'a coruscation of spiritual and unearthly is playing over the head in mystic lightning flash of glory'.[20] This quality of *glory* comes spiritually from within. Its analogue is in the refulgent quality of the albumen print in which the light appears to come from within; like fresco, as Sir Henry Layard described it, 'Instead of absorbing light like oil-painting, it may be said to throw out light itself.'[21] The opposite of this effect would be the *glare* described by eighteenth-century aestheticians who deplored external illumination of subjects of no intrinsic power.

Dickens wrote that women had discovered exactly in this period that women's treasure was their hair, particularly auburn hair: 'I hold that no woman can be ugly, or even plain, if she have a profusion of hair.'[22] The difference between the styles of dressing the hair in Hill and Adamson's photographs and in Cameron's is very marked. In the eighteen-forties hair was plastered down over the temples 'in formal sheets of polished veneer, or tied up in a wisp and hid in a box behind'. The image of primness, maidenliness, and femininity demanded it. In Cameron's period the loose hair of the penitent but experienced woman changed not only the image but reflected a change in consciousness. If love was a visible sign of freedom then the hair could embody that idea divinely as well as mortally. The lightning flash gives the *Angel at the Tomb* a physical vitality unexpected in any order of angels. Jameson wrote, 'Of all the personages who figure in history, in poetry, in art Mary Magdalene is at once the most unreal and the most real: – the most *unreal*, if we attempt to fix her identity, which has been the subject of dispute for ages; the most *real*, if we consider her as having been, for ages, recognised and accepted in every Christian heart as the impersonation of the penitent sinner absolved through faith and love.'[23] A doctrine of religious reserve controls Cameron's approach at this moral level where the sensuous and the spiritual are reconciled. There are no alabaster boxes of ointment; there is no narrative detail to intrude upon this portrait idealization. There is the subtlest sense of a transition in a woman's consciousness, as well as of an intimation of the Resurrection.

A Christian typology, with references to the Old and New Testament, combined with Arthurian legend, and the world of English poetry, provided Cameron with a basic system within which to explore the Victorian consciousness. What she called a series of images forming 'a work of some theological interest',[24] multiplied into each other and produced a complexity of meaning exceeding any simple addition of images. She had found in

OPPOSITE
iv. *Iago. Study from an Italian*, 1867. (National Portrait Gallery, London)

24

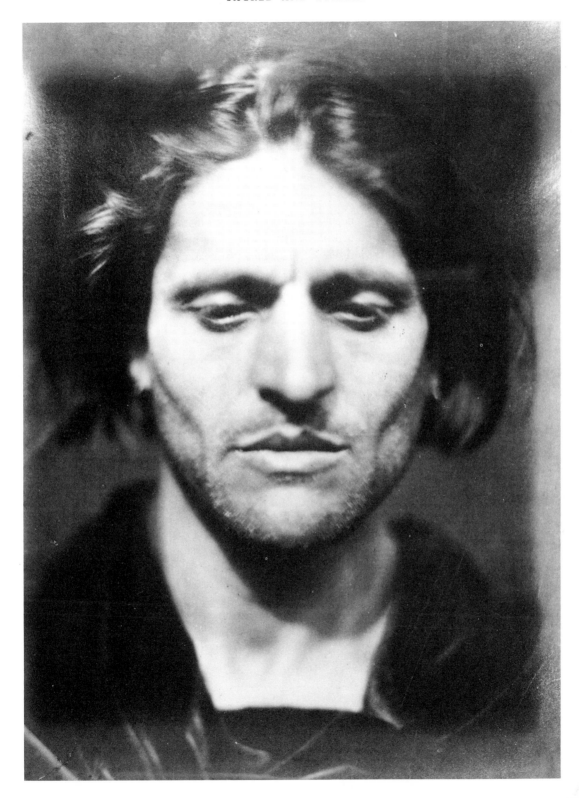

sacred art a subject large enough to receive the abundance of her energetic and sympathetic mind. Her most creative pictures are those which take a sacred or legendary subject as their idea and turn it into a symbol of great reserve. The moments she chooses express a deep, brooding unconsciousness, reflected in the eyes, in the posture, in the hair – of men as well as women – in which the inward feelings are manifested but cannot be specifically explained. The images take over as symbols of a mystery which is inexpressible except in Cameron's own pictorial terms. *The Dream* (no. 1.52) keeps its secret so well that two leading Cameron scholars, Colin Ford and Helmut Gernsheim, are unable to agree whether the sitter is Mary Hillier or Cyllene Wilson. Ostensibly a Miltonic subject, it is the central image in all Cameron's work. The unfocused hint of lily-of-the-valley tells us it contains the Madonna element, and ought to be of Hillier, but the Magdalenian profile suggests Wilson. The image combines the sinner as saint with the saint who has known carnal love. What we have here is the Magdalene sanctified and purified as patron Saint. All the Madonna and Magdalene studies meet in this wonderful picture. Others who have written on her work have been obsessed with the identities of her sitters as if by naming them directly they were giving the pictures meaning, when actually the images find their meaning in the space between idealist fiction and realist fact. She was turning actual models into ideal subjects.

In the Sir John Herschel album there is an image unique, so far as we know, in all her work – entitled *Iago, Study from an Italian* (fig. iv). This *Iago*, is he not the Man of Sorrows? If George Eliot used Jews and Italians as interchangeable racial types, and Italian models in London like this one could be used for both classical and biblical subjects, could

we not have here a preposterous and beautiful attempt to depict Christ? The same model had been used by Watts as the Prodigal Son – a type of David and a type of Christ – but a single glance at this image tells us that it is Christ. Cameron's title puts us in mind of a villainous type, anxious and riddled with bad conscience – the contra-type of Christ, his betrayer Judas. In Shakespeare, his type would, indeed, be the Iago who betrayed the Moor, Othello. This image, typical in origin, is secularized by Cameron not only to avoid profanity, but to express her own anxiety about the gloomy, even sinister, quality of her attempt to depict Christ. In discussing representations of Christ in *The History of Our Lord,* Jameson remarked that the Roman soldiers took Him for a criminal, even as Christians recognized him as the Christ:

Thus there must always be a compromise between what we have termed temporary fact and permanent truth, and that at the expense of the least important of the two. And this compromise, which is the soul of Christian Art, is not proper to that only. It is the soul also, in the strictest sense, of all Art. What is the Drama without it? There is always the fact for the actors, and the truth for the spectators. That Othello sees in Iago an honest man is the fact; that we see him to be a villain is the truth. The real object of the play is always outside the boards.[25]

In drawing her title from Shakespeare, Cameron was following Jameson's advice to merge Christian iconography with English poetry. The works of Shakespeare, Milton, Keats, Byron and Tennyson offer an Anglo-Saxon testament to take its place with the Bible as a source of ideal types. Usually, however, Cameron contented herself with Sibyls and Prophets. Only here – and possibly in her images of Tennyson – does she appear to have attempted an adult depiction of her Saviour.

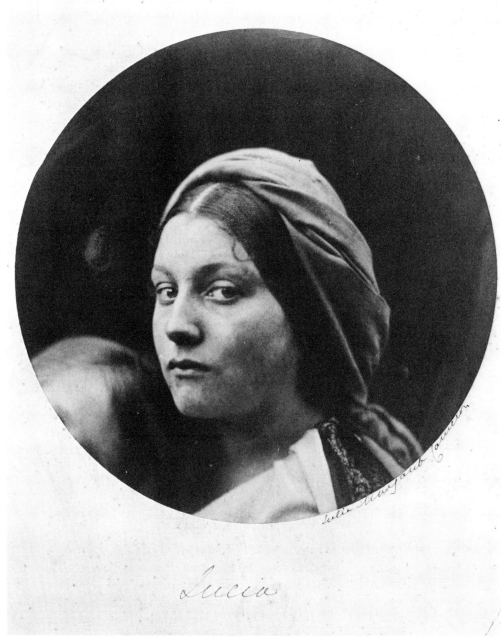

Lucia

1.2

1.1
G. F. WATTS
Julia Margaret Cameron,
1850–52

Oil on canvas
61 × 58
National Portrait Gallery,
London (5046)

'I have no *pride*. I have a
great deal of confidence in
myself & my fellow crea-
tures & if they disappoint
me I am more sorry for
their sakes than my own.'
Cameron to her sister,
Adeline Vaughan, 15
November 1875 (Bodleian
Library, Oxford, *Misc. Eng.
Lett. d* 444, *fol. 161*)

(*See* frontispiece)

1.2
LUCIA, *c.* 1869

18 diam.
The Royal Photographic
Society (C18: 2308)

Associating St Lucia with
the Virgo Sapientissima, the
most wise Virgin, Cameron
has transformed the picture
from a Madonna study (the
Infant Jesus cropped in the
circular print) to one
emphasizing the eyes which
typify celestial light.

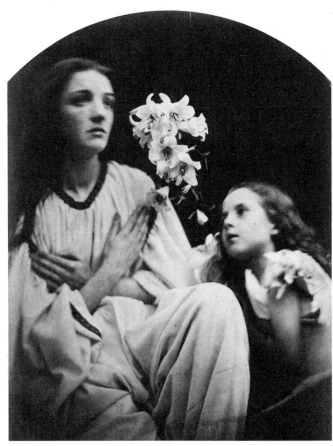

1.3

1.3
*The Annunciation/
FreshWater* 1865

Colnaghi blind stamp
Arched top, 35.3 × 27.7
The Royal Photographic
Society (C11: 2165)

This combines the image of
the Madonna Purissima, of
the Immaculate Concep-
tion, with the subject of the
Annunciation in which

Mary and the Angel mani-
fest 'just sufficient of
attitude and expression to
place them in relation to
each other, or with such
accompaniments as served
to carry out the mystical
idea, still keeping it as far as
possible removed from the
region of earthly possi-
bilities'.

Jameson, *Legends of the
Madonna,* 170

1.4
GIRL PRAYING, registered
1866

31.8 × 26.5
Lent by the Visitors of the
Ashmolean Museum,
Oxford

1.5
STUDY —MADONNA,
registered 1870

32.8 × 28
The Royal Photographic
Society (C11: 2166)

The child, who appears to
be wearing an animal skin
and is holding a cross, is
more likely to be John the
Baptist, the messenger and
precursor of Christ, rather
than Christ himself. The
madonna lilies suggest the
theme of the Annunciation
rather than the birth of
Christ.

(*see* p. 16)

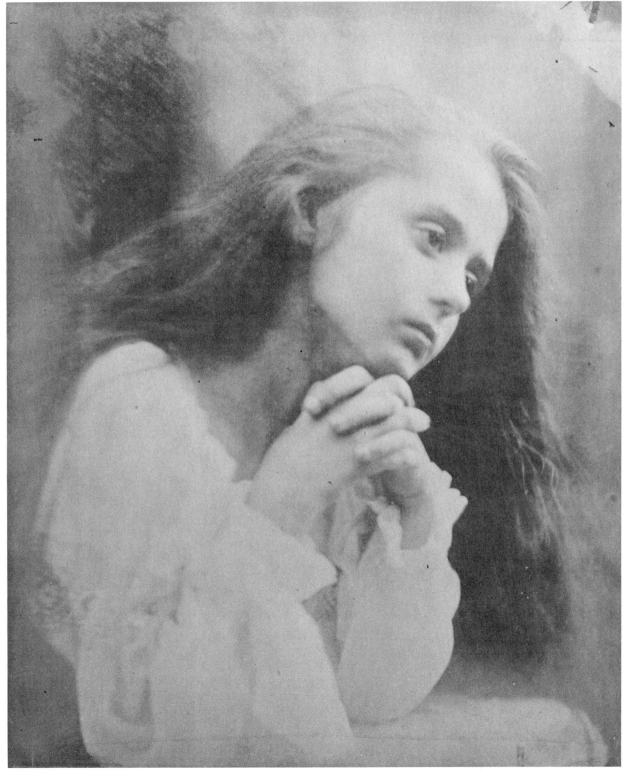

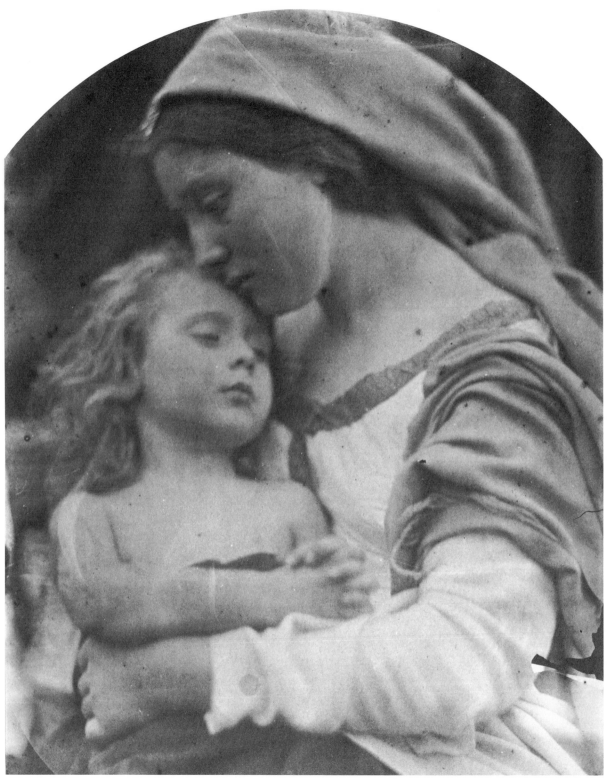

1.6

1.6

STUDY – MADONNA AND CHILD, registered 1865

Arched top, 25.4 × 20.4
The Royal Photographic
Society (C11: 2178)
Presented by J. H. Frere,
1939

Jameson designated one treatment of the Madonna and child 'the Mater Amabilis'. 'The Virgin is not here the dispenser of mercy; she is simply the mother of the Redeemer. She is occupied only by her divine Son. She caresses him, or she gazes on him fondly.'

Jameson, *Legends of the Madonna*, 115.

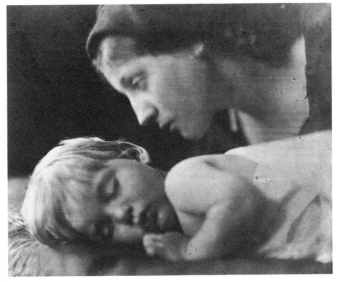

1.7

1.7

MY GRANDCHILD
August 1865 (George
Eastman House)

Colnaghi blind stamp
22.8 × 28
The Royal Photographic
Society (C11: 2396)
Presented by J. H. Frere,
1939

'A beautiful version of the Mater Amabilis is the *Madre Pia*, where the Virgin in her divine Infant acknowledges and adores the Godhead.'

Jameson, *Legends of the Madonna*, 125.

1.8

My GrandChild
August 1865 (George
Eastman House)

19.1 diam.
The Royal Photographic
Society (C11: 2176/1)
Presented by J. Howard
Frere

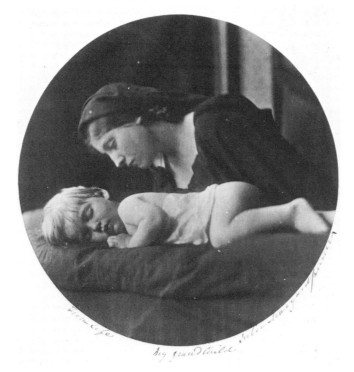

1.8

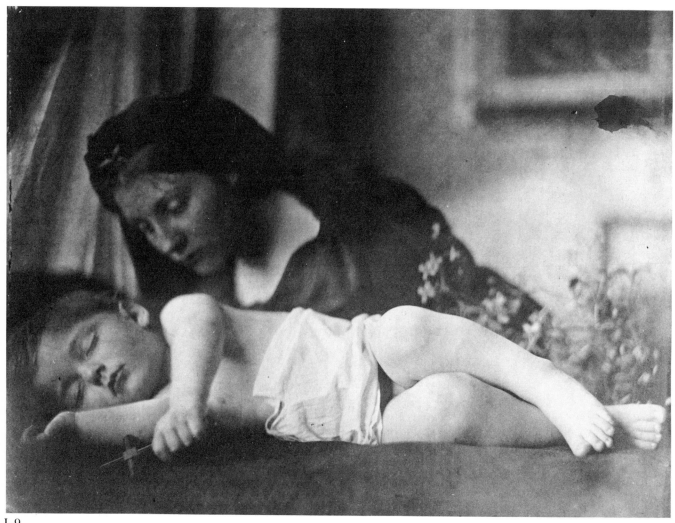

1.9

1.9
*The Shadow of the Cross /
August 1865*

Colnaghi blind stamp
27 × 36.5
Victoria & Albert Museum,
London (45160)

'With Guido and
Franceschini He lies asleep
on His Cross dreaming of
His Passion. This is a lovely
infant, as is our woodcut [of
the Franceschini], perfect in
colour and limb, but nothing
more. We need the pathetic
contrast between innocence
and His predestined fate to
convey the religious feeling.'

Jameson, *History of Our Lord*,
II: 381.

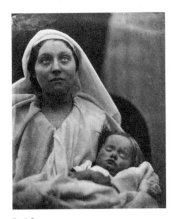

I.10

I.10

FERVENT IN PRAYER,
c. 1864–65

26.3 × 21.2
Victoria & Albert Museum,
London (44754)

Of the class of Mater
Amabilis, but 'Miserable
beyond the reach of hope,
dark below despair, that
moral atmosphere which
the presence of sinless
unconscious infancy cannot
for a moment purify or
hallow!'

Jameson, *Legends of the
Madonna*, 115

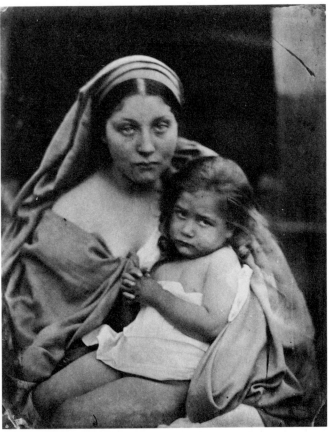

I.II

I.II

Goodness, (Ford 127),
registered 1864

27 × 21.6
Victoria & Albert Museum,
London (44756)

'The theme, however
inadequately treated as
regarded its religious
significance, was sanctified
in itself beyond the reach of
a profane thought.'

Jameson, *Legends of the
Madonna*, 115.

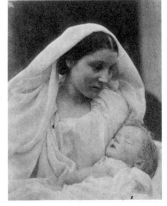

I.12

I.12

*La Madonna Riposata/Resting
in Hope*, registered 1865

25.4 × 20
National Portrait Gallery,
London (X18025)

'We must bear in mind that
the Riposo, properly so
called, is not merely the
Holy Family seated in a
landscape; it is an episode of
the Flight into Egypt, and is
either the rest on the jour-
ney, or at the close of the
journey; quite different
scenes, though all go by the
same name.'

Jameson, *Legends of the
Madonna*, 238

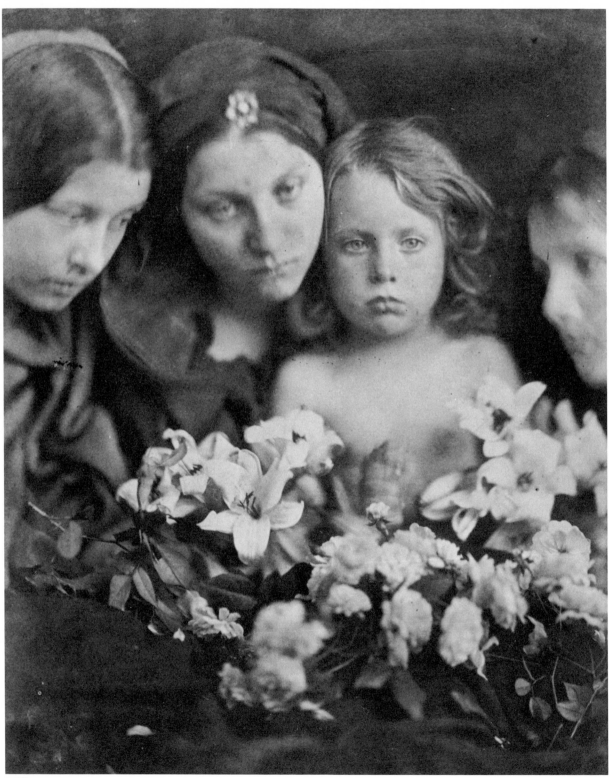

1.13

The return 'after three days',
registered 1865

Colnaghi blind stamp
28 × 22.8
Victoria & Albert Museum,
London (44960)

The title refers, perhaps,
both to Christ among the
Doctors, where He is the
teacher of men, and Christ
resurrected, since according
to the *Credo*, on 'the third
day he rose again . . . and
ascended into heaven'.
'. . . in the life of the Virgin,
the whole scene changes its
signification. It is no longer
the wisdom of the Son, it is
the sorrow of the Mother
which is the principal
theme.'

Jameson, *Legends of the
Madonna*, 272.

1.14

A Study of a Holy Family,
registered 1872

Arched top and bottom,
34.4 × 28.6
The Royal Photographic
Society (CII: 2161)

'The Mater Amabilis in a
more complex and pic-
turesque, though still devo-
tional form. The Virgin . . .
reclines on a verdant bank,
or is seated under a tree. She
is not alone with her Child'.

Jameson, *Legends of the
Madonna*, 127

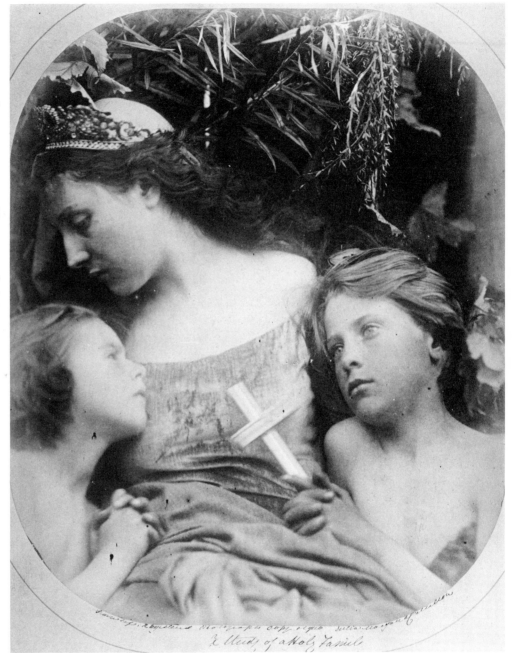

1.14

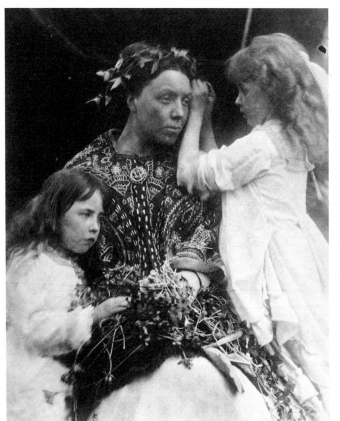

1.15

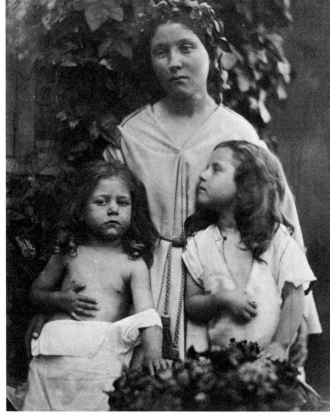

1.17

1.15
LADY RITCHIE AND HER
NIECES, *c.* 1868

35.3 × 28
The Royal Photographic
Society (C11: 2163)
Presented by Mrs Trench

1.16
STUDY – MADONNA AND
CHILDREN, *c.* 1872

27.3 diam.
The Royal Photographic
Society (C11: 2160)
Presented by F. Hollyer,
1931

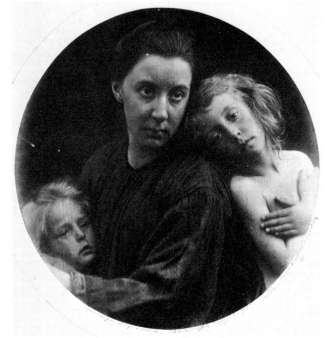

1.16

1.17
Spring, registered 1865

25.8 × 20.3
Victoria & Albert Museum,
London (44757)

'In our present illustration
the linear composition of
the group – that is to say,
the direction of the lines
which form the skeleton of
the drawing, and uncon-
sciously lead and hold the
vision – is such as to destroy
the effect of what has some
elements of a very beautiful
picture. The horizontal lines
forced on the eye by the
level arms of the children,

the straight, strained top of the shirt, and the distorted fingers, are bad. The effect of the vertical line defined by the rosary and by the folds of the woman's dress, parting right and left at the throat, like the cusps of an ill-drawn window of modern perpendicular Gothic, and leading the eye nowhere, is absolutely destructive.'

Anonymous, 'Studies from Life by Mrs Cameron,' *Art Pictorial and Industrial* III (January–June 1872), 25–6, where this image, laterally reversed, was published as a heliotype reproduction entitled *A Study from Life*.

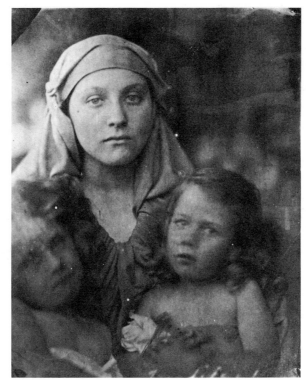

1.18

1.19

I.18

STUDY OF MADONNA WITH TWO CHILDREN, *c.* 1864

26.5 × 21.3
Liverpool City Libraries
(12)

I.19

L'INCORONATA, *c.* 1865

35.5 × 28.5
Liverpool City Libraries (4)

'The usual type of the Church triumphant is the *Coronation of the Virgin* properly so called . . . it is the last and most glorious event of her history. The Mother, dying on earth, is received into glory by her Son who had gone before her, and who thus celebrates the consummation of his victory and hers.

But when the scene is treated apart as a single subject . . . then the subject must be regarded as absolutely devotional and typical.'

Jameson, *Legends of the Madonna*, 13–14.

THE ARUNDEL SOCIETY

The purpose of the Society for Promoting the Knowledge of Art was to make a collection of watercolours, tracings, and photographs from frescoes of the fourteenth, fifteenth, and sixteenth centuries otherwise not available in the form of engravings, and to exhibit and publish them by various modern processes, including chromolithography. In 1855 the Society exhibited its Giotto tracings at the Crystal Palace, Sydenham, and from 1859 was allowed to offer its publications for sale in the South Kensington Museum (now the Victoria and Albert Museum). It exhibited its copies of all kinds in a gallery for such reproductions at the Museum, and sold photographs of paintings in the National Portrait Exhibition of 1866–7. It also made available reduced copies of the Elgin Marbles in plaster, bronze, and ivory.

Julia Margaret Cameron was a long-standing member. She is recorded as a subscriber on both extant membership lists, that of 1859 and that of 1866. In 1859 Lord Elcho, Holman Hunt, Sir Coutts Lindsay, John Ruskin and the prime mover of the Society, Sir Henry Layard, were on the Council. Other members included Viscount Hardinge, Sir Charles Eastlake, John Gibson, Lord Lindsay, Walter Savage Landor, and Roger Fenton, the photographer. By 1861 there were more than a thousand members, and by the mid-seventies more than three thousand.

Ludwig Gruner (1801–82), engraver, art publisher, adviser to Prince Albert, and Keeper of the Royal Print Room, Dresden, directed the production of chromolithographs by the Berlin firm of Storch and Kramer. Cesari Mariannecci, who was one of the first professional copyists employed by the Society, made eighty-five watercolours, and twenty-six were acquired by the South Kensington Museum. He was much criticized for restoring the frescoes in his copies, and regarded as inaccurate and occasionally arbitrary in what he chose to include. All the watercolours exhibited are from his hand, and all the chromolithographs shown are based on his original water-colours. Almost nothing is known about him.

I.20
CESARI MARIANNECCI
after Bernardino Luini
Head of the Virgin from
The Adoration of the Magi
(Sanctuaria della Vergine,
Saronno)

Arundel Society water-colour, n.d.
36.2 × 25
National Gallery, London.
On permanent loan to the University of Leeds, Department of Fine Art (NG 295)

I.21
After Giovanni Boltraffio
(then attributed to
Leonardo da Vinci)
Virgin and Child
(S. Onofrio, Rome)*

Arundel Society chromolithograph by Storch and Kramer from a watercolour copy by Mariannecci, 1859
32.2 × 51.1
By permission of the Curators of the Bodleian Library, Oxford.

I.22
After Giovanni Santi
(Sanzio)
The Virgin and Child and Saints and the Resurrection of Christ (S. Domenico, Cagli)*

Arundel Society chromolithograph by Storch and Kramer from a watercolour copy by Mariannecci, 1859
54 × 41.1
By permission of the Curators of the Bodleian Library, Oxford.

I.20

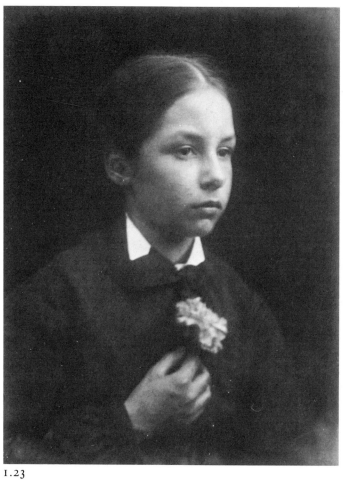

I.23

I.23

MARGARET NORMAN

33.4 × 25.4
The Royal Photographic
Society (C10: 2563)

Margaret Norman was one
of Cameron's grand-
children.

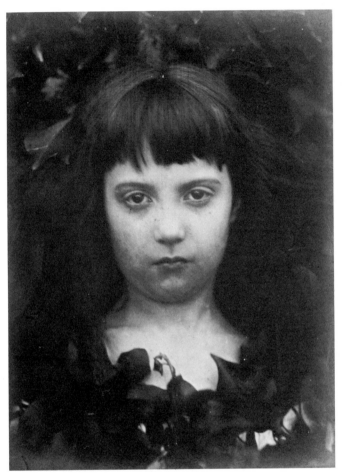

1.24

1.25

1.24
A STUDY – FLORENCE
FISHER, 1872

Colnaghi blind stamp
35.9 × 26.7
The Royal Photographic
Society (C10:2150/2)

1.25
Study of St John the Baptist
September 1872 (George
Eastman House)

Colnaghi blind stamp
34.3 × 25.5
The Royal Photographic
Society (C10:2153/1)
Presented by F. Hollyer

1.26
*Venus chiding Cupid &
removing his Wings/
FreshWater 1873/A Gift to
Mr Hollyer from
Mrs Cameron Aug. 22d 1873*

Colnaghi blind stamp
30.2 × 26.7
The Royal Photographic
Society (CII: 2179/1)
Presented by F. Hollyer,
1931

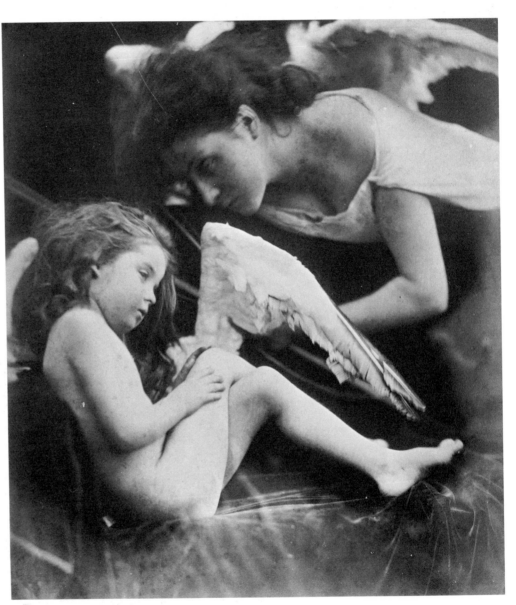

1.26

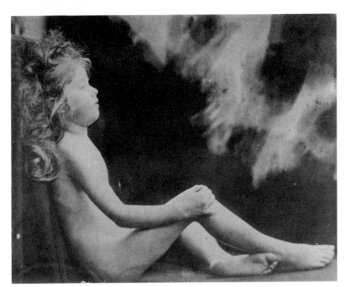

1.27

1.28
Love in Idleness, c. 1867
(Gernsheim 194)

29 diam.
Liverpool City Libraries (7)

'Where the bolt of Cupid fell;
It fell upon a little western flower,
Before milk-white, now purple with love's wound,
And maidens call it Love in idleness.

Shakespeare, *Midsummer Night's Dream* II. i, 163

1.27
The Young Endymion

26.7 × 34.4
Mrs Angus Hewat

'His eternal sleep on Latmus
is assigned to different
causes; but it was generally
believed that Selene had
sent him to sleep, that she
might be able to kiss him
without his knowledge . . .
There is a beautiful statue of
a sleeping Endymion in the
British Museum.'

Smith, *Classical Dictionary of
Greek and Roman Biography*,
240.

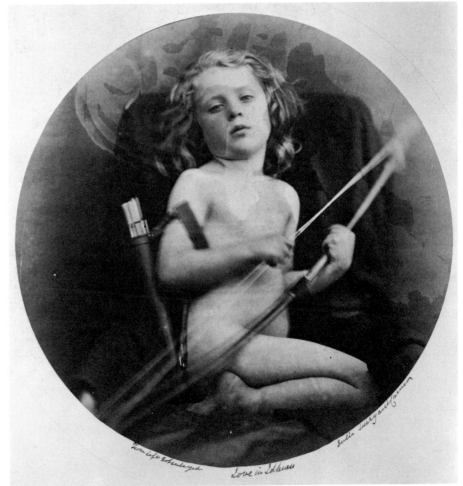

1.28

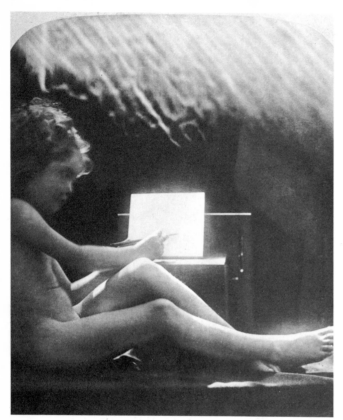

I.29

1.30
I Wait, registered 1872

Colnaghi blind stamp
31.4 × 23.5
The Royal Photographic
Society (C9: 2562)
Presented by F. Hollyer,
1931

Both the pose and the
expression of the child in
Cameron's picture derive
from one of the *putti* in
Raphael's *Sistine Madonna*, a
painting upon which
Rejlander also based at least
one of his photographs.

1.31
ESME HOWARD *1869 March*

32.5 × 25

The Hon. Edmund
Howard

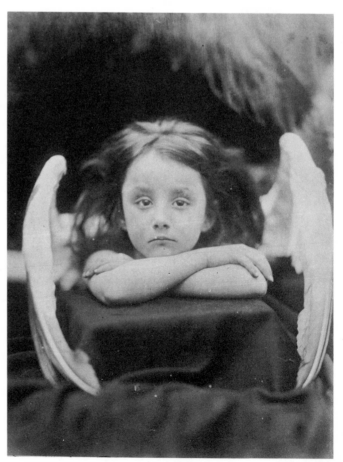

1.29

CUPID'S PENCIL OF LIGHT,
1870

Brown carbon, Autotype
blind stamp
Arched top, 33.7 × 28.3
The Royal Photographic
Society (C9: 2123/1)

'An interesting and beauti-
ful study of the nude taken
in the studio with the sun-
light streaming through the
glass upon the figure. The
descending rays of light are
produced by withholding
the "cyanide" at the proper

moment, and the effect is
marvellous. Altogether a
most artistic picture.'

P. H. Emerson, *Sun Artists*,
42

Putti, often manipulating
cameras themselves,
became the standard
decorative motif on the
backs of photographic
firms' cards during the
1860s, which suggests this
picture was a 'manifesto'
for photography.

1.30

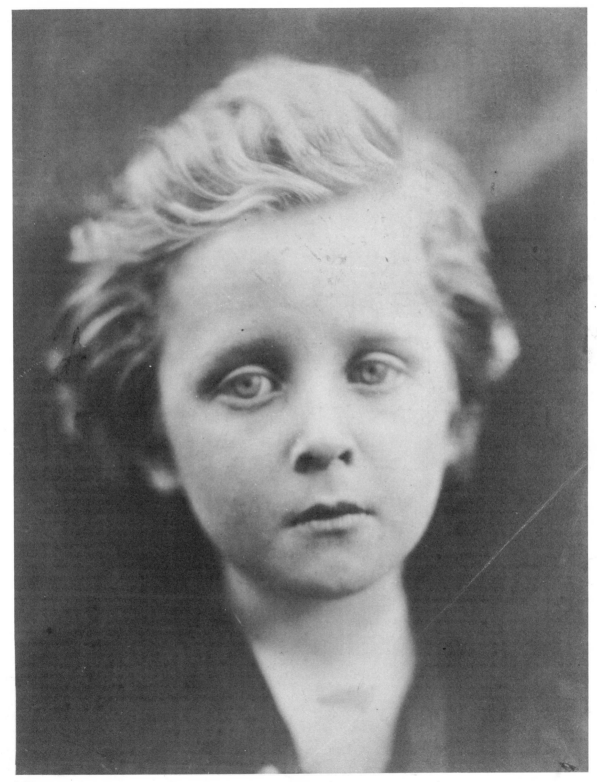

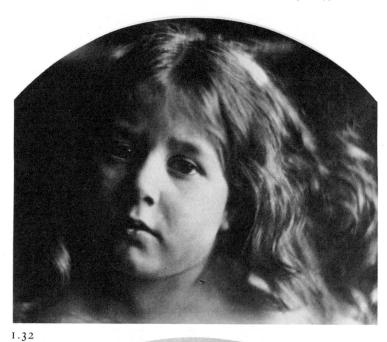

1.32

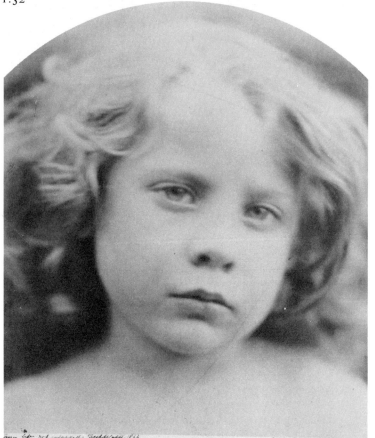

1.33

I.32
CHILD'S HEAD, *FreshWater Bay Isle of Wight*
February 1866 (Gernsheim 191)

Colnaghi blind stamp
Arched top, 23.6 × 28.6
Victoria & Albert Museum, London (940–1913)

I.33
CHILD'S HEAD, *FreshWater*
1866

Arched top, 32.6 × 28.5
Victoria & Albert Museum, London (939–1913)

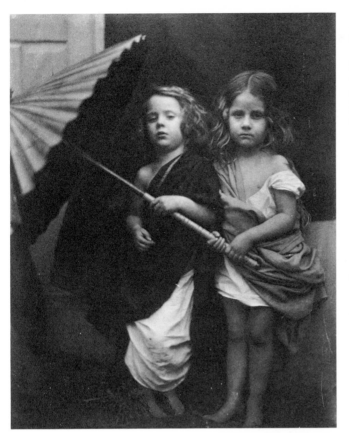

1.34

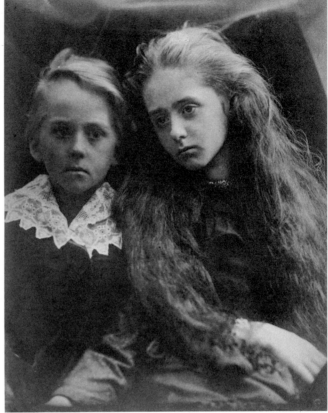

1.35

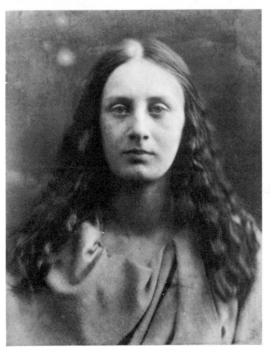

1.36

1.34
Paul and Virginia, registered
1865

Colnaghi blind stamp
26.6 × 21
Victoria & Albert Museum,
London (45148)

Paul et Virginie, a novel by
Bernardin de Saint Pierre,
appeared in numerous
editions and translations
during the nineteenth
century.

1.35
*Claud [&] Lady Florence
Anson/Aug. 1870*

Colnaghi blind stamp
34.4 × 28.3
The Royal Photographic
Society (C10: 2144/2)

1.36
MAY PRINSEP, 1866

28.1 × 22
National Portrait Gallery,
London (X18015)

I.37
My favourite Picture My Niece Julia/April 1867
(Ford 133)

Colnaghi blind stamp
29.2 × 24.3
Lent by the Visitors of the Ashmolean Museum, Oxford

Julia Prinsep Jackson was the daughter of Cameron's sister Maria. She married Herbert Duckworth in 1867 and eight years after his death in 1870, married Leslie Stephen. Virginia Woolf was one of their children.

I.38
JULIA JACKSON – MRS
HERBERT DUCKWORTH,
Saxonbury 1867 April

Oval, 34.4 × 26.3
National Portrait Gallery,
London (X18018)

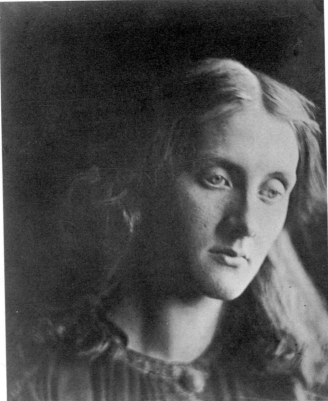

I.37

I.39
MRS DUCKWORTH WITH
CHILD, *Aug. 1872*

Arched top, 30.9 × 21.6
National Portrait Gallery,
London (X18017)

Devotional images of the Madonna appealed to the faithful, but 'domestic' images were less religious than simply familial. Jameson distinguished the *Sacra Conversazione* from the *Sacra Famiglia* in this way (*Legends of the Madonna*, 250–1). In her Duckworth series Cameron secularizes the Madonna as a type.

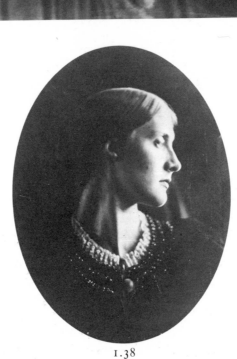

I.38

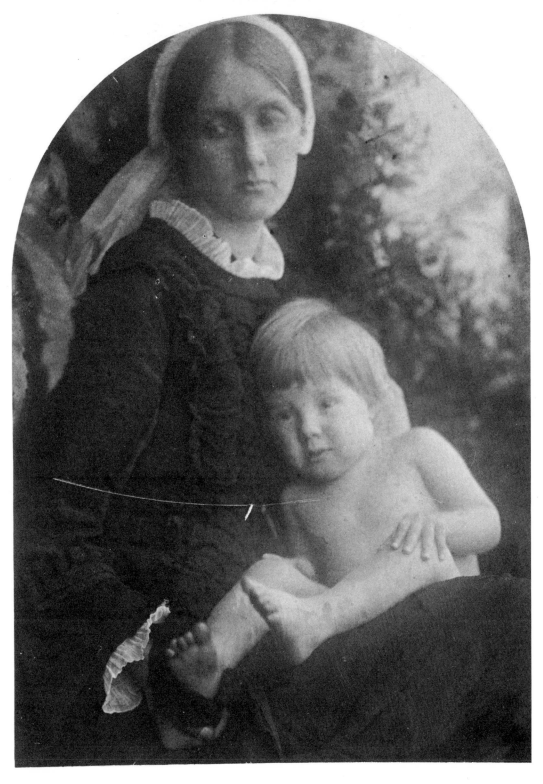

1.40

I.40
MRS DUCKWORTH IN
GARDEN, 1872

30 × 24.7
National Portrait Gallery,
London (X18019)

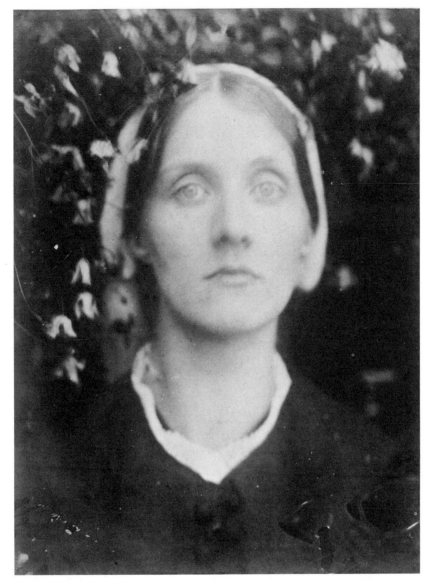

1.41

1.41
A beautiful Vision
June 1872 (Royal Photo-
graphic Society C18:
2312/1)

35.3 × 25.4
The Royal Photographic
Society (C18: 2312/2)
Alvin Langdon Coburn
Gift, 1930

'There is a vision in the heart of each,
Of justice, mercy, wisdom, tenderness
To wrong and pain, and knowledge of their cure;
And those embodied in a woman's form
That best transmits them pure as first received
From God above her to mankind below!'

Browning, *Colombe's Birthday: A Play*.
Cited by Jameson, *Legends of the Madonna*, liii.

1.42

I.42
CESARI MARIANNECCI
after Fra Bartolommeo
Noli Me Tangere (Villa dei
Frati di S. Marco, near
Florence)

Arundel Society water-
colour, 1865
59.5 × 61.3
National Gallery, London.
On permanent loan to the
University of Leeds,
Department of Fine Art
(NG 128)

I.43

PRE-RAPHAELITE STUDY,
registered 1870

38.2 × 30.8
Lent by the Visitors of the
Ashmolean Museum,
Oxford

I.43

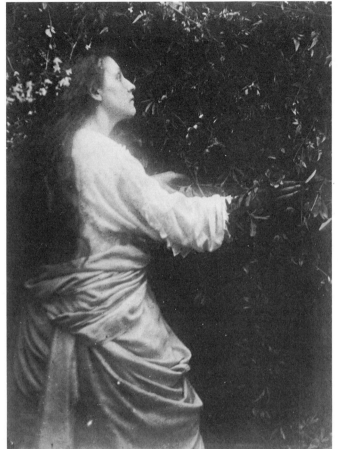

I.45

I.44

I.44
Gretchen/Margaret see Faust,
c. 1870

Colnaghi blind stamp
35 × 26.4
The Royal Photographic
Society (C13: 2204/1)
Presented by F. Hollyer,
1931

Gretchen ('dolorosa') was
one of the *Female Characters
from Goethe* illustrated by
William Kaulbach, London
1874.

I.45
A STUDY FOR 'MAUD',
c. 1875

37.5 × 27.9
The Royal Photographic
Society (C13: 2213)

Tennyson gave Cameron
an inscribed copy of the
Moxon edition of *Maud and
Other Poems* (1855) dated
July 25th, 1855. This study
for 'Maud' is different from
the image Cameron pub-
lished in the second part of
her *Idylls of the King,* May
1875.

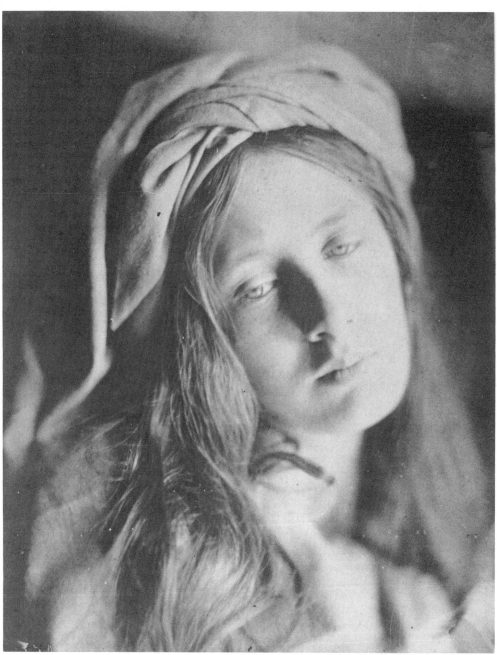

1.46

1.46
Beatrice/FreshWater
19 Oct 1870 (Gernsheim 192)

Colnaghi blind stamp
35 × 28
The Royal Photographic
Society (C18: 2302)
Presented by H. S. Marfleet,
1931

Shelley's play *The Cenci*
(1819) went through
numerous editions during
the second half of the
nineteenth century. It tells
the story of Beatrice Cenci,
who committed incest with
her father, and plotted his
murder.

1.47
A Study of the Beatrice Cenci
(The Royal Photographic
Society C18: 2301/4)
FreshWater, Sept. 1870
(Taylor Album, Bodleian
Library)

37 × 29.1
Lent by the Visitors of the
Ashmolean Museum,
Oxford

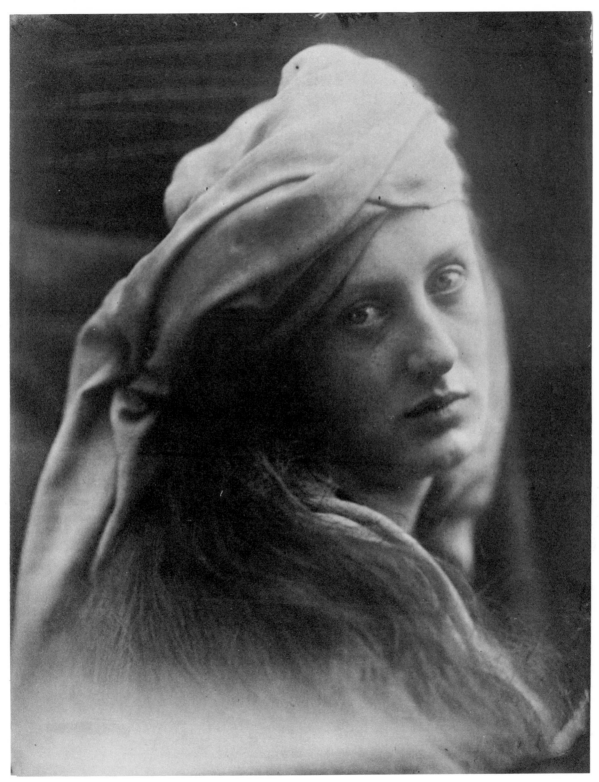

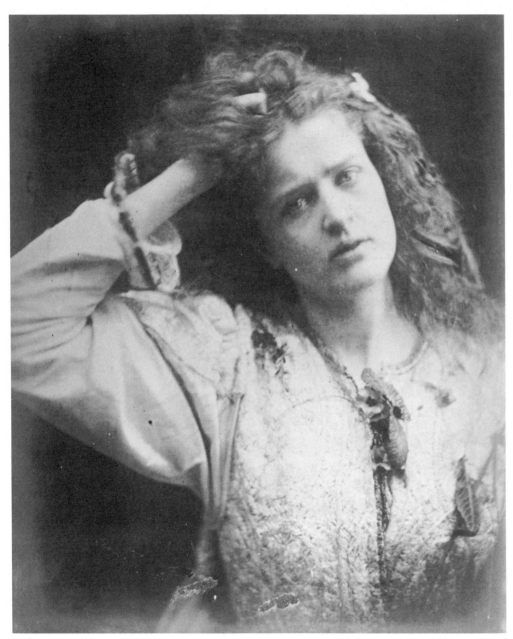

1.48

1.48

OPHELIA, *c.* 1875

Colnaghi blind stamp
34.6 × 29.9
The Royal Photographic
Society (C15: 2253/1)
Presented by Mrs Trench,
1929

'When thrown alone amid
harsh and adverse destinies,
and amid the trammels and
corruption of society with-
out energy to resist, or will
to act, or strength to
endure, the end must needs
be desolation.'

Jameson, 'Ophelia', *Charac-
teristics of Women*, I: 254.

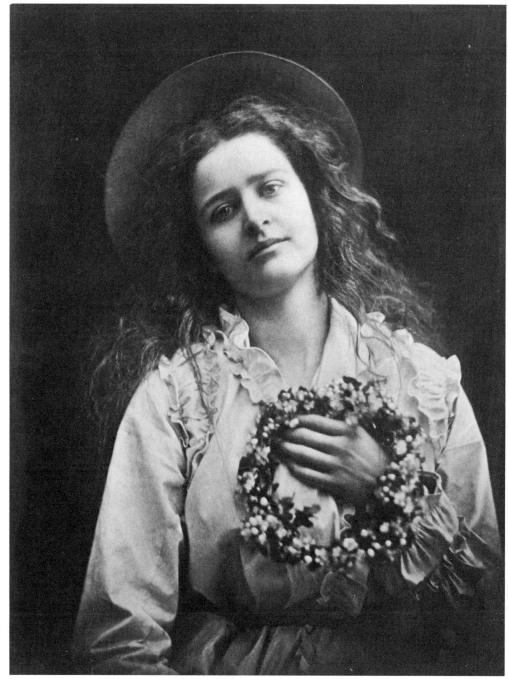

1.49

I.49

THE MAY QUEEN, registered
1875

Brown carbon
33.3 × 25.4
The Royal Photographic
Society, (C17: 2281/1)
Presented by Mrs Trench,
1930

This is one of Cameron's
two illustrations for
Tennyson's poem 'The
May Queen' included in
Part Two of her *Idylls of the
King*.

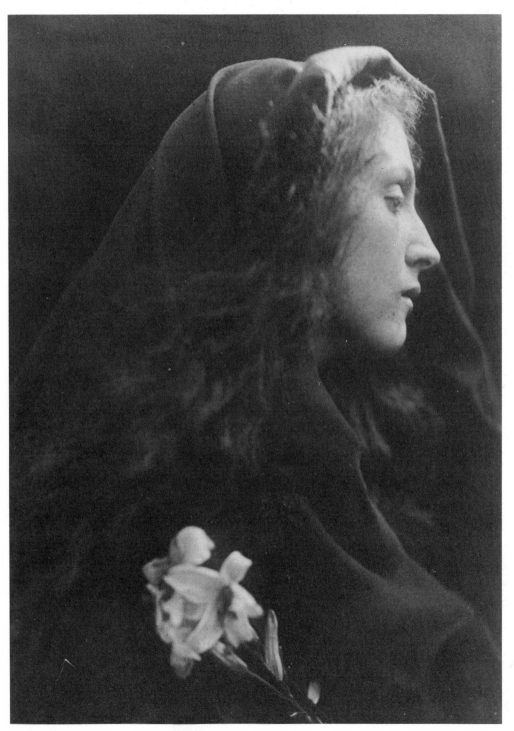

I.50
The Angel at the Sepulchre
1869 (Gernsheim 194)

35.3 × 25.6
Victoria & Albert Museum,
London (936–1913)

The images of the Magda-
len and of the Angel (in the
Bible represented by a man)
are conflated here. 'It is
assumed by several com-
mentators that our Saviour
appeared first to Mary
Magdalene, because she, of
all those he had left on
earth, had most need of
consolation. "The disciples
went away to their own
home; but Mary stood
without the sepulchre
weeping".'

Jameson, *Sacred and Legen-
dary Art,* I: 336.

I.51
*The Angel at the
Tomb/FreshWater 1869*

Colnaghi blind stamp
Arched top, 35.3 × 25.7
The Royal Photographic
Society (C17: 2289/10)

I.50

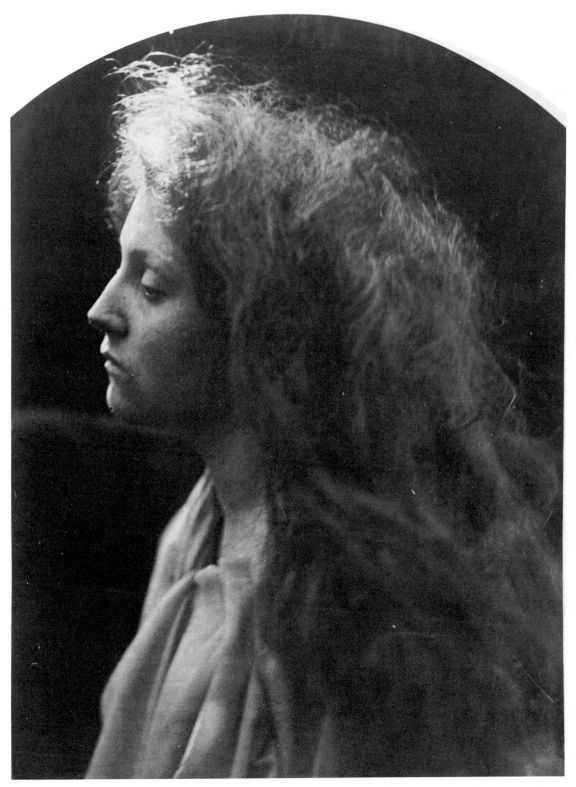

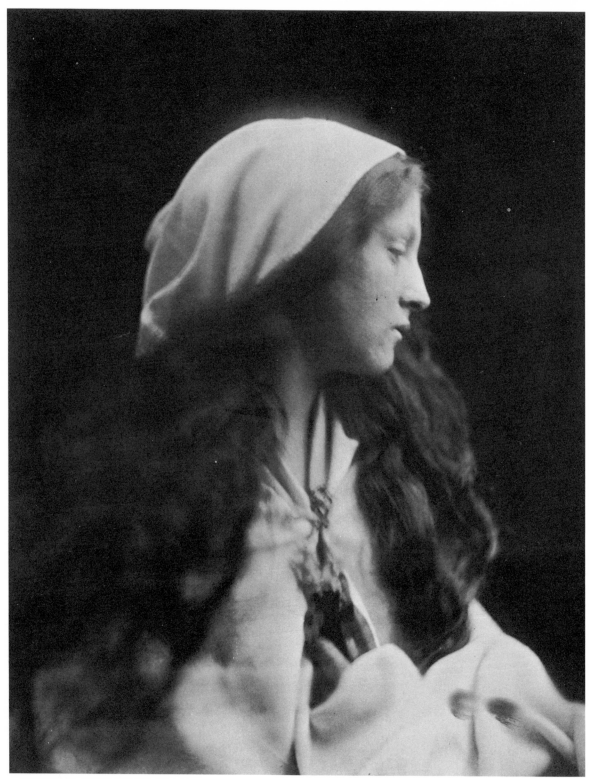

I.52

1.52
The Dream /FreshWater April 1869/
'Methought I saw my late espoused saint'
Lithographically inscribed, 'Quite Divine G F Watts'

Colnaghi blind stamp
30.3 × 24.4
Lent by the Visitors of the Ashmolean Museum,
Oxford

'Methought I saw my late espousèd saint
 Brought to me like Alcestis from the grave,
 Whom Jove's great son to her glad husband gave,
 Rescued from death by force, though pale and faint.
Mine, as whom wash'd from spot of child-bed taint
 Purification in the old law did save;
 And such, as yet once more I trust to have
 Full sight of her in Heaven without restraint,
Came vested all in white, pure as her mind:
 Her face was veil'd, yet to my fancied sight
 Love, sweetness, goodness, in her person shined
So clear, as in no face with more delight.
 But oh! as to embrace me she inclined,
I waked, she fled, and day brought back my night.'

Milton, 'On his Deceased Wife', written *c.* 1658.

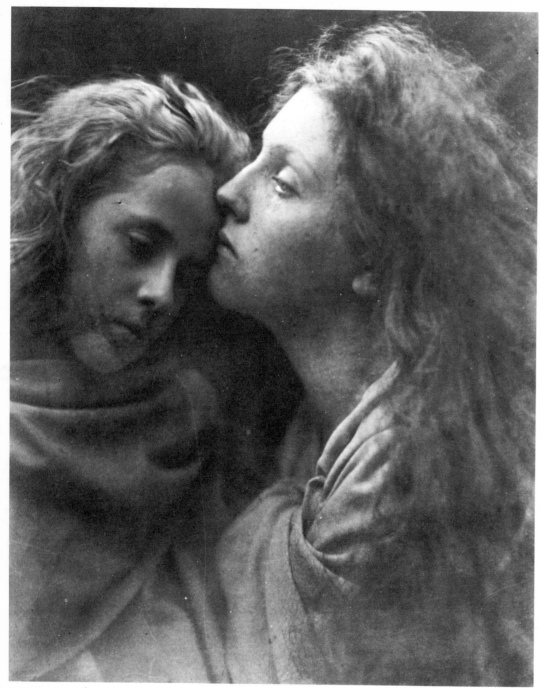

1.53
The Kiss of Peace
1869, (Gernsheim 191)

34.3 × 27.7
The Royal Photographic
Society (C11: 2177/2)

'. . . The baptised shall
embrace one another, men
with men and women with
women. But let not men
embrace women.'
Gregory Dix (ed.), *The
Treatise of the Apostolic Trad-
ition of St Hippolytus of
Rome*, London 1968:29

'A picture instinct with
delicate observation, sweet-
ness and refinement. One of
the noblest works ever pro-
duced by photography.'
P. H. Emerson, *Sun Artists*,
41

1.53

I.54
CALL AND I FOLLOW,
c. 1867

35 × 27
The Royal Photographic
Society (C18: 2311/1)

'I fain would follow love, if that could be;
I needs must follow death, who calls for me;
Call and I follow, I follow; let me die.'

Tennyson, 'Lancelot and Elaine', *Idylls of the King*.

1.55

I.55
CALL I FOLLOW, I FOLLOW
LET ME DIE, *c.* 1867

Brown carbon, Autotype
blind stamp
38.7 × 29.9
The Royal Photographic
Society (C18: 2311/2)
Alvin Langdon Coburn
Gift, 1930

When Cameron placed her
negatives in the hands of the
Autotype Company she
committed herself to a
commercial, photo-
mechanical process which
often entailed retouching at
the hands of the printers
and a definite loss of tonal
range in the print. Occa-
sionally, however, the
prints could be very beauti-
ful, and Cameron was
impressed by their claim to
permanency.

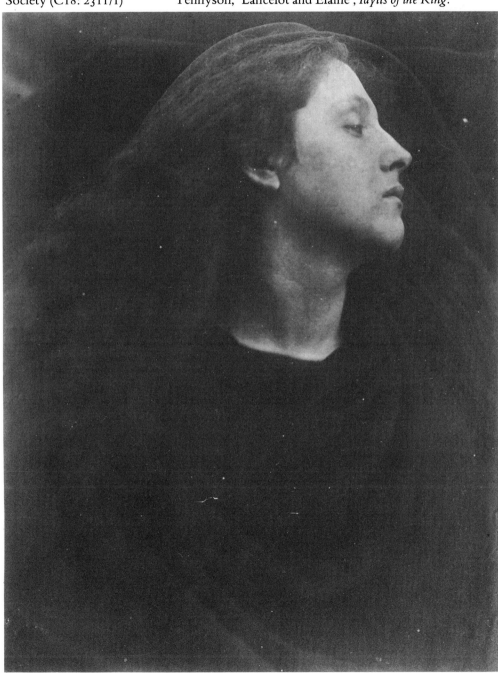

I.54

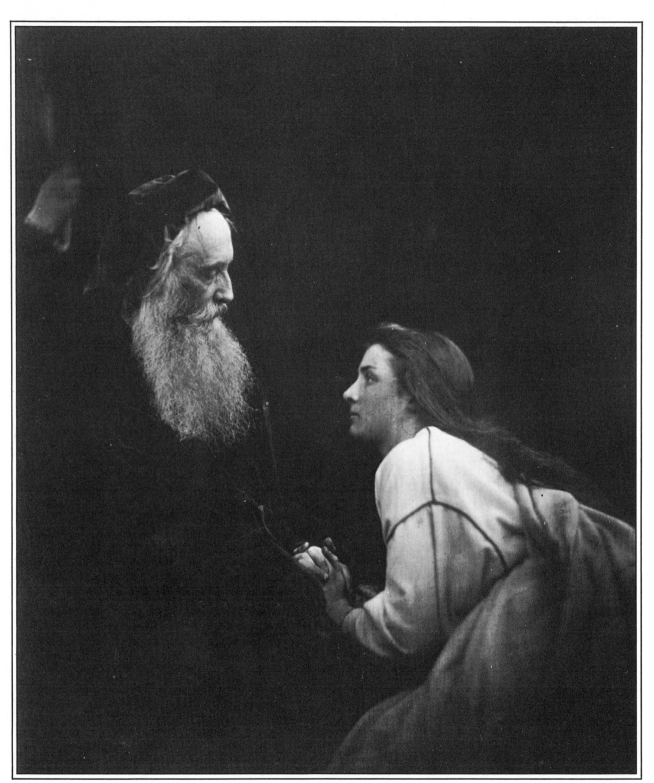

no. 2.25 (*see* page 85)

2·Legends and idylls

The dominant categories of Victorian art were *genre*, historical painting, and illustration. But historical painting and *genre* were marginal interests for Cameron in a way they were not for the photographers Wynfield and Rejlander. She preferred the grand subjects of high character. Her stories were already known to everyone. So the idea of illustration in her work is not the usual one. Charles Dickens identified illustration with *genre*, and considered that the newest Sixties school of illustrators had given up presenting even the dramatic highlights of a story. He described the usual scenes depicted in book and magazine illustration: 'Two or three people seated round a table, partaking of a meal; a couple of young fellows chatting over their wine; a lady showing a picture-book to her little girl; lovers in pairs, without end; single figures, also without end; young ladies reading love-letters, or overwhelmed with some piece of ill news just received.'[26] He regarded these generalized scenes as 'well-executed nothings', which offered no more than an opportunity to the illustrator to show what he could do: 'Our modern men occupy themselves less with the thing to be done than with the manner of doing it. Their ambition seems to be confined to the desire of producing a beautiful work of art.' So they chose scenes in which the narrative fettered them least. Dickens was necessarily thinking of the illustration of the novel, which in the nineteenth century was a primarily realistic medium. The question of realism in art was fiercely debated in Cameron's period. Sir John Herschel was reading books of idealist philosophy, and so was Tennyson, but others, like George Eliot and Ruskin, who were determined students of nature, were supporting the realist cause. George Eliot, in *Adam Bede*, showed her own ultimate preference for Northern, realist art against Italian, idealist art. She came down specifically on the side of old women rather than Sibyls: 'All honour and reverence to the divine beauty of form! Let us cultivate it to the utmost in men, women and children – in our gardens and in our houses. But let us love that other beauty too, which lies in no secret of proportion, but in the secret of deep human sympathy.'[27]

In practice Cameron united her version of Northern art, the Rembrandtesque, with the Italian, the Raphaelesque. The photographic journals were preoccupied with dramatic lighting of the Rembrandt kind, and offered special folding screens to facilitate its use. The Madonnas and children of her Italian-influenced subjects undergo a Northern change. They are subjected to the climatic changes of mortal life and are weathered, darkened. Her 'light manner' gives way to a 'dark manner'. The series of pictures of Julia Jackson, who became Mrs Duckworth (nos. 1.37–1.41), offers the image of a Puritan Madonna from the North as an alternative to the Catholic Marys, Hillier and Ryan, of the South.

As an illustrator Cameron would have agreed with Dante Gabriel Rossetti that her duty was 'to embody and symbolise without interfering with the subject *as* a subject'.[28] Rossetti had Ophelia crush a rose in her hand as an emblem of the whole play, *Hamlet*, instead of offering a detailed, realist scene from the play. George Eliot agreed with this approach: 'I am quite convinced that illustrations can only form a sort of overture to the text.'[29] Emblem, overture, idealization – these are the words used to describe the illustration's relation to the text. In a letter to the Bristol Art Society at the time of the publication of her illustrations to Tennyson's *Idylls of the King*, Cameron wrote that the poet was pleased with 'this ideal representation of his Idylls'.[30] If she took tuition from Sir Henry Taylor in preparation for a play-reading of *St Clement's Eve* we can assume that she had discussed the problems of illustration with Tennyson. According to Tennyson's son, the father had said of the *Idylls*: 'My meaning was spiritual. I only took the legendary stories of the Round Table as illustrations. Arthur was allegorical to me. I intended him to represent the Ideal in the Soul of Man coming into contact with the warring elements of the flesh.'[31] From this it is clear that Tennyson's approach to the subject he had made

his own was also an idealization. As Arthur was illustrious, so the whole poem was an illustration. Cameron arrived at a conception of the art of illustration more elevated than that expected of the usual illustrator. Her illustrations were ideal representations of other works which were themselves ideal representations of legendary subjects. Her involvement with Tennyson's *Idylls of the King* is embodied in her gift to him, 16 August 1859, just when he was most creatively engaged on the subject, of the new three-volume *Morte d'Arthur*, edited by Thomas Wright the year before.

An idyll is a pictured moment. One poem by Tennyson, *The Gardener's Daughter*, which Cameron illustrated, is subtitled *or, The Pictures*. Such pictures are allusive rather than narrative. They develop their meaning by juxtaposition. They are both emblematic and serial. Cameron's work, which appears to fall into the conventional categories of subject-pictures (*genre*), illustration, and portraiture is cast in this idyllic mode. Her work is only illustrative in the sense that it consists of pictured moments of great emotional intensity relating to a spiritual world.

In 1857 Cameron went to the Oxford Union to see its Arthurian decorations by Rossetti, Morris, Burne-Jones, and her nephew Valentine Prinsep. As sons and daughters of Empire the Cameron family subscribed to the Ango-Saxonism which saw Arthur as a British Messiah. King-hero of a united people of Britons, Saxons, and Normans, he was used by successive English kings to authorize their divinity and counter the power of the Roman church. In Cameron's eyes Tennyson was King Alfred and King Arthur come again. Her friend, Sir Coutts Lindsay, to whom Lord Lindsay had dedicated his *Sketches of the History of Christian Art* (1847), wrote early British plays, *Alfred* (1845) and *Boadicea* (1857). She made at least one image of the British heroine herself (no. 3.52), in 'illustration' of a poem by Tennyson.

Others before her had tried to illustrate the *Idylls*, and other poems by Tennyson. Amy Butts made sixteen etchings in 1863, dedicated by per-

mission to the poet. Mrs S. C. Lees had made lithographs, and Daniel Maclise drawings for wood-engravings of *The Princess*. Eleanor Vere Boyle had illustrated a little edition of *The May Queen* with Tennyson's permission. The Art-Union of London announced in its Annual Report of 1862 that it had awarded one hundred guineas to Paolo Prioli for his line drawings from the *Idylls*. For his sixteen drawings he favoured Enid, Vivien and Merlin, and Guinevere as subjects. So did Cameron. The gift-book format, which works of illustration usually took, perhaps reassured Tennyson that they offered no real threat to the need to buy the text because they were so big that they had to be published separately. He appears to have been compliant to the wishes of others in this respect, whereas Rossetti was careful to publish his poems without illustrations, and only illustrated those of others, as if to preserve a purely literary approach for his own work. But Tennyson actually asked Cameron to provide illustrations for the Cabinet edition of his works published, 1874–77, by Henry S. King. Three – of Elaine, Arthur and Maud – appeared there as wood-cuts, after Cameron's photographs. The size of the wood-cuts may have had some effect on her later decision to issue miniature editions of the large-format gift-books of illustrations from the *Idylls*, and of her other works. The miniature images approximate to the size of the wood-cuts of the Moxon edition of Tennyson's *Poems*. She had originally conceived her works as framed pictures for a room rather than for a portfolio or as book illustration. They had magnitude – they were 'from life', and 'not enlarged'. This was what High Art required. But she was not unaware of the commercial possibilities of carte de visite and cabinet sizes.

Cameron's work coincided with the greatest period of Victorian book-illustration. Curmer's edition (1838) of *Paul et Virginie* by Bernardin de St Pierre had influenced the engravers Dalziel and Swain to develop the wood-cut in England in the early eighteen-forties. William Allingham's *The Music Masters* (1855) was published with

illustrations by Rossetti, Millais, and Arthur Hughes. Robert Aris Willmott's selection, *The Poets of the Nineteenth Century* (1857) was illustrated with wood-cuts. Sir John Gilbert's illustrations to Shakespeare appeared in 1858. In Tennyson's library there are copies of Christina Rossetti's *Goblin Market* (1862), and *Prince's Progress* (1866) with wood-cuts after drawings by her brother, and Cameron's name is upon the title-pages of both. Also in Tennyson's library is a collection of Millais' illustrations, published by Strahan in 1866. The sixties saw the rise of important magazines associated with wood-cut illustration, *The Cornhill, Once a Week,* and *Good Words,* in which Millais' *Parables of our Lord* (1864) first appeared.

The key volume of the period for Cameron was undoubtedly 'The Moxon Tennyson', the illustrated edition of his *Poems* first published by Edward Moxon in London in 1857. In a letter to William Allingham, 23 January 1855, Rossetti gave an account of the making of this book:[32]

The other day Moxon called on me, wanting me to do some of the blocks for the new Tennyson. The artists already engaged are Millais, Hunt, Landseer, Stanfield, Maclise, Creswick, Mulready, and Horsley. The right names would have been Millais, Hunt, Madox Brown, Hughes, a certain lady, and myself. NO OTHERS. What do you think? . . . Each artist, it seems, is to do about half-a-dozen, but I hardly expect to manage so many, as I find the work of drawing on wood particularly trying to the eyes. I have not begun even designing for them yet, but fancy I shall try the *Vision of Sin* and *Palace of Art*, etc., – those where one can allegorize on one's own hook on the subject of the poem, without killing for oneself and every one a distinct idea of the poet's. This, I fancy, is *always* the upshot of illustrated editions, – Tennyson, Allingham, or any one, – unless where the poetry is so absolutely narrative as in the old ballads, for instance.

The 'right' names may not have been as transparent to Cameron. After all, Maclise had illustrated her translation of Bürger's *Leonora*, and her own illustrations of *The Gardener's Daughter* and *The May Queen* owe something to J. C. Horsley's pic-

turesque drawings. She must have been especially proud to have been associated with Maclise who was favourably compared by Millais with Bronzino. But Rossetti was making precisely a point about ideal representation which she agreed with. To allegorize on one's own behalf was her aim, too. William Holman Hunt echoed this view with regard to *The Lady of Shalott*, 'she being the evident impersonator of a Soul entrusted with an artistic gift destined to bring about a great end, who failing in constancy, is overwhelmed by the ruin of her life's ideal'. He illustrated this idea rather than the poem, introducing an image of the Saviour as well as of the Knight. And Tennyson was not pleased. Why was the Lady's hair streaming in all directions? 'Rather perplexed, I replied that I had wished to convey the idea of the threatened fatality by reversing the ordinary peace of the room and of the lady herself . . .' But Tennyson still disapproved.[33]

Cameron's approach was to reduce detail wherever possible. Consider her subject known as 'A Pre-Raphaelite Study' (no. 1.43). If we compare this figure leaning on a cushion with similar images by Hunt and Frederic Leighton we notice striking differences. Hunt's is an illustration (1867) from Keats' poem, *Isabella, or the Pot of Basil*, but there is no pot containing Lorenzo's head, the focus of this morbid narrative, in Cameron's picture. In Leighton's *An Odalisque* (1862), we find the figure with bosom half-exposed, and attributes of swan, peacock feathers, and a butterfly – an image, as William Michael Rossetti called it quoting Blake, 'of soft deceit and idleness'.[34] In transposing the subject to the sorrowful, Cameron has avoided both the passionate and the languorous, yet retained the feeling of both. She has moved the subject from the narrative to the pictorial.

George du Maurier, whose family Cameron photographed, and who mocked the vogue for Camelot (fig. v), pointed out that there were two methods for drawing for wood-engraving. One was to make a finished wash drawing, detailed and fully shaded, to be interpreted by the engraver.

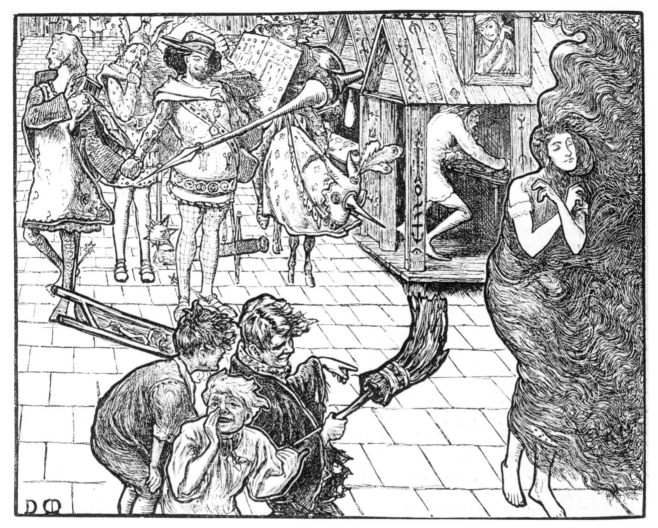

v. George du Maurier, 'A Legend of Camelot, Part I',
Punch L (3 March 1866), 94

> *Then quoth the pure Sir Galahad,*
> *'She seems, methinks, but lightly clad!*
> *O miserie!*
> *The winds blow somewhat chill today;*
> *Moreover, what would Arthur say!'*

The other, which du Maurier preferred, was the method of Millais and Gilbert: to draw a black contour line to enclose figure and face, add some simple cross-hatching to suggest tone, and so confine the engravers to a facsimile: 'I infinitely prefer the scratchy pen-and-ink designs, which give just the essence of what one most wishes to see, and leave out everything else.'[35] Once again, two tendencies manifest themselves, one artist believing in leaving something to the imagination, the other in leaving nothing out. Rossetti once boasted of being able to include a whole town in the smallest portion of a drawing.

In her poem, 'On a Portrait' (*Writings*, p. 158), Cameron wrote that it was the task of the artist to 'search the key-note'. But such a key-note was intended to be dynamic, not static. She assumed that it would mark a parabola in which moments

can be predicted before and after the one chosen. Tennyson called his idylls parabolic in the sense that they not only typified spiritual and moral relationships but did so serially, by means of juxtaposed episodes. The parabola is related also, perhaps, to the parable. The Protestant interest in parables as moral stories drew Millais to *The Wise and Foolish Virgins,* five with lamps in one image, five without in the other. The images have, essentially, the same parabola but then diverge to make the moral difference, and indicate a type of the Last Judgement.

In single figures like Millais' *Mariana* (no. 2.10), the curve of back and neck, present in Hunt's *Isabella* and Cameron's 'Pre-Raphaelite Study' (no. 1.43), to which it might be compared, becomes an ideogram of despair as well as the key-note. Millais used this curve in his illustrations for *The Miller's Daughter, A Dream of Fair Women,* and *Dora* (no. 2.10) (all in the Moxon Tennyson). The curve is very much a Pre-Raphaelite shape, but Charles Cameron had also written about it in his *Essay on the Sublime and Beautiful*:

A weeping willow, as the very name of the species indicates, represents the attitude, and therefore partakes of the beauty of sorrow. The effect of sorrow on the human frame is to prevent all muscular exertion, consequently every part which in ordinary circumstances is sustained by such exertion alone, droops and collapses under the influence of that depressing passion. Every thing, therefore, which droops (for that word seems to express the whole idea of bending downwards, without any pressure, from the mere effect of gravitation and the want of support) has a sorrowful and beautiful expression. Hence it is, that the painters when they would fill the mind with images of grief, not only dispose the heads and limbs of their figures as grief would dispose them, but take care that the hair and the drapery shall also droop, though it is just as consistent with probability that they should be fluttering in the wind.[36]

The inclination of body towards body, head to head, cheek to cheek, lips, and brow is a motif as strong in the Moxon Tennyson as it is in Cameron. See, in the Moxon Tennyson, Hunt's *Oriana* and *The Beggar Maid*, and Millais' *The Talking Oak, Locksley Hall* (no. 2.10), and *Edward Gray*. In Rossetti's *The Palace of Art* (no. 2.12) the mouth comes into contact as if to devour – in Rossetti's kisses there is always the perverse suggestion of merging, defining a sensibility of menace as well as consuming passion. But this is something Cameron does not suggest. *The Kiss of Peace* (no. 1.53), is not that kind of Pre-Raphaelitism at all. In this photograph she joins the profiles in a distinct clear line which remains soft and tender.

Cameron's best illustrations – her best photographs – are pretexts because they relate as much to her own *oeuvre* as to the text which they purport to illustrate. Consider the figure of *The Young Endymion* (no. 1.27): does it not also have something of the traditional body alignment of a Deposition of Christ, such as the one found in Julia's sister Mia's album,[37] which is illustrated and identified in Jameson's *History of Our Lord* as a *pietà* by Fra Bartolommeo?[38] By harmonizing the Classical subject with the Christian story, it makes the curve the keynote of the most sorrowful and the most beautiful image in the history of Christendom.

2.1

*The Minstrel Group/We sing
a slow contented song and
knock at Paradise*, registered
1867

Colnaghi blind stamp
35 × 28
The Royal Photographic
Society (C9: 2135/2)
Presented by Col. Cameron,
1929

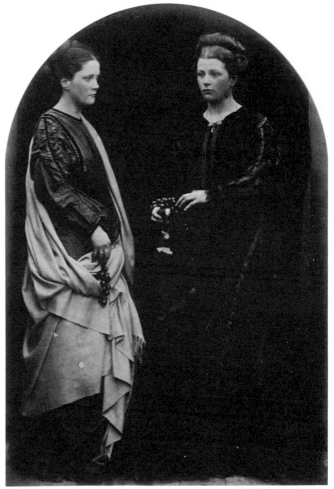

2.2

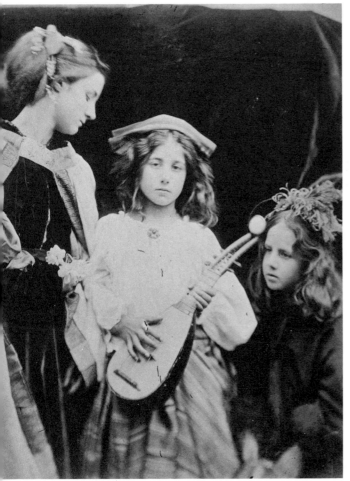

2.1

2.2

SISTERS

Colnaghi blind stamp
Arched top, 34.4 × 23.9
The Royal Photographic
Society (C12: 2197)

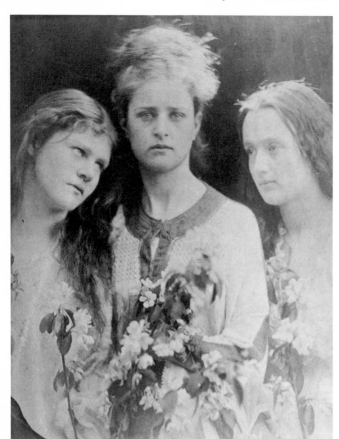

2.3

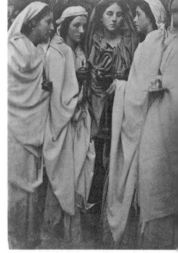

2.4

2.4
The Five Wise Virgins, registered 1864

25.9 × 21.2
Victoria & Albert Museum, London (44759)

Jameson suggests that the parable of the wise and foolish virgins 'in its mystical signification' symbolizes the Last Judgement: 'The righteous, who watched and prayed, and entered not into temptation, are accepted and enter into Paradise.'

Jameson (and Eastlake) *History of Our Lord*, I: 390

2.3
Three King's Daughters Fair/ FreshWater May 1873

'*Ah! says the second one
Fly away O my heart away
I think the day's begun
So sweet*'

'*Ah! says the eldest one
Fly away O my heart away
Far off I hear the drums
So sweet*'

'*Ah! says the youngest one
Fly away O my heart away
It's my true love my own
So [sweet]*'

34.9 × 26.4
The Royal Photographic Society (C12: 2187/3)

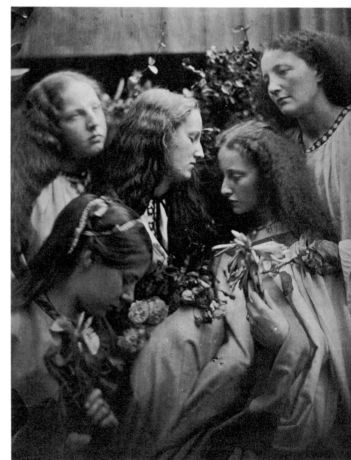

2.5

2.5
The Rose bud garden of girls/FreshWater June 1868

35 × 29.2
The Royal Photographic Society (C12: 2191)
Presented by Col. Cameron, 1929

'An ambitious work, full of the naïve sentiment of the early Italian masters coupled with the delicate observation and masterly drawing of modern work. It is a picture that does not give me so much pleasure as others I have noted.'

P. H. Emerson, *Sun Artists*, 42

2.7
La Contadina/June 1866

35 × 27.5
Science Museum, London (1955/71)

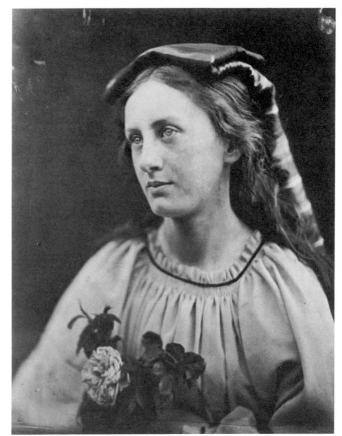

2.7

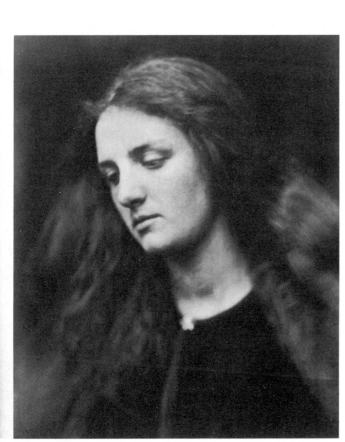

2.6

2.6
The Wild Flower 1867 (Ford 136)

Colnaghi blind stamp
29.2 × 25.1
The Royal Photographic Society (C16: 2271)
Alvin Langdon Coburn gift, 1930

'To see a World in a Grain of Sand
And a Heaven in a Wild flower,
Hold Infinity in the palm of your hand,
And Eternity in an hour.'

William Blake, 'Auguries of Innocence', *The Ballads*, written after 1807.

THE MOXON TENNYSON

Edward Moxon first published Tennyson's *Poems* with illustrations in 1857. There were many editions including one of 1866, from which page references are given below to illustrations in the exhibition and in the catalogue.

Edward Moxon (1801–58) was the principal publisher of Charles Lamb, Wordsworth, and Tennyson. He also published Coleridge, Keats, and Sir Henry Taylor. His most famous productions before the Moxon Tennyson were the edition with Cadell of Samuel Rogers' *Italy* and its companion volume of *Poems* of the early thirties. They were illustrated by J. M. W. Turner, and others. The illustrated Tennyson is a reprinting of the *Poems* (1842), though some of the poems are rearranged in order. It cost Moxon £2,000 to produce. The price for each drawing was £25 to the artist and at least £5 to the engraver. The project began in 1854 and took three years to accomplish.

2.8a

2.8

JOHN CALCOTT HORSLEY (1817–1903)

a) 'The Gardener's Daughter; or The Pictures' (p. 203)
Wood engraving by J. Thompson
9.8 × 6.9

b) 'Circumstance' (p. 62)
Wood engraving by J. Thompson*
9.2 × 8.2

c) 'The May Queen' (p. 131)
Wood engraving by W. J. Linton*
9.5 × 8.2

d) 'New Year's Eve' from 'The May Queen' (p. 134)
Wood engraving by W. J. Linton*
9.4 × 8

By permission of the Curators of the Bodleian Library, Oxford

'*May 18th 1854*. I called on Moxon to arrange the "Illustrated Edition of Poems", and we went round to the artist Creswick, a capital broad genial fellow; Mulready, an old man, was full of vivacity and showed me lots of his drawings and one or two of his pictures. Then on to Horsley who was likewise very amiable and said that I was the painter's poet, etc., then on to Millais, who has agreed to come down in a month's time and take little Hallam as an illustration of "Dora". Sir E. Landseer I did not call upon and Holman Hunt was out of town.'
Tennyson's letter-diary cited in Hallam Tennyson, *Alfred Lord Tennyson*, London 1897, 375–6.

2.9b

2.9

DANIEL MACLISE
(1806–70)

a) 'Morte d'Arthur' (p. 191)
Wood engraving by
J. Thompson*
11.9 × 9.1

b) 'Morte d'Arthur' (p. 199)
Wood engraving by
Dalziel, Brothers
11.9 × 9.2

WILLIAM MULREADY
(1786–1863)

c) 'The Deserted House'
(p. 43) Wood engraving
by J. Thompson*
8 × 9.6

d) 'The Sea-Fairies' (p. 31)
Wood engraving by
J. Thompson*
8 × 9.3

By permission of the
Curators of the Bodleian
Library, Oxford

'The book itself was an
apple of discord with the
public. In trying to please
all, the publisher satisfied
neither section of book
buyers. The greater propor-
tion were in favour of the
work done by prominent
artists of the old school, and
their admirers were scandal-
ised by the incorporation of
designs by members of the
Pre-Raphaelite Brother-
hood; while our fewer
appreciators would not buy
the book in which the pre-
ponderance of work was by
artists they did not approve.
Thus the unfortunate book
never found favour until
after Moxon's ruin and

death, when it passed into
other hands and was sold at
a reduced price.'
W. H. Hunt, *Some Poems of
Alfred Lord Tennyson*,
London 1901, xxiii–xxiv.

2.10

JOHN EVERETT MILLAIS
(1829–96)

a) 'Mariana' (p. 7) Wood
engraving by Dalziel,
Brothers
9.3 × 7.8

b) 'Dora' (p. 219) Wood
engraving by J. Thompson*
8.9 × 8.1

c) 'Locksley Hall' (p. 267)
Wood engraving by
J. Thompson*
9.3 × 8

d) 'St Agnes' Eve' (p. 267)
Wood engraving by

Dalziel, Brothers*
9.6 × 7.1

By permission of the
Curators of the Bodleian
Library, Oxford

Tennyson to Millais, on a
visit of 22 November 1854:
'If you have human beings
before a wall, the wall
ought to be picturesquely
painted, and in harmony
with the idea pervading the
picture, but must not be
made intrusive by the
bricks being *too* minutely
drawn, since it is the human
beings that ought to have
the real interest for us in a
dramatic subject picture.'

Hallam Tennyson, *Alfred
Lord Tennyson*, London
1897, 380–381.

2.10a

2.11

WILLIAM HOLMAN HUNT
(1827–1910)

a) 'Ballad of Oriana' (p. 51)
Wood engraving by
Dalziel, Brothers*
9.2 × 7.9

b) 'Ballad of Oriana' (p. 55)
Wood engraving by
Dalziel, Brothers*
8 × 9.4

c) 'The Lady of Shalott'
(p. 67) Wood engraving by
J. Thompson
9.2 × 7.9

d) 'The Beggar Maid'
(p. 359) Wood engraving
by T. Williams*
9.2 × 8

By permission of the
Curators of the Bodleian
Library, Oxford

'I did not have photographs
taken of all my completed
drawings before they were
cut. Those from the "Lady
of Shalott," "Lady
Godiva," and "Oriana" I
still possess; comparison of
these with the impressions
in the book more than
accounts for the disap-
pointment I felt when at
first I saw my designs in
Moxon's volume. A certain
wirelike character in all the
lines was to me, as to all
artists with like experience,
eminently disenchanting.
Undoubtedly each block
had been cut with care and
skill, but in a few cases I had
to have parts removed, and
drew details over again on
the newly inserted wood.

Over those drawings of which no photographs were made, I had less power of correction.'

W. H. Hunt in *Some Poems of Alfred Lord Tennyson* London 1901, xxiii – xxiv.

2.12

DANTE GABRIEL ROSSETTI (1828–82)

a) 'The Lady of Shalott' (p. 75) Wood engraving by Dalziel, Brothers*
9.4 × 8

b) 'Sir Galahad' (p. 305) Wood engraving by W. J. Linton*
9.3 × 7.9

c) 'The Palace of Art' (p. 113) Wood engraving by Dalziel, Brothers
9.2 × 7.8

d) 'The Palace of Art' (p. 119) Wood engraving by Dalziel, Brothers*
7.9 × 9.3

By permission of the Curators of the Bodleian Library, Oxford

'Five subjects are from the pencil of Rossetti; with the exception of "Sir Galahad," a vigorous and effective study, but, so far as we can make it out, without the slightest reference to any descriptive line in the poem it professes to illustrate, these designs are beyond the pale of criticism; if Millais and Hunt have shown something like an inclination to abjure

2.11C

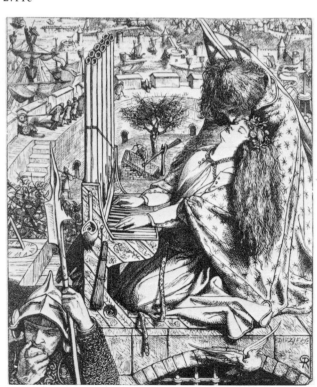

2.12C

their artistic creed, Rossetti seems to revel in its wildest extravagances: can he suppose that such art as he here exhibits can be admired? Is it not more calculated to provoke ridicule, or, if not ridicule, pity for one who can so misapply his talents?'

Anonymous review, *The Art-Journal* III (July 1857), 231.

2.13

Dora as the Bride/Mrs Ewen Hay Cameron/Nov 18th 1870

Colnaghi blind stamp Arched top, 33 × 25.1
The Royal Photographic Society (C13: 2219/2)
Presented by Mrs Trench, 1929

2.14

Elaine the Lily-maid of Astolat/FreshWater Isle of Wight 1874

34.6 × 28.6
The Royal Photographic Society (C8: 2099/1)
Alvin Langdon Coburn Gift, 1930

'Elaine the fair, Elaine the
loveable,
Elaine, the lily maid of
Astolat,
High in her chamber up a
tower to the east
Guarded the sacred shield of
Lancelot.'

Tennyson, 'Lancelot and Elaine' from Cameron, *Idylls of the King*, Part One.

2.13

2.15

2.14

2.15

*The Twilight Hour /
FreshWater 74*

*'And always when Adam had
stayed away for several weeks
from the Hall-Farm /and
otherwise made some show of
resistance to his passion as a
foolish one/Hetty took care to
entice him back into the net, by
little airs of meekness /and*

*timidity as if she were in trou-
ble at his neglect. /But as to
marrying Adam that was a dif-
ferent affair. /see Adam Bede'*

Colnaghi blind stamp
34.4 × 28
The Royal Photographic
Society (C8: 2555/2)
Presented by Col. Cameron,
1929

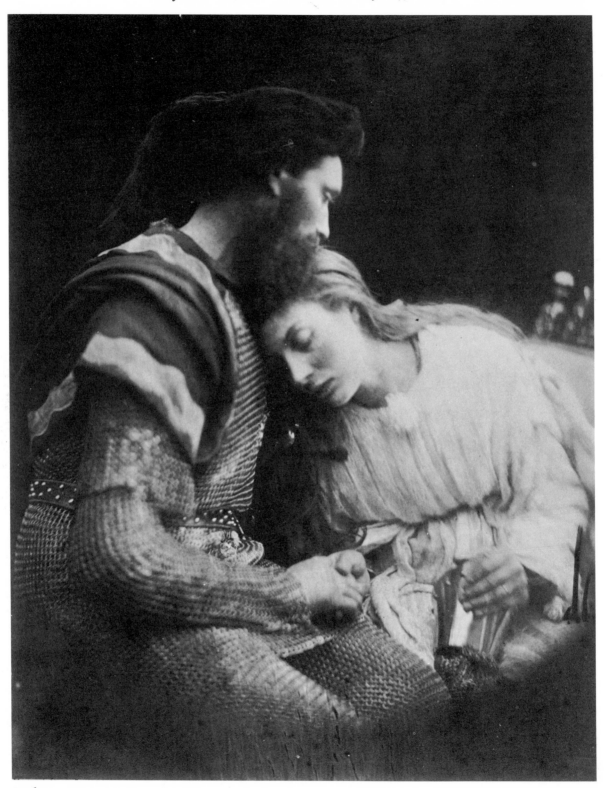

2.16

2.16

The Parting of Sir Lancelot and Queen Guinevere/FreshWater Isle of W. Sep 1874

34.9 × 26.7
The Royal Photographic Society (C8: 2106/1)
Alvin Langdon Coburn Gift, 1930.

'And Lancelot ever promised, but remain'd,
And still they met and met. Again she said,
"O Lancelot, if thou love me get thee hence."
And then they were agreed upon a night
(When the good King should not be there) to meet
And part forever. Passion-pale they met
And greeted . . .'

Tennyson, 'Guinevere', from Cameron, *Idylls of the King,*
Part One.

2.17

Sir Galahad and 'The Pale Nun'/FreshWater Isle of Wight 1874

34.6 × 27
The Royal Photographic Society (C8: 2103)
Alvin Langdon Coburn Gift, 1930

'. . . *My knight, my love, my knight of heaven,*
O thou, my love, whose love is one with mine.
I, maiden, round thee, maiden, bind my belt.'

Tennyson, 'The Holy Grail' from Cameron,
Idylls of the King, Part One.
(Cameron's own underlining)

2.18

Come Pensive Nun devout and pure/Sober stedfast &
demure, 1865

Colnaghi blind stamp
25.3 × 20.2
Victoria & Albert Museum, London (45146)

'Come pensive Nun, devout and pure,
Sober, stedfast, and demure . . .
There, held in holy passion still,
Forget thyself to marble, till,
With a sad leaden downward cast,
Thou fix them on the earth as fast.'

John Milton, 'Il Penseroso' 1632

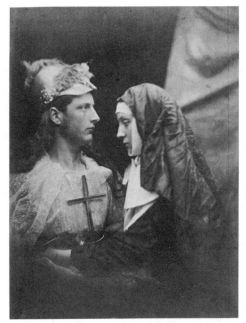

2.17

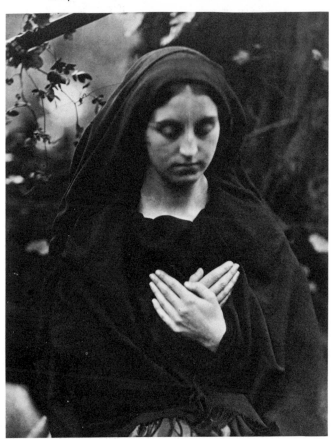

2.18

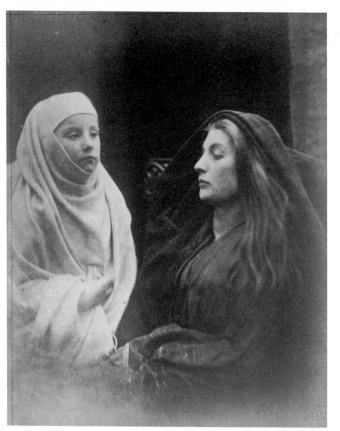

2.19

2.20
*A group of Kalutara Peasants
the girl being 12 years of age &
the old Man/saying he is her
Father & stating himself to be
one Hundred years/of age/
Ceylon 1878*

34.25 × 27.3
The Royal Photographic
Society (C1: 2076)

2.19
*The Little Novice and the Queen in 'the Holy House at
Almesbury'/FreshWater Isle of W, 1874*

35.3 × 28
The Royal Photographic Society (C7: 2102)
Alvin Langdon Coburn Gift, 1930.

> 'So the stately Queen abode
> *For many a week, unknown, among the nuns;*
> *Nor with them mix'd, nor told her name, nor sought,*
> *Wrapt in her grief, for housel or for shrift,*
> *But communed only with the little maid,*
> *Who pleased her with a babbling heedlessness*
> *Which often lured her from herself.'*

Tennyson, 'Guinevere' from Cameron, *Idylls of the King*,
Part One.
(Cameron's own underlining)

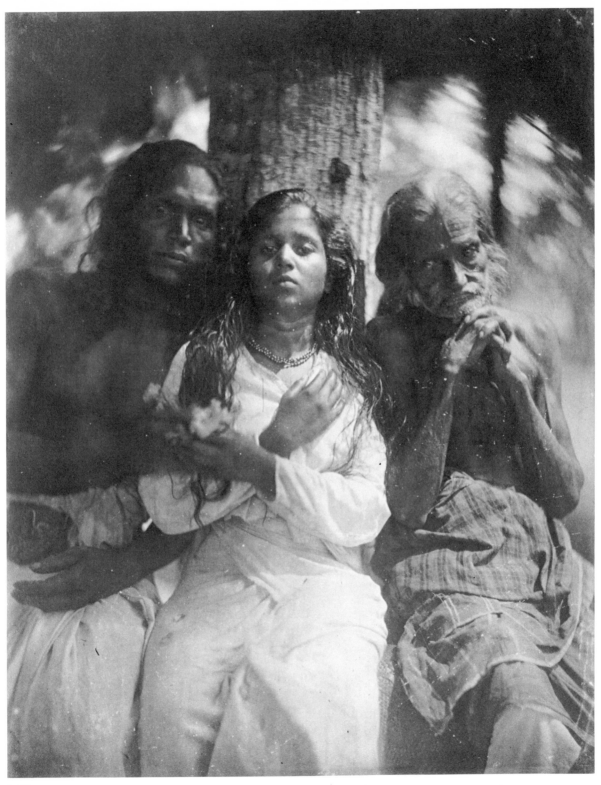

2.21

*Jephthah and his Daughter/
FreshWater, c.* 1865

Colnaghi blind stamp
36.2 × 28
The Royal Photographic
Society (C7: 2088)
Acquired 1930

'Later theologians con-
sidered Jephthah's daughter
as a type of the Virgin –
making a somewhat forced
analogy between the
sacrifice of the maiden to
God and the Virgin's dedi-
cation in the Temple.'

Jameson and Eastlake,
History of our Lord, I: 194.

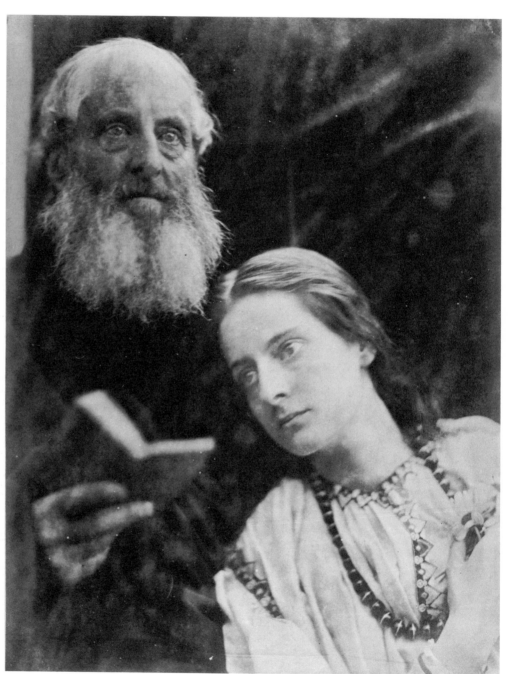

2.21

2.22

King Lear allotting his King-dom/to his three daughters/ "What shall Cordelia do/ Love and be silent"/ FreshWater/1872 (Mozley 47)

Brown carbon, Autotype blind stamp
35.2 × 28.6
The Royal Photographic Society (C7: 2096/5)

'Every thing in her seems to lie beyond our view, and affects us in a manner which we feel rather than perceive. The character appears to have no surface, no salient points upon which the fancy can readily seize: there is little external development of intellect, less of passion, and still less of imagination.'

Jameson, 'Cordelia', *Characteristics of Women*, II: 89.

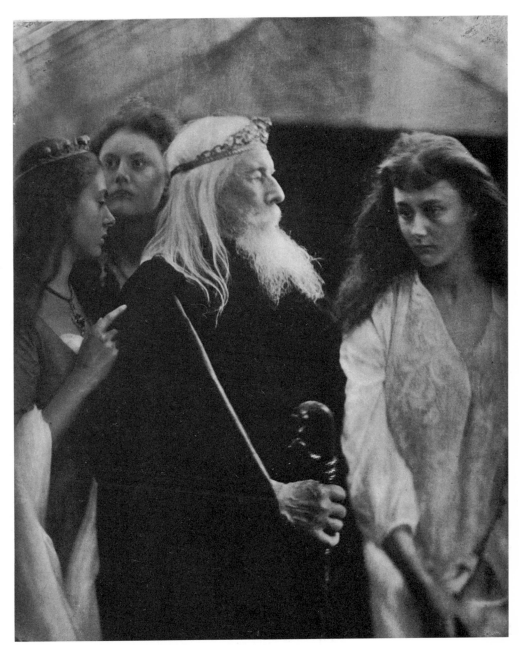

2.22

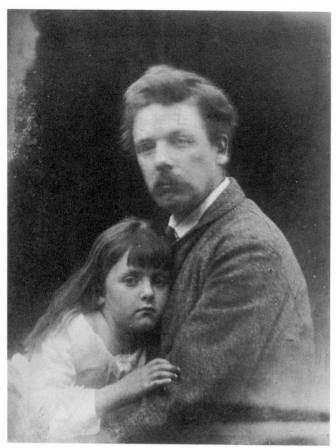

2.23

2.23

GEORGE DU MAURIER AND
CHILD, *c.* 1870

34.6 × 27
The Royal Photographic
Society (C11: 2001)
Alvin Langdon Coburn
Gift, 1930

Cameron did not take her-
self – or the Pre-Raphaelites
– so seriously as not to
photograph the illustrator
who, in several issues of
Punch (March 1866),
mocked the Arthurian
legend in 'A Legend of
Camelot'.

2.24
*Queen Esther before King
Ahasuerus,* registered 1865

32.4 × 29.5
The Royal Photographic
Society (C8: 2112/1)
Presented by H. S. Marfleet,
1931

'Help me that I am desolate
and have no other *helper* but
thee, O Lord. Thou hast
knowledge of all things;
and thou knowest that I
hate the glory of the
wicked, and abhor the bed
of the uncircumcised, and
of every alien.'

'The Rest of Esther,' *The
Apocrypha,* Cambridge
1896, 176.

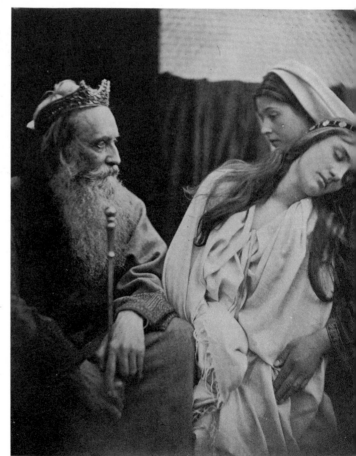

2.24

2.25
Prospero and Miranda, registered 1865

Colnaghi blind stamp
35.3 × 28.6
The Royal Photographic
Society (C7: 2114/1)

'The character of Miranda
resolves itself into the very
elements of womanhood.
She is beautiful, modest and
tender, and she is these
only; they comprise her
whole being, external and
internal. She is so perfectly
unsophisticated, so deli-
cately refined, that she is all
but ethereal ... this pure
child of nature, this "Eve of
an enchanted Paradise".'

Jameson, 'Miranda',
Characteristics of Women,
I: 281

(*see* p. 64)

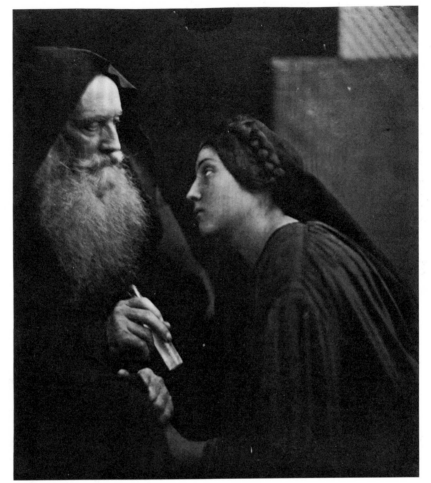

2.26

2.26
Friar Laurence and Juliet, registered 1865

31.8 × 28.5
Victoria & Albert Museum, London (941–1913)

'And I will do it without fear or doubt,
To live an unstained wife to my sweet love!'

Shakespeare, *Romeo and Juliet*. Cited by Jameson,
'Juliet', *Characteristics of Women*, I: 194.

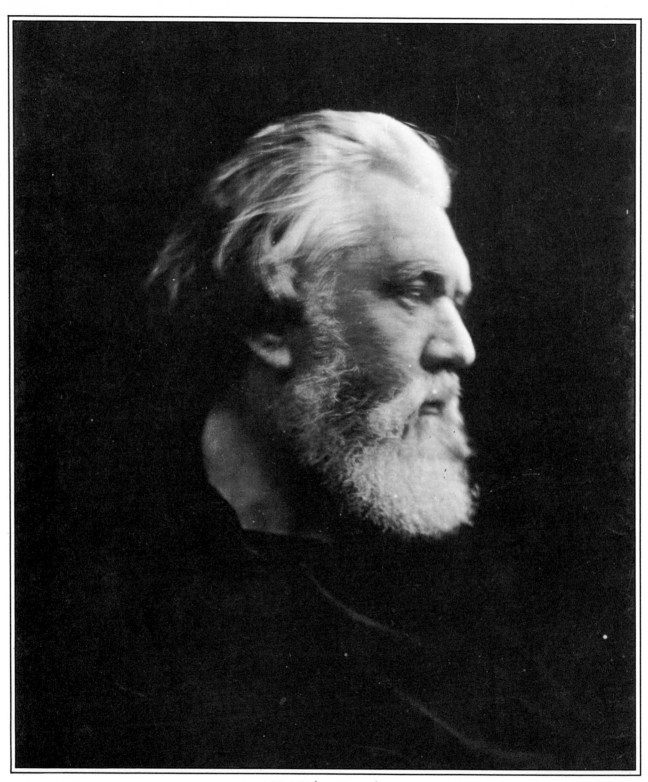

no. 3.30 (*see* page 112)

3·Prophets and sibyls

In his famous set of lectures published as *Heroes and Hero-Worship and the Heroic in History* (1840) Carlyle wrote that the poet as hero had to be many things. 'I fancy there is in him the Politician, the Thinker, the Legislator, Philosopher – in one or the other degree he could have been, he is all these.' King Arthur is the type, perhaps, that Carlyle had in mind when he wrote that the poet 'could not sing the Heroic warrior, unless he himself were at least the heroic warrior too'. But poets were also prophets: 'In some languages, again, the titles are synonymous; *Vates* means both Prophet and Poet: and indeed at all times, Prophet and Poet, well understood, have much kindred of meaning.'[39] They penetrate the divine mystery both as moralists and artists.

Tennyson, the contemplative poet, was balanced by Sir Henry Taylor, the practical poet, but both remained prophets as well. Taylor's preface to his play *Philip van Artevelde* (1834) showed his preference for the moral against the aesthetic (or 'Phantastical') approach to poetry. In devoting herself to the promotion of Taylor's work over a long period Cameron obviously approved of the moral standpoint. In 1862 she organized her own reading of his latest play *St Clement's Eve*. 'I would wish you to hear it so as to have the Author's own conception of it as taught to me', she wrote to the select few Pre-Raphaelites she invited to the four or five hour reading.[40]

Cameron also admired Taylor as the author of *The Statesman* (1836), the classic account of the path to preferment in the civil service. Taylor himself was not ambitious. He turned down the offer of the Governorship of Upper Canada in 1835, and the Under-Secretaryship of the Colonies in 1847. He had a good mind but was quite without the will to power which Carlyle expected of the poet-hero. His *Notes from Life* (1847) is a book of precepts for private life as practical as those in *The Statesman* were for public life. Cameron came home from India to this compendium for the age on Money, Independence, Marriage, Wisdom, Children, and the Life Poetic. A poet was someone to turn to in

difficulty: 'The poet, being himself frank and unreserved (as I think poets for the most part will be found to be), should beget frankness and unreserve on the part of his companions, who should come to him for advice and sympathy in all the emergencies of life.'[41] The poet offered 'living knowledge' gained in just this way. That Cameron offered him such special companionship is evident from his letter-books in the Bodleian Library, Oxford. She acted as his copyist for many of his letters.

Her admiration for Taylor was based on his historical romance in the form of a play, *Philip van Artevelde*, which is about political life and the conflict between an active and a contemplative life. The closeness of his relationship with Cameron is evident in one of the surviving letters she wrote to him, a letter of 8 March 1875. He had asked her to return a lifetime of his letters to her, suggesting that it would be better if they did not end up 'swelling her autobiography'. Cameron was hotly indignant at such an ignoble thought – as if she would break the sacred seal of friendship: 'I hold your letters to be pearls of great price to me, as records of every event of pain or joy, of every nursing trouble and more mature anxiety that has overtaken me all these past 26 years throughout which tract of time it has been my habit to seek your sympathy and counsel, and my reward to find it ever answer to my need.'[42] Taylor's attitude towards women is to be found in his long review article of John Stuart Mill's *The Subjection of Women* (1869).[43] He was a conservative beside Mill. He was in favour of votes for women and of the Married Women's Property Bill but on grounds of expediency rather than justice. He considered women too incompetent to vote without the guidance of men. At the same time he maintained that women ruled the household. It was the liberal viewpoint.

If Cameron never stood any nonsense from her heroes, she saw past their human foibles to what she could absorb from them. She wrote to Taylor, who was critical of Tennyson's selfishness and sulkiness: 'In talking of all great men truth may assert

itself but in writing I think the mention of personal peculiarities is greatly to be avoided.'[44] Too much attention has been given to the personal characteristics of this remarkable woman and her family, and too little to their intellectual background. Charles Cameron's relationship with her has been almost completely overlooked. Taylor wrote that sometimes a young woman will be dazzled by an older man's achievements, 'and what is heroical or illustrious may inspire a feeling which, distinct though it be from that which youth inspires in youth, is yet not unimaginative, and may suffice to sanctify the marriage vow'.[45] Charles offered Julia a richly rewarding, imaginative companionship.

Mr Cameron had helped Macaulay with the writing of the Indian Penal Code, and before that had made an important contribution to the reform of government in Ceylon, where he had joined a fellow Commissioner of inquiry, W. M. G. Colebrooke, to consider the state of administration and justice in Mauritius, the Cape of Good Hope and Ceylon. The Commissioners were deeply resented by the Governor of Ceylon, Sir Edward Barnes, who immediately scented the reforming spirit of Utilitarianism, and also disapproved of the Commissioners' proposal for a college in Ceylon. But Mr Cameron believed in the law and education as the means of obtaining personal liberty for the native population. In this he was in the tradition of Jeremy Bentham and John Stuart Mill who believed in civil equality and respect for the individual based on Christian principles. The Secretary of State for the Colonies received the reports from Colebrooke and Cameron favourably. The Ceylon Charter of Justice (1833) was Mr Cameron's work.[46]

In 1833 and 1834 Charles Cameron was on the Committee of the Society for the Diffusion of Useful Knowledge which published *The Penny Magazine*. Lady Eastlake's husband, Charles, was also on the Committee,[47] and in India Cameron took up the cause of education alongside his other duties. He became President of the Council of Education for Bengal. The fourth member of the Supreme Council of India was not allowed to be an East India Company man, and Mr Cameron wrote that he thought this meant the need was recognized for 'a man who might bring in the Council of India a knowledge of those general principles of jurisprudence, political economy, and government, which are generally supposed to be acquired only by much reading and reflection'.[48] He devoted much of his time to thinking about what policy with regard to education the colonial powers ought to have, but in the House of Commons there was much opposition to his ideas of educational opportunity before the law: educated natives would throw the British out in three weeks, they said. But Mr Cameron denounced this attitude: 'the deliberate intention of keeping them down . . . is a most unworthy object of ambition for a great man – or for a great nation. It is at any rate a scheme to which I never would have been a party.' That his liberalism was imperialistic and his radicalism was Christian goes without saying. He was a Whig Reformer with the Whigs out of power, who prescribed for India a despotic government rather than a parliamentary one, staffed by civil servants, British and Indian, educated according to British standards and Christian principles of 'gentleness, purity and self-denial'. Quoting a masterly report by Macaulay on the use of English in the Empire, Cameron considered that English would not only bind the Indians to each other but also to Britain. He therefore proposed English as the language of instruction for higher education. Sir Edward Ryan, another of the trustees of his marriage settlement, introduced a scholarship system, and Cameron drew up the curriculum and set and marked the examination papers. Somewhat earlier Sir John Herschel, a great friend of the Camerons, had proposed the curriculum for what would become eventually the University of Cape Town. The outcome of Mr Cameron's efforts was the University of Calcutta.

Sir John Herschel's work at the Cape as an astronomer left him time for botanical studies and for the use of a *camera lucida* to draw the landscape,

and the curriculum for his new college stressed the importance of the experimental method. It was he, perhaps, who gave Charles Cameron his conviction that Bacon's *Novum Organum*, then being translated into English, was a basic model for education: 'It will be recollected that there are minds while not devoid of reasoning powers, yet manifest a decided inaptitude for mathematical studies – which are *estimative*, not *calculating*, and which are more impressed by analogies and by an apparent preponderance of general evidence in argument than by mathematical demonstration.'[49] He emphasized inductive philosophy but in a context which recognized that there was a conflict in empirical and idealistic approaches to nature. He reconciled the problem in Christian terms: whatever man perceives and whatever he conceives is due to the Creator in any case. But he was concerned to have both the contemplative and practical faculties developed by a liberal education. His great contemporary, the mathematician William Whewell, only coined the word 'scientist' in the forties, and these natural philosophers still believed in a Classical education. When Julia Margaret translated Bürger's *Leonora* (1847), she was not only emulating Sir Walter Scott but also Herschel and Whewell who had both done versions. She could not have known that D. G. Rossetti had made one in 1844 at the age of sixteen, because it was not published until 1900. She took her lead from the great scientists, and Scott.

On 11 March 1838, Sir John left the Cape to return to England. Julia and Charles were married on 1 February in Calcutta. It is possible that they spent their honeymoon at the Cape with the man she called her beloved friend. If she gave Tennyson, on 12 May 1875, Richard Anthony Proctor's *Half-Hours with the Telescope* (1868), it was because Herschel was as much her hero as Tennyson himself. The Philosopher and Thinker was a prophet too.

Julia Margaret Cameron regarded her heroes, Tennyson, Taylor, Herschel and Mr Cameron as Representative Men, in Ralph Waldo Emerson's sense, but she also saw them as Old Testament prophets like Isaiah and Jeremiah. Longfellow was another prophet-poet, and Henry Thoby Prinsep another prophet-legislator. But *H. T. Prinsep* (no. 3.29), as well as being himself, could also impersonate the Joseph in Francia's *Adoration of the Magi*. The photograph has a circular streak drawn in the collodion as if to imitate the halo. But Cameron no more chose to title this picture 'Joseph', than she chose to call the portrait of Henry Taylor 'Jeremiah'. She wanted, perhaps, to embody the types in her sitters, rather than abstract the identities of her sitters. In seeking the incarnation of the type in living subjects she reconciled her impulse towards portraiture, the study of the Individual Man, with her desire to make High Art of universal application.

The basic type for Sir Henry Taylor is King David. Lady Eastlake wrote: 'David is in a closer sense the type of Christ than any other that the Scriptures afford. His name and the Idea of Christ have a mysterious and actual identity throughout the sacred text.'[50] But with his crown, downcast look and folded hands he appears to us as if before Nathan who has charged him to repent (no. 3.25). Here is a type of Repentance like the Prodigal Son. The image which immediately follows Taylor as David in the Sir John Herschel album is of *Henry Taylor: a Portrait* (no. 3.5). But if we know the picture of Jeremiah on the Sistine ceiling (no. 3.2), illustrated by a wood-cut in Jameson's *History of Our Lord*, we recognize him immediately: 'head on hand, wrapt in the meditation appropriate to one called upon to utter lamentations and woe. He has neither book nor scroll.'[51] The absence of such attributes suggests how recognizable he was to Cameron's audience without them. Jameson quoting Sir Henry Taylor who was, himself, quoting an eighteenth century theologian on the child's image of God as 'of a composed, benign, countenance, with his own hair, clad in a morning gown of a grave-coloured flowed damask, sitting in an elbow chair' puts us in mind of Taylor in his embroidered robe. [52]

On Christmas Day 1873, Cameron gave Tennyson the works of Apollonius of Rhodes – in Greek, with Latin notes. Anna Jameson believed that Classical subjects were suitable for contemporary art, and Ruskin, Arnold and Pater stressed the need for reconciliation between Christian and Hellenist values. Jameson wrote, 'in the mythology of the Pagans the worship was to *beauty*, *immortality* and *power*, and in the Christian mythology – if I may call it so – of the Middle Ages, the worship was to *purity*, *self-denial* and *charity*.'[53] In her 'Notes on Art' she asked herself how Greek legend could be used by contemporary artists in the way poets like Goethe and Keats had used the Classical tradition in *Iphigenia* and *Hyperion*. She thought there could be occasions when 'an abstract quality or thought is far more impressively and intelligently conveyed by an *impersonation* than by a *personification*'. She meant that Jonathan and David (or Pylades and Orestes) might impersonate friendship, for instance. Contrasting phases of the destiny of woman could be represented by Rebecca and Rachel, and characters from Shakespeare and Spenser could be used, too. She especially recommended Miranda and Cordelia. In her *Characteristics of Women* she wrote that 'If Cordelia reminded us of anything on earth, it is one of the Madonnas in the old Italian pictures'.[54] But she also insisted that these Shakespearean characters 'must either have the look of real individual portraiture, or become mere idealisations of certain qualities; and Shakespeare's creations are neither one nor the other.'[55] Nor, we may say, are Cameron's. The picture, *The Mountain Nymph, Sweet Liberty* (no. 3.60) is both an individual portrait and an illustration from Milton's 'L'Allegro', an idealization of vital womanhood from the living model.

If Cameron depicted the Prophets she also portrayed the Sibyls, the heathen prophetesses who predicted the Messiah for the Gentiles as the prophets did for the Jews. It was the Cumean Sibyl, impersonated by Lady Elcho in Cameron's photograph with stern sadness (no. 3.6), who saw God not face to face but through a glass darkly.

She offered Tarquin nine books of oracles, themselves types of the Scriptures, and when he refused her price she went away and burnt three of them. The Sibylla Libyca, according to Eastlake, announced Christ to the Gentiles. She may be the type of the 'Study of a Sibyl' in Cameron's photograph (no. 3.39). St Agnes, as a classical figure with a palm (no. 3.53), may be a variant of the Sibylla Hellesponte, who prophesied the Incarnation and the Crucifixion and combined the role of martyr and sibyl. Again, Eastlake wrote: 'In the great system of Christian Art the Sibyls may be said to go hand in hand with the Prophets, and there can be no doubt that grand and picturesque female figures, of inspired action and countenance, were exceedingly welcome to painters and sculptors in this juxtaposition, either in series, or in composite representations.'[56] She cited, in particular, the Sibyls of Michelangelo on the Sistine Chapel ceiling, where 'they form a gigantic framework round the subjects of the Creation, of which the Birth of Eve, as the type of the Nativity, is the intentional centre'. She remarked that Michelangelo's and Raphael's Sibyls do not bear the attributes necessary to identify them. Michelangelo's are 'wrapt in self-contemplation', while Raphael's are simply 'beautiful women of antique form'.[57] Cameron's handling of the subject may be said to be closer to Raphael's in that the sybilline references are obscure, and the occasion for the representation of beautiful women, inwardly inspired, seems to have been her main motivation for making the pictures.

In a feminine, as opposed to a feminist, society it was inevitable that women would not be cast as heroes as men were. Cameron wrote to Sir Henry Taylor that men were 'great thro' genius, the women thro' love. Love . . . that which women are born for.'[58] But as prophetesses, sometimes the wives and daughters of Apollo, sometimes like *Daphne* (no. 3.47), the beloved of Apollo, these sibylline figures prepare the way for Christ and His martyrs. 'Pharoah's Daughter' (no. 3.50) discovers Moses in the bulrushes, 'Rebecca' (no. 3.49)

is a type of the Church, and *St Agnes*, in the two versions which Cameron offers (nos 3.53, 3.54), seems to bridge the Classical and Christian eras. *Boadicea* (no. 3.52) is a kind of British martyr, analogous to King Arthur. In the end, *Mary Mother* (no. 3.61) is as much a Sibyl as the Mother of Jesus.

In 1859 Cameron gave Tennyson *Adam Bede* by George Eliot, Wright's edition of *Morte d'Arthur*, the second volume of Carlyle's *Frederick the Great* and John Stuart Mill's *On Liberty*. The choice of such books proves the quality of her mind. She would have to wait ten years to read Mill on *The Subjection of Women* (1869), but it is inconceivable that she did not discuss the nature of liberty and subjection, freedom and tyranny, with her husband and her friends. Sir Henry Taylor engaged Mill in debate, directly and indirectly. Mary Spartali, a woman artist who studied with Madox Brown, and who exhibited at the Dudley Gallery in 1867 (*Head of Antigone, Ianthe*) and at the Royal Academy Exhibition of 1873 (*Sir Lancelot and Elaine*),[59] impersonated for Cameron, *Mnemosyne*, mother of the Muses, and, more importantly, *Hypatia* (no. 3.41), the neo-Platonist philosopher, denounced as a Circe and murdered by the Church in Alexandria – an intellectual martyr between two dispensations, the Classical and the Christian.

3.1
CESARI MARIANNECCI
after Raphael
The Four Sibyls (S. Maria della Pace, Rome)*

Arundel Society watercolour, 1865
41.9 × 83.8
National Gallery, London. On permanent loan to the University of Leeds, Department of Fine Art (NG 368)

'They are simply beautiful women of antique form, to whom, with the aid of books, scrolls, and inscriptions, the Sibyllic idea has been given, but who would equally pass for the abstract personifications of virtues, or cities. They are four in number – the Cumana, Phrygia, Persica, and Tiburtina; all, with the exception of the last, in the fullness of youth and beauty, and occupied, apparently, with no higher aim than that of displaying both. Indeed, the Tiburtina matches ill with the rest, either in character or action. She is aged, has an open book on her lap, but turns with a strange and rigid action as if suddenly called. The very comparison with her tends to divest the others of the Sibylline character.'

Jameson and Eastlake, *History of Our Lord,* I: 256

3.2
CESARI MARIANNECCI
after Michelangelo
The Prophet Jeremiah (Sistine Chapel, Rome)

Arundel Society watercolour, 1867
54 × 46
National Gallery, London. On permanent loan to the University of Leeds, Department of Fine Art (NG 330)

3.3
CESARI MARIANNECCI
after Michelangelo
The Persic Sibyl (Sistine Chapel, Rome)*

Arundel Society watercolour, 1867
55.1 × 43
National Gallery, London. On permanent loan to the University of Leeds, Department of Fine Art (NG 333)

'The Sibylla Persica, supposed to be the oldest of the sisterhood, holds the book close to her eyes, as if from dimness of sight, which fact, contradicted as it is by a frame of obviously Herculaean strength, gives a mysterious intentness to the action.'

Jameson and Eastlake, *History of Our Lord* I: 253

HIEREMIAS

3.2

3.4
After Masaccio
Two Heads from *The Tribute Money* (Brancacci Chapel, S. Maria del Carmine, Florence)*

Arundel Society chromolithograph by Storch and Kramer from a watercolour copy by Mariannecci, 1861
Each head 37 × 24.8
By permission of the Curators of the Bodleian Library, Oxford.

'The figure to the spectator's right, with a broad forehead, denoting much strength of character, wearing an ample red cloak, which is thrown over his shoulder, is traditionally believed to be the portrait of Masaccio himself, painted, according to Vasari, by the aid of a mirror . . . His peculiar method of giving the effect of relief and roundness by placing the highlights on the edge of his forms, is well illustrated in this fresco. He does not appear to have been followed in it by any other painter.'

Sir Henry Layard, *The Brancacci Chapel,* Arundel Society 1868, 54–5.

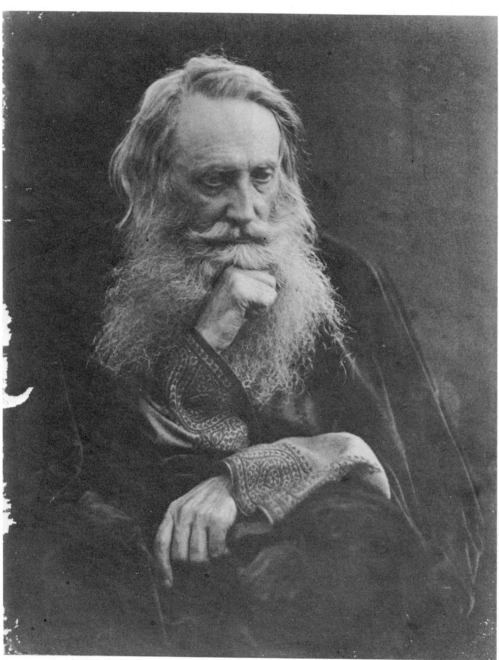

3·5
Henry Taylor A Portrait,
1865 (Ford 134)

27.5 × 21.8
National Portrait Gallery,
London (X18021)

'There is a trick of sham
Elizabethan writing now
prevalent that looks plaus-
ible, but in most cases
means nothing at all. Darley
has real lyrical genius,
Taylor, wonderful sense,
clearness and weight of
purpose; Tennyson, a rich
and exquisite fancy. All the
other men of our tiny gen-
eration that I know of are,
in poetry, either feeble
or fraudulent.'

Carlyle, quoted in C. C.
Abbott, *Life and Letters of
George Darley,* London
1928, 246

3.6
*Lady Elcho/as the Cumean
Sibyl*, registered 1865

25.3 × 20.1
Victoria & Albert Museum,
London (45139)

3·5

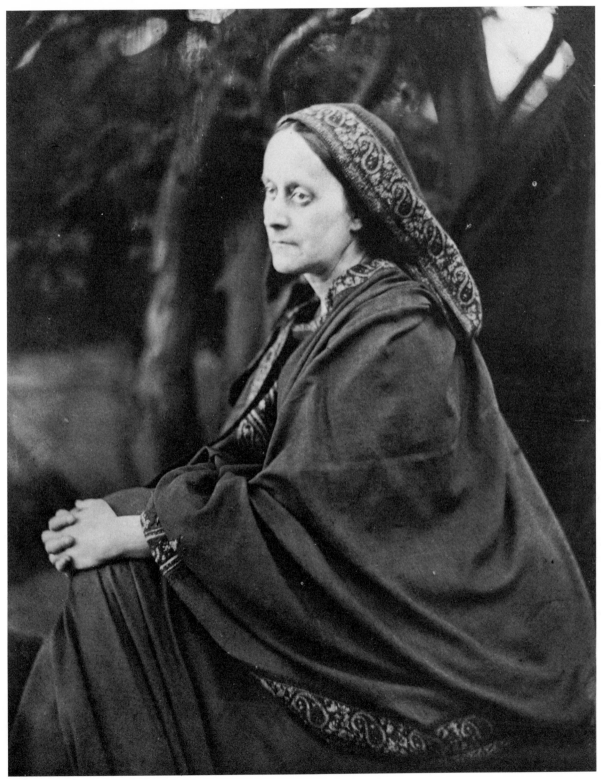

3.7
WHISPER OF THE MUSE,
registered 1865

25.4 × 19.7
The Royal Photographic
Society (C3: 2025)

This picture may have been
influenced, both in its con-
ception and composition,
by Rembrandt's painting,
*The Evangelist Matthew
Inspired by the Angel,* 1661.

3.8
*King Arthur/FreshWater Isle
of W 74*

35.9 × 28
The Royal Photographic
Society (C8: 2107)
Alvin Langdon Coburn
Gift, 1930

'And even then he turn'd; and
more
*The moony vapour rolling
round the King,*
Who seem'd the phantom
of a Giant in it,
*Enwound him fold by fold,
and made him gray
And grayer, till himself
became a mist
Before her, moving ghost-
like to his doom.'*

Tennyson, 'Guinevere'
from Cameron, *Idylls
of the King,* Part One
(Cameron's own under-
lining)

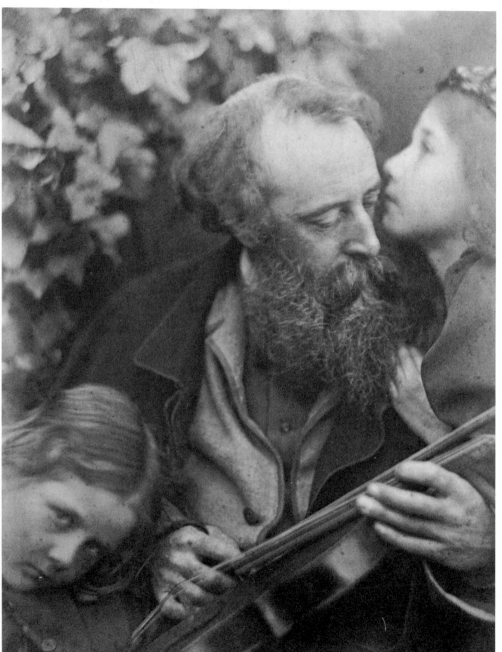

3.7

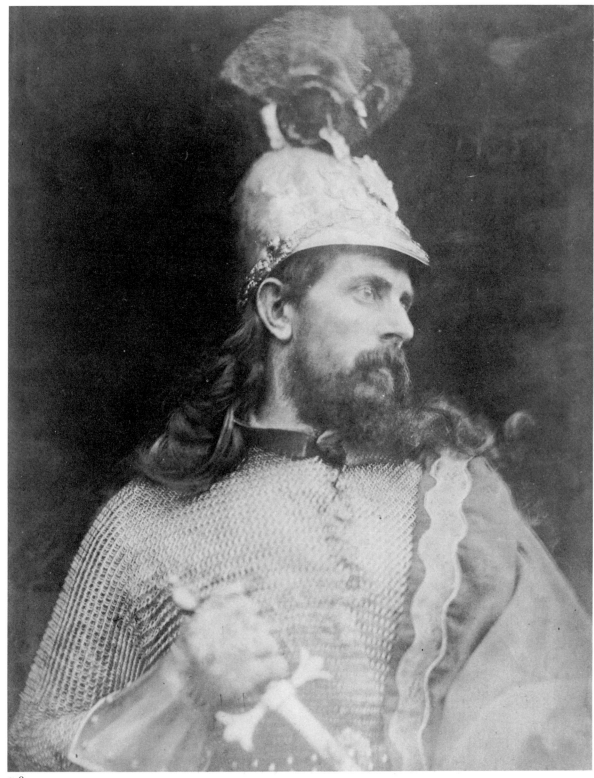

3.8

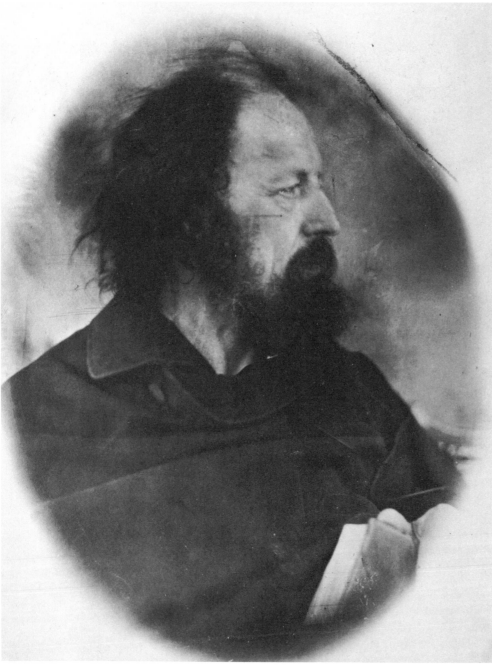

3.9
'THE DIRTY MONK'
3 June 1869 (Firestone
Library, Princeton)

Oval, 24.2 × 19.1
The Royal Photographic
Society (C5: 2055/1)
Presented by Col. Cameron,
1929

'What can be more unpromis-
ing as subjects for the artist,
than the religious orders of
the Middle Ages, where the
first thing demanded has
been the absence of beauty
and the absence of colour?
Ascetic faces, attenuated
forms, dingy dark
draperies, the mean, the
squalid, the repulsive, the
absolutely painful, . . . these
seem most uncongenial
materials, out of which to
evolve the poetic, the grace-
ful, and the elevating!'

Jameson, *Legends of the
Monastic Orders*, xviii

3.9

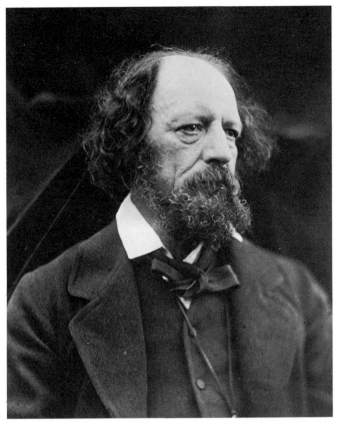

3.10

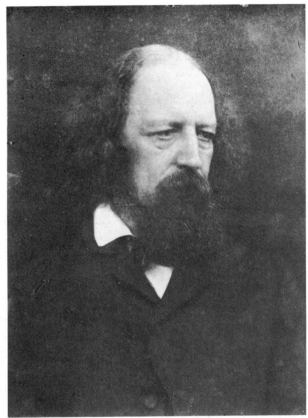

3.11

3.10

ALFRED, LORD TENNYSON
June 3, 1869 (Firestone
Library, Princeton)

28.3 × 23.1
The Royal Photographic
Society (C5: 2056/1)
Presented by A. C.
Norman, 1929

'A masterly work, with all
the breadth of effect and
vigorous simplicity that
belongs to great art.
Reminds me of Velasquez.'

P. H. Emerson, *Sun Artists,*
41

3.11

TENNYSON, 1867

Brown carbon
38.1 × 28.9
Royal Photographic Society
(C5: 2515)
Alvin Langdon Coburn
Gift, 1930

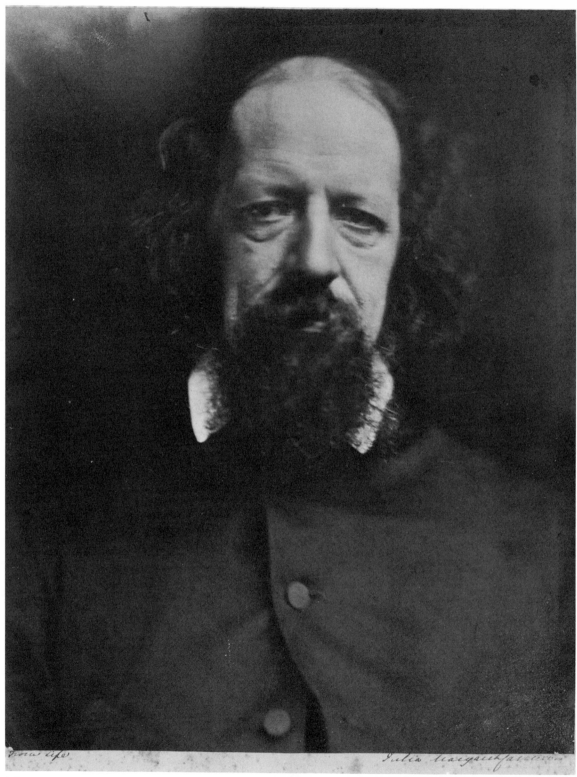

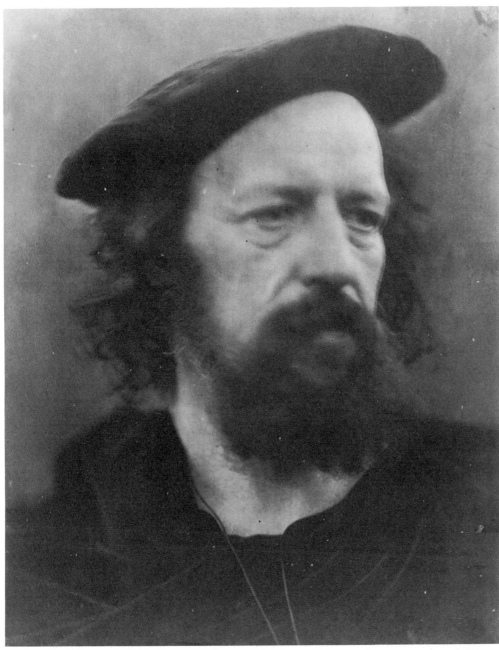

3.13

3.12
TENNYSON, *c.* 1867

31.5 × 25
Liverpool City Libraries
(19)

'He is a very interesting
person, a singular com-
pound of manliness and
helplessness – manly in his
simplicity, and, I should
think, in his understanding
also. A new edition of his
"In Memoriam" is just out,
5,000 strong; and, except
Wordsworth for some ten
years of his life, I should
think he is the only really
popular poet since Byron.'
*Correspondence of Henry
Taylor,* ed. E. Dowden,
London 1888, 194.

3.13
Tennyson . . . with cap,
lithographically signed by
the sitter, 1866

Colnaghi blind stamp
27.8 × 22.8
Victoria & Albert Museum,
London (45132)

'I wish you would paint a
Vandyck [in words] of
Alfred Tennyson. It has
been complained of that the
contemporaries of Shakes-
peare & Milton did them no
justice. Let not the same be
said of Alfred Tennyson &
Henry Taylor.'
Cameron letter to Sir
Henry Taylor, 1 July 1876
(Bodleian Library, Oxford,
Ms. Eng. Lett. d 13 fol. 84).

3.14

3.14
ROBERT BROWNING, regis-
tered 1865

18.5 × 22.8
Wellcome Institute Library,
London

' . . . there is a theatrical air
about the work which
makes it poor art. This was
taken at Little Holland
House.'

P. H. Emerson, *Sun Artists*,
41.

The bottom third of this
image has been cropped.

3.15
Aubrey de Vere, registered
1864

Arched top, 24.3 × 19.1
National Portrait Gallery,
London (X18001)

3.15

3.16

3.16
James Spedding, registered
1864

Oval, 22 × 17.5
Liverpool City Libraries,
(16)

Spedding was a member of
Tennyson's college set
which included Charles
Brookfield, Arthur Hallam,
and Stephen Spring Rice.

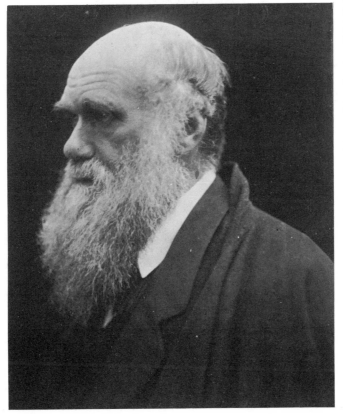

3.17

3.17
Charles Darwin, signed, or
lithographically signed,
by the sitter. *July/August,
1868*

Colnaghi blind stamp
25.4 × 21
The Royal Photographic
Society (C3: 2397/2)
Lent by A. C. Norman,
1929

In 1868 Darwin and his
family visited Freshwater,
where they stayed in
Cameron's guest cottage,
attached to her own home.
His visit followed the open-
ing of the Freshwater Read-
ing Room which Cameron
had established: 'I could not
let it fail for every moment I
could give to it.' (Cameron
letter to Darwin, 10 July
1868, Cambridge
University Library).

3.18

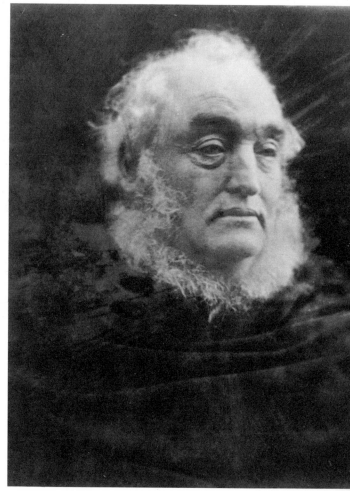

3.19
*Lord Justice James/FreshWater
Aug 1870*

Colnaghi blind stamp
35.2 × 28.5
Lent by the Visitors of the
Ashmolean Museum,
Oxford

An intimate friend from
Charles Cameron's youth,
according to Sir Henry
Taylor.

3.18
*Hon. Frank Charteris,
FreshWater August 1867*

*Presented by Mrs. Cameron
thro' Dr. Acland to the
University Gallery, Oxford*

Colnaghi blind stamp
34.5 × 26.5
Lent by the Visitors of the
Ashmolean Museum,
Oxford

Charteris was the son of
Lord and Lady Elcho. She is
represented in this exhibi-
tion as 'the Cumean Sibyl'.
He played a significant role
in obtaining the Oxford
Union commission for the
Pre-Raphaelites, among
them Cameron's nephew,
Val Prinsep.

3.19

3.20
Longfellow, signed 'Henry
W. Longfellow' litho-
graphically by the sitter
FreshWater 1868 (Mozley 38)

Colnaghi blind stamp
35 × 27.6
Lent by the Visitors of the
Ashmolean Museum,
Oxford

'A fine profile, but looks
posed'.

P. H. Emerson, *Sun Artists*,
41

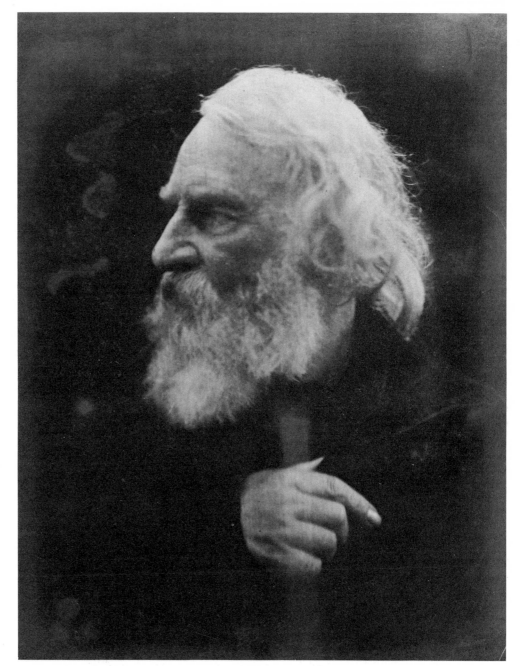

3.20

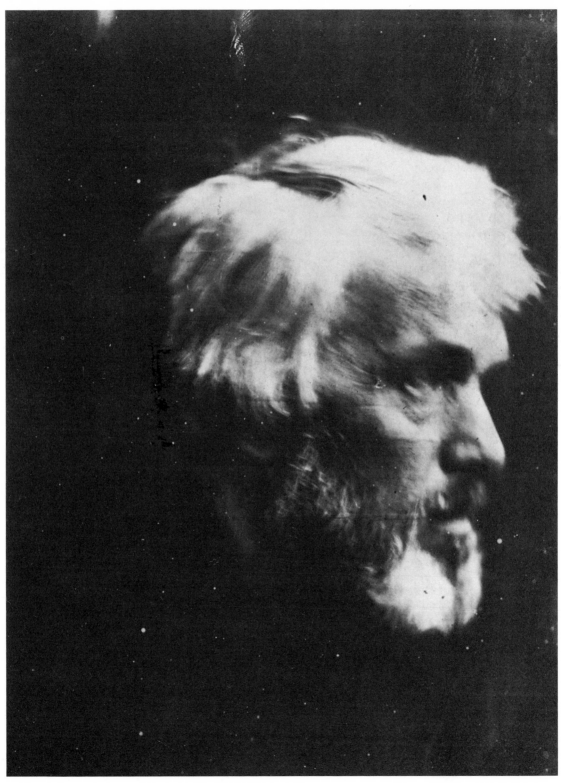

3.21

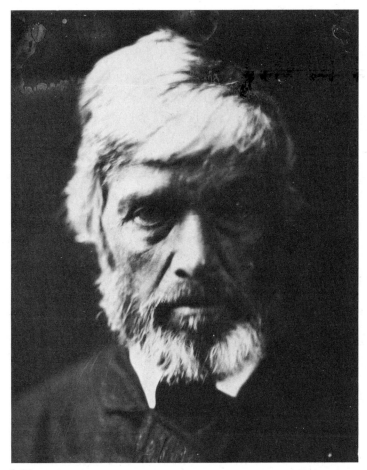

3.22

3.21
Carlyle (PROFILE), regis-
tered 1867

33.7 × 24.5
The Royal Photographic
Society (C3: 2029/)
Presented by Col. Cameron

3.22
*Carlyle like a rough block of
Michael Angelo's Sculpture,*
(Ford 117) registered 1867

35.6 × 28
The Royal Photographic
Society, (C3: 2505)
Presented by Col. Cameron,
1929

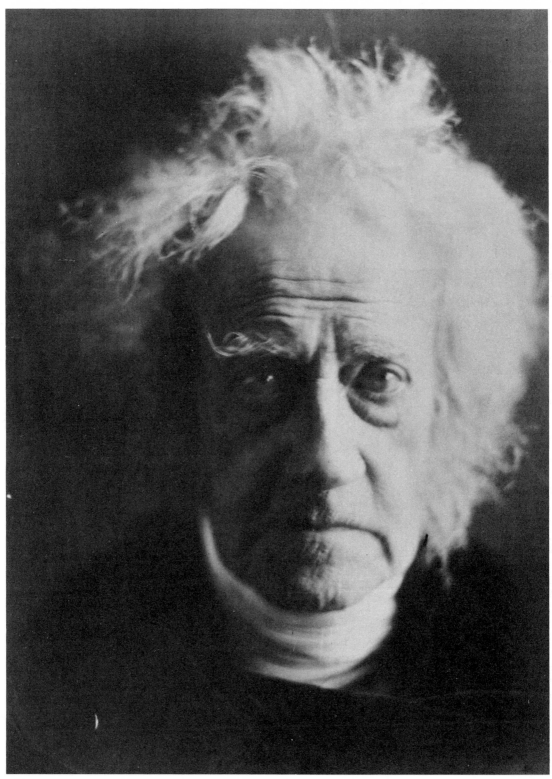

3.23

3.23
Sir John Herschel, signed lithographically 'J F W Herschel' by the sitter

Colnaghi blind stamp
34.4 × 25
Lent by the Visitors of the Ashmolean Museum, Oxford

3.24
Sir John Herschel in cap, signed lithographically 'J F W Herschel' by the sitter, *taken at Sir John Herschel's own residence Collingwood April 1867*

Colnaghi blind stamp
34.9 × 26.1
Lent by the Visitors of the Ashmolean Museum, Oxford

'He was to me as a Teacher and High Priest'.

Cameron, 'Annals of my Glass House', (*Writings*, p. 154)

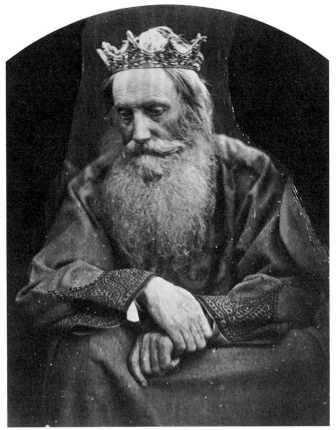

3.25

3.25
Study of King David/1869

Arched top, 27.9 × 22.5
The Royal Photographic Society (C4: 2110/2)

Cameron's picture probably represents David repenting after Nathan charged him with slaying Uriah and taking his widow, Bathsheba, as his wife (2 Samuel XII: 1–6).

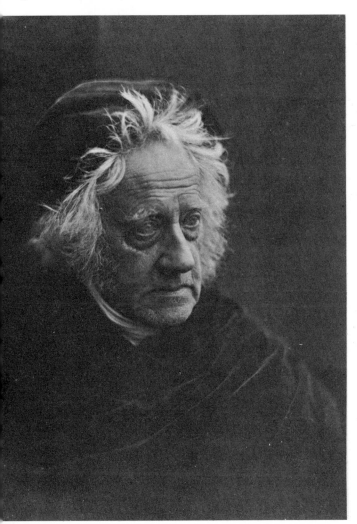

3.24

3.26

3.26

HENRY TAYLOR DCL,
Fresh Water Oct. 1867

Presented by Mrs. Cameron thro' Dr. Acland to the University Gallery, Oxford

Presented by Colnaghi

34.5 × 26.7
Lent by the Visitors of the Ashmolean Museum, Oxford

'Jealousy and vanity were unknown to him, and if a man cannot be a poet without belonging to the "genus irritabile", a poet he was not.'

Sir Francis Hastings Doyle, *Reminiscences and Opinions*, London 1886, 408–9.

3.27
Study of Prospero
May 1875 (Ford 135)

27.3 × 21.9
The Royal Photographic Society (C4: 2046/3)

'One of her earliest works, and one of the best. Recalls Leonardo da Vinci in its elaboration, lighting, and sentiment. A great work in many ways.'

P. H. Emerson, *Sun Artists*, 41

A print in the Sir Henry Taylor Album of Cameron photographs in the Bodleian Library, Oxford, has the inscription 'Caezar Borgia', possibly in Taylor's own hand.

3.28
HENRY TAYLOR A
'REMBRANDT' *c.* 1866

24.2 × 19.9
National Portrait Gallery, London (X18020)

'I think Taylor's poem [*Philip van Artevelde*] is the best light we have ever had upon the genius of Shakspear. We have made a miracle of Shakspear, a haze of light instead of a guiding torch, by accepting unquestioned all the tavern stories about his want of education and total unconsciousness. The internal evidence all the

3.27

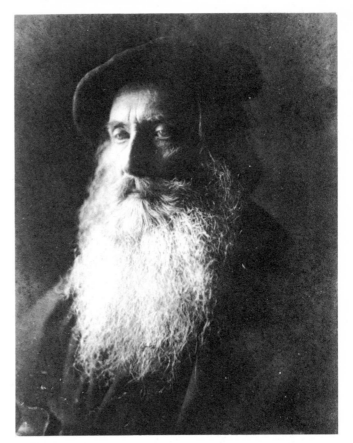

3.28

time is irresistible that he was no such person. He was a man, like this Taylor, of strong sense and of great cultivation; an excellent Latin scholar, and of extensive and select reading, so as to have formed his theories of many historical characters with as much clearness as Gibbon or Niebuhr or Goethe. He wrote for intelligent persons, and wrote with intention. He had Taylor's strong good sense, and added to it his own wonderful facility of execution which aerates and sublimes all language the moment he uses it, or, more truly, animates every word.'

The Journal of Ralph Waldo Emerson, London 1910, III: 452–3.

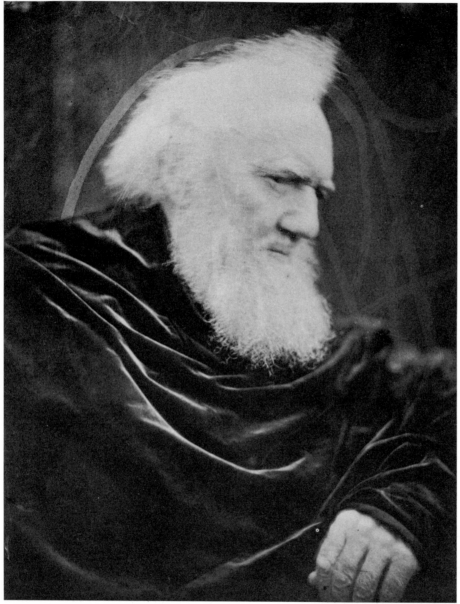

3.29

(see p. 86)

3.30
*A. H. Layard Esq. M.P./
1869 FreshWater*

30.5 × 24.5
The Royal Photographic
Society (D: 2028/1)

Sir Henry Layard
(1817–94), the author of
Ninevah and its Remains
(1848–9) went on a tour of
Italy in 1853, which pro-
duced in him a deep desire
to see the frescos of the
fifteenth and sixteenth cen-
turies recorded and pre-
served. On his return he
helped to found the
Arundel Society, and wrote
many of the monographs it
published.

3.31
C. H. CAMERON, signed by
the sitter, *FreshWater May
1868*

Colnaghi blind stamp
35.9 × 28
The Royal Photographic
Society (C4: 2032)

'He is an accomplished
scholar & gentleman of
great literary & general
knowledge, & his writings
are in grace, force & clear-
ness of diction, superior to
almost any of his time that I
am acquainted with.'
Testimonial on behalf of
C. H. Cameron by Sir
Henry Taylor, 11 June 1861
(Bodleian Library, Oxford,
*Ms. Eng. Lett. d 12 fols.
17–18*).

3.29
H. T. Prinsep, registered
1865

36.7 × 28.5
Lent by the Visitors of the
Ashmolean Museum,
Oxford. Presented by Sir
Weldon Dalrymple-
Champneys

This close family friend,
one of the trustees of
Cameron's marriage settle-
ment, here represents not so
much himself as Joseph in
Francia's *Adoration of the
Magi*.

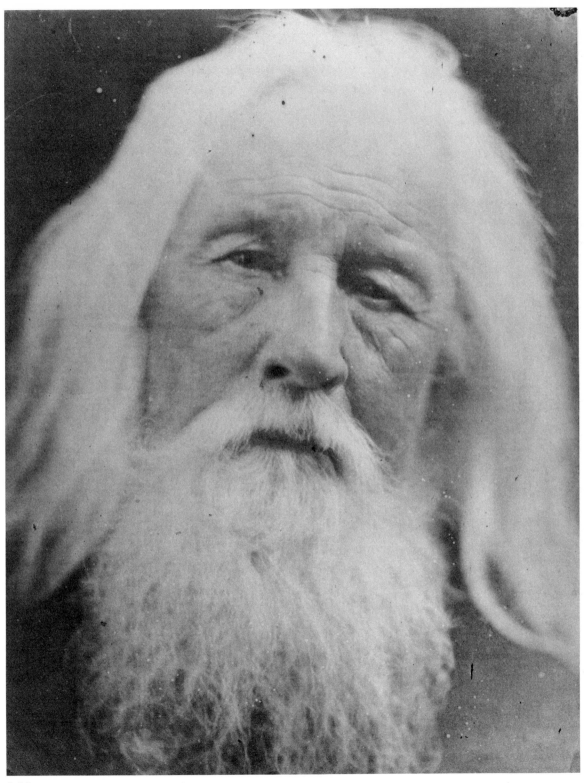

George Frederick Watts (1817–1904)

Like Cameron, Watts was concerned to portray men of
creative ability whose visionary idealism could be dis-
covered in their faces. In the sixties, when Cameron was
beginning her career and seeking his advice on composi-
tion, he was asking her to help him obtain sittings with
such literary figures as Browning, Carlyle, Taylor, and
Tennyson. His indebtedness to the Venetian painters is
well established. Tintoretto's influence shaped his
approach to Tennyson and Taylor, and Titian's his own
self-portrait. His conception of creating a Victorian pan-
theon which would also transcend the age was one he
shared with his intimate friend, Julia Margaret Cameron.
They both wished to elicit the unconscious sublimity of
their subjects, and so create a gallery of types of both
secular and spiritual significance.

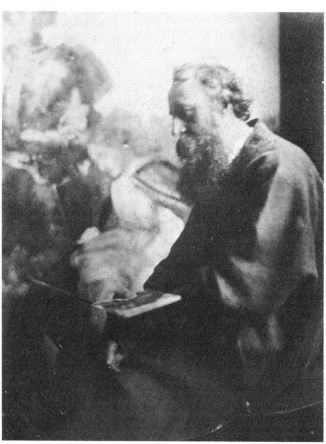

3·32

3·33

3.32

G. F. WATTS, c. 1863–68

25.4 × 19.9
National Portrait Gallery,
London (P. 125)

'Having heard much of the
productions of "Julia
Margaret Cameron," our
attention was directed in the
first place to her portraits,
of which she exhibits five.
They are of somewhat large
size, and appear to have
been taken with a lens
possessing the same photo-
graphic qualities as a spec-
tacle eye; or, if any kind of
sharpness has existed in the
negative, a contrivance
must have been affected for
allowing at least a quarter of
an inch to intervene bet-
ween the collodion film and
the paper on which the
proofs are printed.'
British Journal of Photography,
XI, 220 (July 22, 1864); 260,
signed Aur. Chl.

3·33
G. F. WATTS
Self-Portrait, c. 1879

Oil on canvas
63.5 × 50.8
National Portrait Gallery,
London (1046)

The G. F. Watts album at
George Eastman House has
Cameron's inscription,
'February 22nd 1864 (My
Eugene's birthday – 24): To
the Signor to whose gener-
osity I owe the choicest
fruits of his Immortal genius
I offer these my first suc-
cesses in my mortal but yet
divine! art of photography.'

3·34
G. F. WATTS
Sir Henry Taylor, c. 1868–70

Oil on canvas
61 × 50.8
National Portrait Gallery,
London (1014)

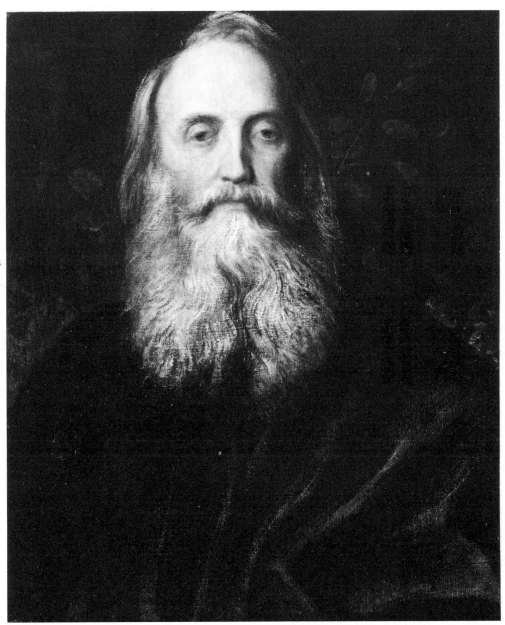

3·34

3.36

3.36
G. F. Watts
Alfred Lord Tennyson,
c. 1863–4

Oil on canvas
61 × 50.8
National Portrait Gallery,
London (1015)

'The head of Tennyson is
the head of a poet. Watts
has painted Tennyson with
his dark dome-like head
relieved against a symbolic
green and blue of the eternal
sea and the eternal laurels.
He has behind him the bays
of Dante and he is wrapped
in the cloak of the prophets.
Browning is dressed like an
ordinary modern man, and
we feel at once that it
should and must be so. To
dress Browning in the
prophet's robe and the
poet's wreath would strike
us all as suddenly ridicu-
lous; it would be like send-
ing him to a fancy-dress
ball.'

G. K. Chesterton, *G. F.*
Watts, 39–40

3.35
G. F. Watts
James Spedding, c. 1853

Coloured chalk on paper
48.25 × 30.5
National Portrait Gallery,
London (2059) *

3.37
G. F. Watts
Robert Browning, 1866

Oil on canvas
66 × 53.4
National Portrait Gallery,
London (1001)*

3.38

FEMALE FIGURE WITH
CYMBALS, *c.* 1868

Colnaghi blind stamp
33 × 25.4
The Royal Photographic
Society (C13: 2216)
Presented by Mrs Trench

Both the woman's dress
and the fact that she is rep-
resented playing the cym-
bals suggest that she may be
a Semite. Cymbals were
'probably introduced by the
Israelites on their return
from Babylon'. (Smith,
Dictionary of the Bible, 376.)

3.39

3.38

3.39

STUDY OF A SIBYL,
*Fresh Water Oct. 1870/
6 of these cabinets*

Arched top, 35.3 × 27.5
National Portrait Gallery,
London (X18012)

Cameron seems to have
ordered six cabinet-size
prints of this image.

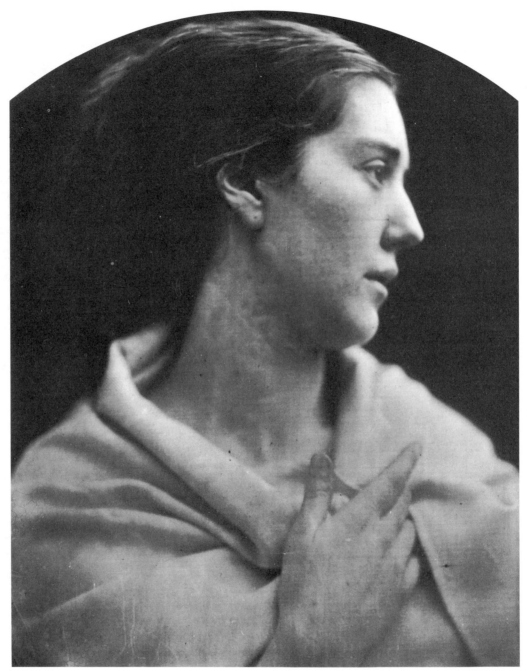

3.40

3.40
Lady Layard/FreshWater
March 1869

Colnaghi blind stamp
Arched top, 30.5 × 24.8
The Royal Photographic
Society (C15: 2255/2)
Alvin Langdon Coburn
Gift, 1930

3.41
Hypatia
1867 (Gernsheim 192)

30.6 × 24.7
Victoria & Albert Museum,
London (1141–1963)

Charles Kingsley's novel,
*Hypatia or New Foes with an
Old Face* was originally pub-
lished in *Fraser's Magazine*
(1851) and appeared in book
form in 1853. It tells the
story of the neo-platonist,
Hypatia, who was killed by
a Christian mob.

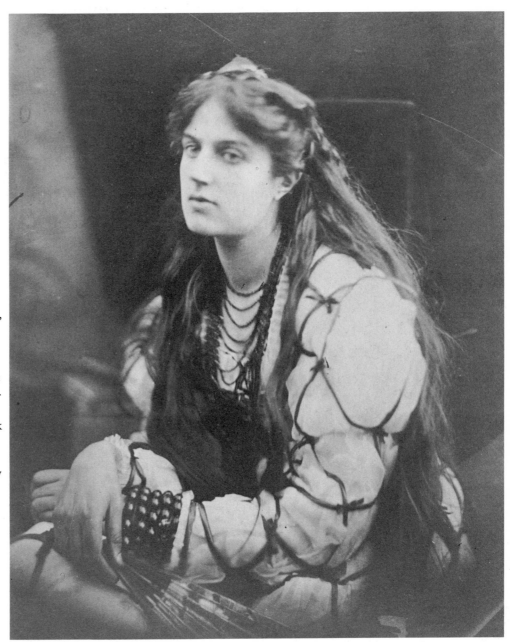

3.41

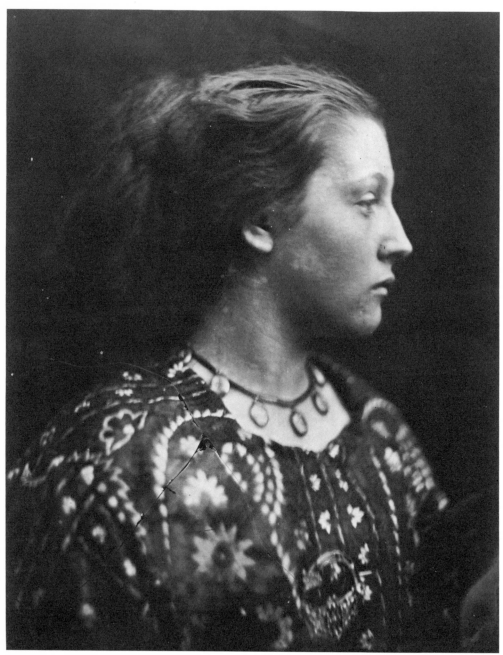

3.42
Sappho, registered 1865

35.7 × 28.3
Victoria & Albert Museum,
London (947–1913)

'Modern writers have
indeed attempted to prove
that the moral character of
Sappho was free from all
reproach; but it is imposs-
ible to read the fragments
which remain of her poetry
without being forced to
come to the conclusion that
a female, who could write
such poetry, could not be
the pure and virtuous
woman, which her modern
apologists pretend.'

Smith, *Classical Dictionary of
Greek and Roman Biography,*
672.

3.42

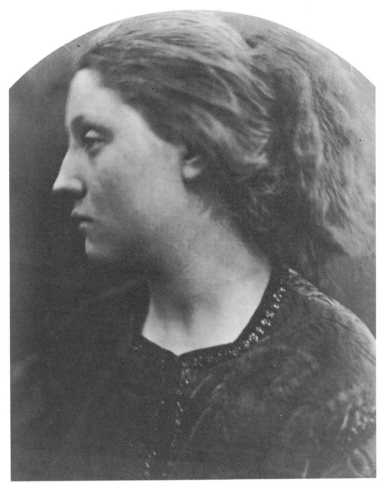

3.43

3.43
Adriana

Colnaghi blind stamp
Arched top, 34.1 × 27.9
Lent by the Visitors of the
Ashmolean Museum,
Oxford

It is possible that the jilted
heroine Adriana Linden, of

Jean Boncoeur's novel
Adriana, which began to be
serialized and illustrated by
Edward Hughes in *Once a
Week* I (31 March 1866), is
the source of Cameron's
title.

3.45
Pomona
September 1872 (Mozley 46)

Colnaghi blind stamp
34.6 × 26.7
The Royal Photographic
Society (2286/1)

Pomona was the Roman
divinity of the trees. She is
often represented with
fruits in her bosom and a
pruning knife in her hand.

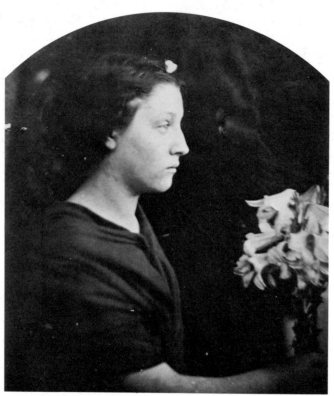

3.44

3.44
A Vestal, 1864–65

Colnaghi blind stamp
22 × 19.5
Victoria & Albert Museum,
London (44951)

'Vestales, the virgin priestesses of Vesta who ministered in her temple and watched the eternal fire ... bound by a solemn vow of chastity ... It was necessary that the maiden should not be under six nor above twelve years of age, perfect in all her limbs, in the full enjoyment of all her senses, patrima et matrima, the daughter of free and free born parents who had never been in slavery, who followed no dishonourable occupation, and whose home was in Italy ... The period of service lasted for thirty years.'

Smith, *Dictionary of Greek and Roman Antiquities*, 1189.

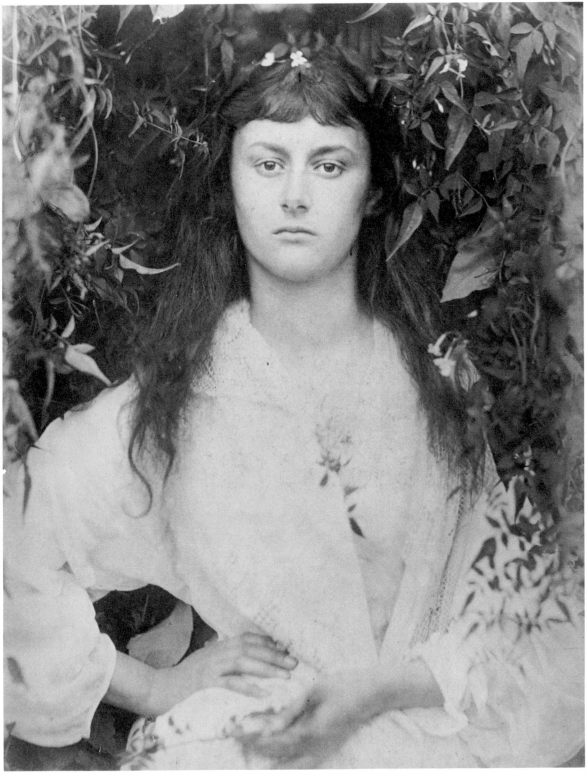

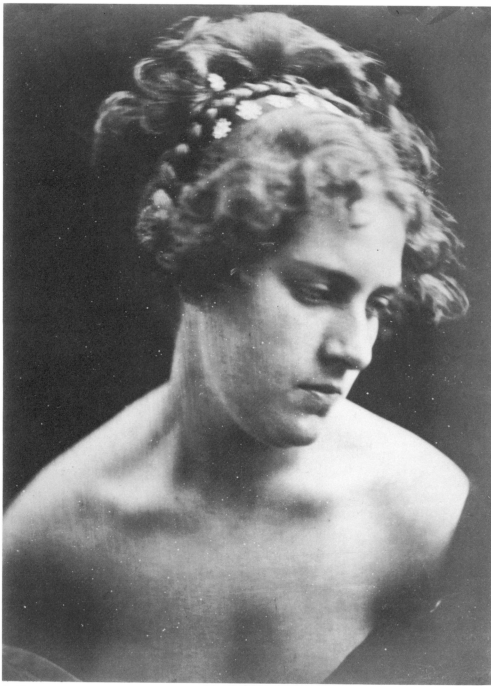

3.46

3.46
*Vectis Isle of Wight/The
Vectian Venus, 1872*

35 × 26.7
The Royal Photographic
Society (C18: 2300)
Alvin Langdon Coburn
Gift, 1930

Vectis was the Roman
name for the Isle of Wight
where Mrs Cameron lived
from 1869–74. This picture
may be a classicalized rep-
resentation of an Isle of
Wight beauty.

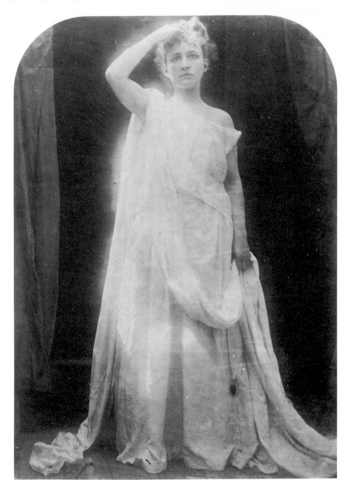

3.48

3.47
Daphne/FreshWater Bay Isle of Wight
c. 1867 (Gernsheim 194)

Colnaghi blind stamp
35.2 × 27.2
Lent by the Visitors of the
Ashmolean Museum,
Oxford

Daphne, the mountain
nymph and the Priestess of
Mother Earth, was pursued
by Apollo. She turned into
a laurel tree as he overtook
her.

3.48
MISS ISABEL BATEMAN – SHE WALKS IN BEAUTY,
registered 1874

Arched top, 35.9 × 26.4
The Royal Photographic Society (C13: 2201p)
Presented by Mrs Trench, 1929

'One shade the more, one ray the less,
Had half impair'd the nameless grace
Which waves in ever raven tress,
Or softly lightens o'er her face;
Where thoughts serenely sweet express
How pure, how dear their dwelling place.'

Byron, 'She Walks in Beauty', *Hebrew Melodies* 1815, verse 2.

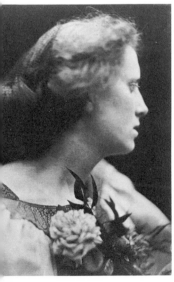

3.47

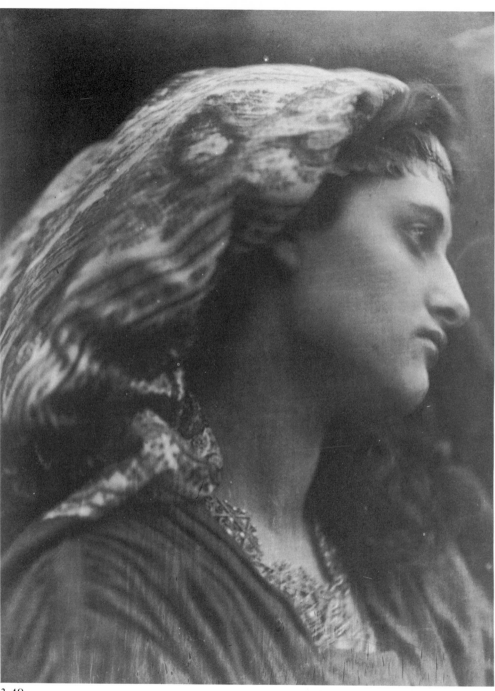

3.49

3.49

REBECCA, 1870

Unidentified blind stamp, 'Registered Photograph' 34.4 × 26.1 The Royal Photographic Society (C18: 2304/2)

Variously called 'The East' and 'Zöe', and related to 'Zuleika' (3.51), this image represents the type of the Church as Spouse. That Cameron entitled a very similar image *Herodias The Mother of Salome* would seem to suggest that an exultant bride rather than a pensive wife was what she had in mind.

3.50

PHAROAH'S DAUGHTER, 1866

Unidentified blind stamp, 'Registered Photograph' 34.3 × 27.3 The Royal Photographic Society (C17: 2285)

'The finding of the child by the princess was, it is true, the needful moment to indicate his adoption by the Egyptians, and even the meaning of his name, for "she called his name Moses: and she said, Because I drew him out of the water." But this in no way precluded the expression of the mother's love, which makes this simply-told tale one of the most touching that Scripture bestows on the artist.'

Jameson and Eastlake, *History of our Lord,* I: 174.

3.51

ZULEIKA, *c.* 1864–67

33.5 × 25.2
Wellcome Institute Library,
London

Cameron has compounded
the image of Zuleika, the
heroine of Byron's poem,
'The Bride of Abydos'
(1815), with that of
Rebecca. According to
Jameson, the latter was con-
sidered 'as a type of Church
(the SPOUSE), and conse-
quently of the Virgin
Mary.'

Jameson and Eastlake,
History of our Lord, 1:146

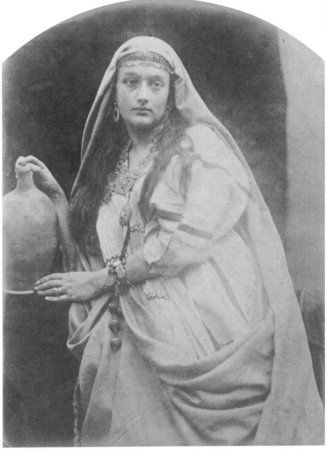

3.51

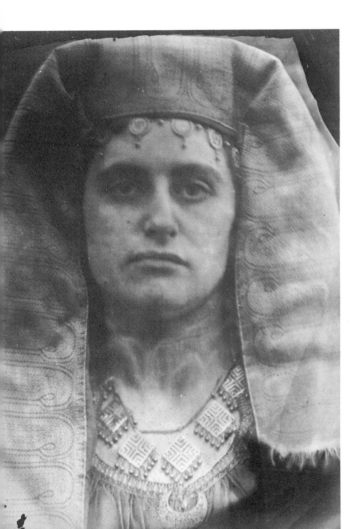

3.50

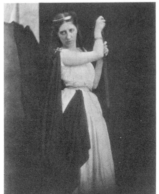

3.52

3.52
Boadicea

26.6 × 21
National Portrait Gallery,
London (X18026)

Boadicea was the subject of
one of Tennyson's poems,
written in 1860.

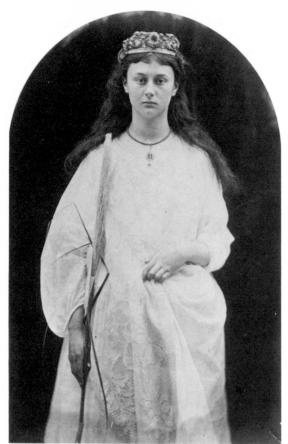

3·53

3·54

St. Agnes looking straight, registered 1864

Colnaghi blind stamp
26.6 × 21.2
Victoria & Albert Museum, London (44751)

'They told her how, upon St Agnes' Eve,
Young virgins might have visions of delight,
And soft adorings from their loves receive
Upon the honey'd middle of the night,
If ceremonies due they did aright;
As, supperless to bed they must retire,
And couch supine their beauties, lilly white;
Nor look behind, nor sideways, but require
Of Heaven with upward eyes for all that they desire.'
Keats, *The Eve of St Agnes*, 1820, verse vi.

3·53

St Agnes, registered 1872

Colnaghi blind stamp
Arched top, 33.3 × 22.6
The Royal Photographic
Society (C12: 2196/1)
Presented by F. Hollyer,
1931

'It chanced that the son of
the prefect of Rome beheld
her one day as he rode
through the city, and
became violently
enamoured, and desired to
have her for his wife ...
But she rejected him and his
gifts, saying, "Away from

me, tempter! for I am
already betrothed to a
lover who is greater and
fairer than any earthly
suitor ... I have tasted of
the milk and honey of his
lips, and the music of his
divine voice has sounded in
mine ears: he is so fair that
the sun and the moon are
ravished by his beauty, ..."'

Jameson, 'St Agnes, Virgin
and Martyr', *Sacred and
Legendary Art*, II: 220–1.

St Agnes bears the palm of
martyrdom.

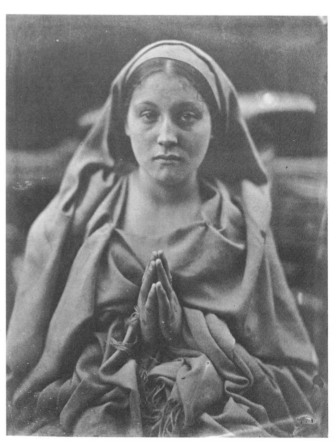

3·54

3·55

THE ANGEL IN THE HOUSE,
*FreshWater May 1873/For
Coventry Patmore*

34 × 25.3
Liverpool City Libraries
(13)

The Angel in the House, a
poem by Coventry
Patmore, was first pub-
lished 1854–6, and went
through numerous editions
during the second half of
the nineteenth century. It
was a celebration of
married love.

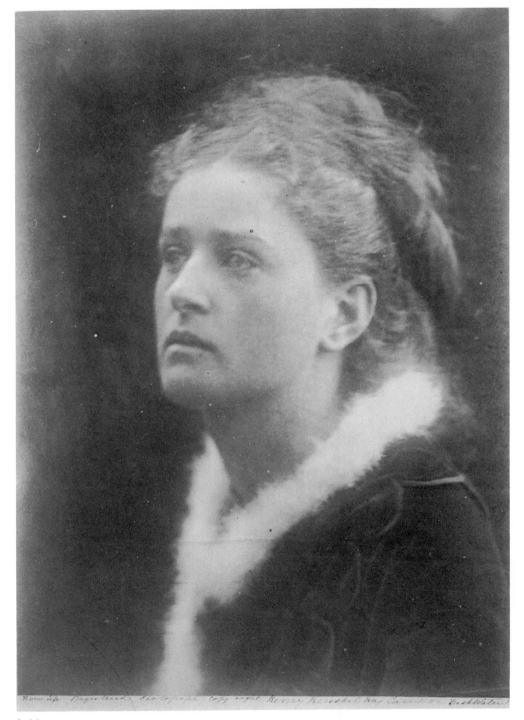

3·55

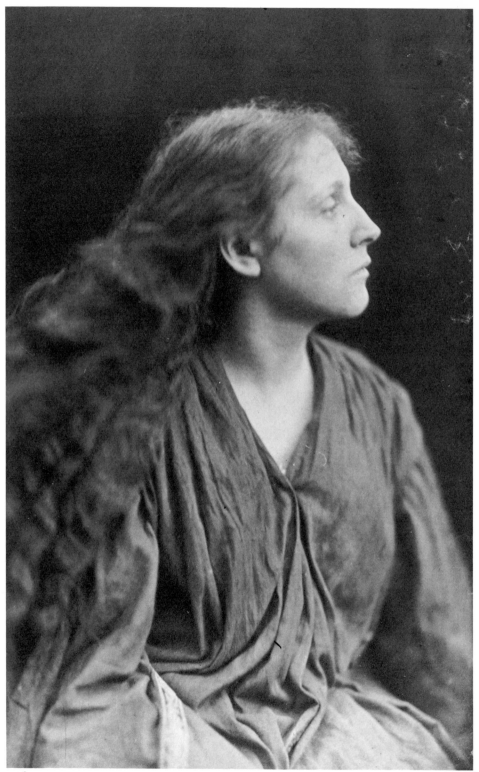

3.56

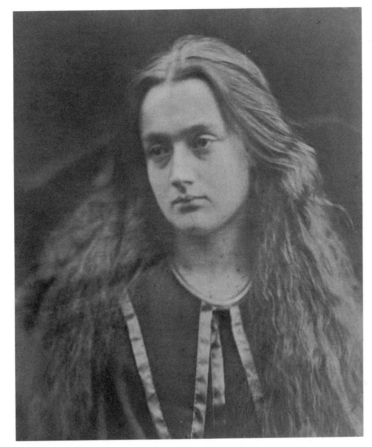

3.57

3.56
Mary/FreshWater 1873
(Royal Photographic
Society C2: 2560)

33.3 × 21.3
The Royal Photographic
Society (C13: 2208)
Alvin Langdon Coburn
Gift, 1930

3.57
*Mrs Ewen Hay Cameron/
FreshWater Nov 1869*

Colnaghi blind stamp
31 × 26
Lent by the Visitors of the
Ashmolean Museum,
Oxford

'A splendid head, full of
life.'

P. H. Emerson, *Sun Artists*,
41.

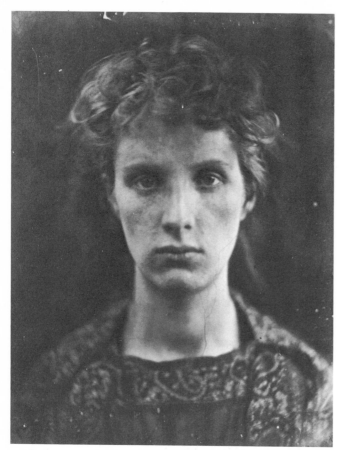

3.58

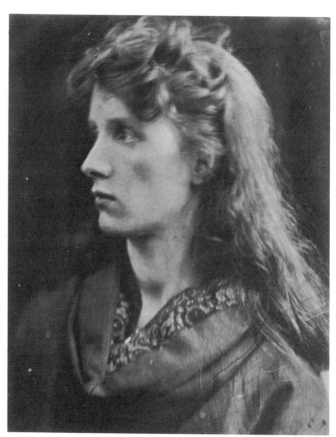

3.60
The Mountain Nymph Sweet Liberty
...from the once perfect now damaged negative
June, 1866 (Gernsheim 194)

Colnaghi blind stamp
36.5 × 28.6
The Royal Photographic Society (C19: 2315/3)
Alvin Langdon Coburn Gift, 1930

'Come, and trip it as you go,
On the light fantastic toe;
And in thy right hand lead with thee
The mountain nymph, sweet Liberty:'

John Milton, 'L'Allegro' 1632

'And Freedom rear'd in that august sunrise
Her beautiful bold brow.'

Alfred Tennyson, 'The Poet', *Poems.*

3.58
Cassiopeia/May 1866

35 × 27.5
Science Museum, London
(1955/71)

'Wife of Cepheus in
Aethiopia and mother of
Andromeda whose beauty
she extolled above that of
the Neriads. She was after-
wards placed among the
stars.'

Smith, *Classical Dictionary
of Greek and Roman Biography,*
153.

3.59
MOUNTAIN NYMPH –
PROFILE, 1866

Colnaghi blind stamp
27.5 × 22.5
The Royal Photographic
Society (C19: 2314)

3.59

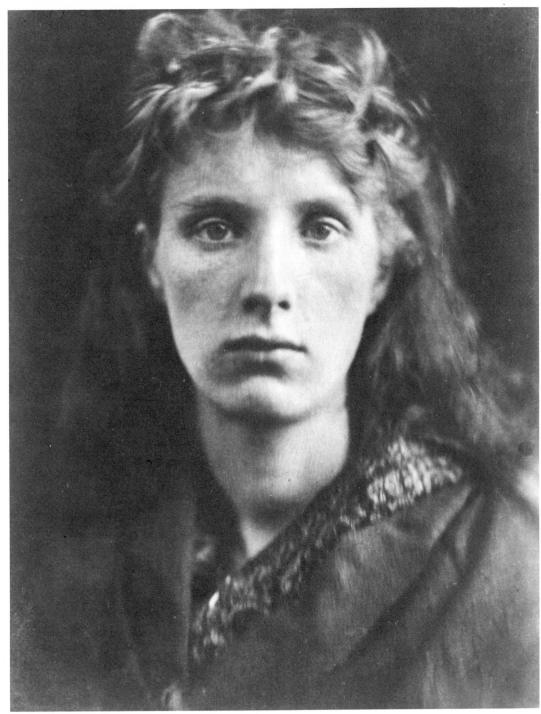

3.60

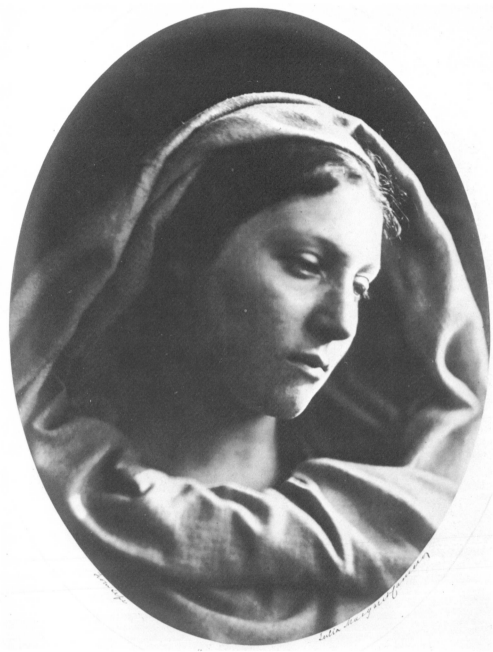

3.61

3.61
Mary Mother

Presented by Mrs Cameron thro' Dr Acland to the University Gallery, Oxford

c. 1866 (Mozley 34)

Oval, 34.9 × 27.1
Lent by the Visitors of the Ashmolean Museum, Oxford

A combination of the class of the Maria Vergine and the Mater Dolorosa: 'The features are properly those of a woman in middle age; but in later times the sentiment of beauty predominated over the mother's agony.'

Jameson, *Legends of the Madonna*, 36.

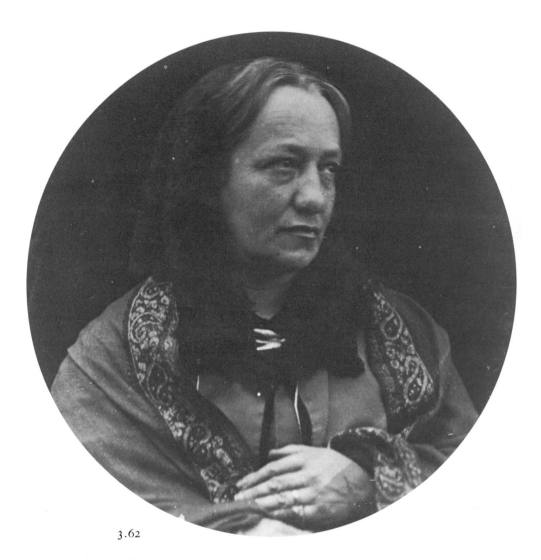

3.62

3.62
H. H. H. CAMERON
(1852–1911)
JULIA MARGARET CAMERON
1870 (cf. Gernsheim Pl. 172)

18.5 diam.
The Royal Photographic
Society (C2: 2557)

Henry Herschel Hay
Cameron (1852–1911) was
Cameron's youngest son.
Several of his photographs
are included in A. Thackeray,
*Alfred, Lord Tennyson and
his Friends. A series of 25
portraits*, London 1890.

The photographer of the sublime

In Tennyson's library at Lincoln the eight volumes of Edmund Burke's *Works* bear Charles Cameron's bookplate, and Tennyson's signature inside the cover of Volume I. This already tells a tale, but when we discover that Cameron followed Burke in writing on the Sublime and Beautiful in art and literature it becomes clear that the Camerons shared with the Taylors and the Tennysons a considerable knowledge of aesthetics. Charles Cameron in his treatise *An Essay on the Sublime and Beautiful* (1835),[60] deals with many of the issues which are fundamental to Mrs Cameron's attitude towards photography. Mr Cameron is working with Archibald Alison, Francis Hutcheson, and Dugald Stewart as his guides rather than Romantic aestheticians. If he played his part in the formation of his wife's sensibility – and surely a young wife with Julia Margaret's enthusiasm for the arts could not have failed to read her husband's treatise written just three years before they married – then it was the very earliest of Victorian sensibilities, one that came out of the eighteenth century. Beauty, Virtue, and the Passions are considered from that background. The relation of morality to art is implicit in the emphasis which Burke placed on the emotion of distress or, in its calmer state, sorrow. This tended to equate the sublime with the sorrowful aspect of sentimentalism. The way was open for a revival of Christian interpretations of the sublime. Mr Cameron, indeed, fastens on qualities of 'unconquerable fortitude' and 'tender remembrance' as types of the sublime and beautiful, respectively. But all 'tumult and agitation' must have passed and been replaced with 'perfect calmness'. It is only when the 'tranquil stage of sorrow' has arrived that the 'act of reflection' can take place. Reflection, making inward the cause in the object and the effect on the feelings, was a property of a mind which contemplated the beautiful and the sublime. Works of art, according to Mr Cameron, are 'effects of human feelings'. But the feelings work in two ways, one to bring to mind by an act of reflection, or imagination, the feelings of the subject of the work, and the other to evoke the 'genius and skill' of the author of the work, which produces the feelings in the first place. The concept of *genius* slowly replaced that of *wit* in the eighteenth century, a shift from judgement to imagination as a value in art. But, together with enthusiasm, energy, and force, genius implied a kind of knowledge less Baconian than 'living', as Taylor had called it. It seemed to Mr and Mrs Cameron that such knowledge was essentially tragic and that sorrowful feelings and the objects which produced them were beautiful – they accorded with Christian 'gentleness, purity and self-denial'. Yet these principles did not prevent them from acknowledging, in his words, erotic feeling:

There are also certain qualities of the human figure which naturally excite that very powerful emotion, the desire of sexual intercourse. These qualities, when unaccompanied by any of the other indications of sublime or beautiful feelings, constitute that very peculiar species of beauty . . . which is found, I think, no where but in the human form and countenance, and which extorts from men of a refined taste an unwilling admiration and reluctant homage.

In an earlier passage Mr Cameron made some important points with regard to taste in treating the human figure:

Perhaps the most beautiful object in nature is a beautiful human figure, although to every human figure belong disagreeable and humiliating incidents. But if an artist should venture to introduce any of these incidents in a work intended to excite sublime or beautiful emotions, the pleasure we might have derived from such parts of his work as were well adapted to the end in view would be, perhaps, totally destroyed by reflections upon the coarseness and indelicacy of that mind which could designedly unite such hateful incongruities; at any rate, would be much more impaired than the pleasure arising from a similar sublime or beautiful object in nature would be by the unfortunate presence of similar incongruities.

But he conceded, in offering examples of incongruity, or tastelessness in Rembrandt and Lucretius, that if the artist employed such elements for a purpose as opposed to simply imitating them from life they were aesthetically justifiable.

Imitation as *trompe l'oeil* ('the handle of a door of which I have seen an imitation in painting so perfect as, at first sight, to deceive the eye') he denied to be artistic on the grounds that it simply drew attention to the skill of the artist. Door-handles were neither sublime nor beautiful in themselves:

Now the introduction of such an imitation into a picture intended to excite powerful emotions – or even the application of that sort of skill which constitutes the beauty of such an object – to the delineation, in such a picture, of an object possessing beauty of a different order, would be a very considerable defect, because it would draw off the attention from the true object of the picture, and, by so doing, would also indicate that the artist was deficient in a sort of skill much nobler and more intellectual than that which he had injudiciously displayed. No man of taste can endure that his reflections upon the death of Cleopatra should be interrupted by the obtrusive accuracy with which the velvet or satin of her dress is depicted. The artist, therefore, who wishes to show how well he can represent satin and velvet with his pencil, should paint a silk mercer's window, but not a dying queen. For so doing he will have the high authority of Sir Joshua Reynolds.

In censuring illusionism he gave examples of what he approved of in theatre. A few unobtrusive trees or columns, and some simple, unspecific classical robes were all that was needed for tragedy: 'To dress Roman senators in the habit of the day, as our ancestors did, would be far more destructive of the true tragic enjoyment by its hideous incongruity, than the present practice is by its beauty and elaborate propriety.' Again, imitation of reality was 'obtrusive aptitude'. Illusionism was for melodrama, a popular art of a lower order.

Mr Cameron acknowledged the primacy of the eye among the organs of sense, but attributed its pre-eminence to touch:

It is by the sense of touch only that we at once acquire the notion of externality, and perceive external things. By the eye we perceive nothing but light, with its varieties of colour and intensity. Experience, however, very soon teaches us that many of these varieties represent the varieties belonging to objects of touch, and, as soon as this connexion between the two senses is once firmly established in our minds, we trust to our eyes to give us information in all ordinary cases, concerning the distances and figures of external objects; and the touch, which originally explained to us the meaning of the modifications of light, is neglected, like the Dictionary of a language with which it has made us familiar.

It was understandable, therefore, that (*pace* Bishop Berkeley) people thought the sublime and beautiful offered immediate, organic pleasure experienced through the eye without benefit of reflection, touch, and imagination. They forgot 'the medium of the understanding': 'A mere assemblage of images connected by no thread of meaning, although every image should be both beautiful and, as far as beauty is concerned, in harmony with all the other images of the assemblage, can never receive much admiration considered as a work of art.' Mr Cameron saw music and poetry as antithetical arts, and paid less attention to the visual arts. Music, he said, did not require 'distinct ideas' to the extent that poetry did; 'Every poem must contain throughout a train of thought addressed to the understanding, and separable from those characteristics which constitute it a

poem.' So he saw poetry as narrative, dramatic, and didactic in a way that music was not. Without referring to the visual arts directly, he discussed the figurative and metaphorical properties of language according to the well-established theory of the association of ideas:

Sounds become magnetised, as it were, by the habitual contact of pathetic ideas, and acquire to themselves that power of moving the passions which at first they could exercise only by means of ideas. The mere sound of the word 'spring' inspires 'vernal delight' – the mere sound of the word 'summer' sends 'a summer feeling to the heart'.

The visual arts, including photography, can be discussed in terms of the distinct and indistinct, clearness and obscurity.

The slur cast early on Cameron's work in terms of 'artistic ignorance' and 'slovenliness of execution' were misunderstandings of the intentions of her controlling hand and creative mind. She had good technical advice available to her. Rejlander was in London, 1862–9, and came to Freshwater Bay, and Jabez Hughes had a studio on the Isle of Wight while she worked there. Lewis Carroll came to Sheen to photograph the Taylor family and Ewen, Cameron's son, and later, when Cameron had taken up photography, she argued with him over the question of soft and hard focus: 'Hers are all taken purposely out of focus – some are very picturesque – some merely hideous – however, she talks of them as if they were triumphs of art. *She* wished she could have had some of *my* subjects to do *out* of focus – and *I* expressed an analogous wish with regards to some of *her* subjects.'[61]

Carroll acknowledged that her focusing was a conscious decision, but whether it was ever out of focus on purpose was disputed by her son Henry Herschel Hay: 'It is a mistake to suppose that my mother deliberately aimed at producing work slightly out of focus. What was looked for by her was to produce an artistic result, no matter by what means.' He went on to say that 'in photography, as in other art, the process is nothing, the final result everything'.[62] His father would have agreed. His mother rounded on her critics herself, defending 'that roundness and fullness of force and feature, that modelling of flesh and limb which the focus I use only can give though called and condemned as "*out of focus*". What is focus – and who has a right to say what focus is the legitimate focus.'[63] This was in 1864, at the beginning of her career. By 1868, Henry Peach Robinson was claiming this right, although an anonymous 'Lady Artist and Photographist' did try to hit back at him.[64]

This controversy was long-established. When John Ruskin characterized Millais and Turner as temperamentally inclined towards sharpness in Millais' case, and short-sightedness in Turner's, he was laying down the model for an argument between the nature of the daguerreotype versus the calotype. By the time Cameron had begun to use the collodion process developed by Scott Archer, Ruskin, who had favoured the hard-edge precision of the daguerreotype, told her in a letter that he had lost interest in photography.[65] He disliked the generalized impression that he thought the newer process offered, compared with the clarity of detail for which he prized the earlier one. His prejudice as a student of nature blinkered him to the possibilities of artistic effect in photography. Ruskin's approach to photography had been to use it as evidence from which to make drawings, whereas the calotypists, Hill and Adamson, had thought of their 'sketches' as drawings in their own right. Lady Eastlake disliked Ruskin for many reasons, but it was what she took to be his insistence on a quantity of information in a picture that offended her idea of pictorial value. With her concern for a quality of beauty, grace, or sweetness, the single, noble effect was what she looked for. She was against Ruskin's 'thought' in painting, which she considered acceptable enough in illustration, *genre*, and caricature, but not in High Art. Leaving out excessive detail, the isolation of the distinguishing feature of a subject, was absolutely necessary to achieve the noble effect. The sketch achieved its meaning by stopping short of completion; 'It

would be an interesting enquiry to ascertain how far two such opposite means as Rembrandt's shadow and Turner's light both conduced to the same end of concealment or subordination to a principal object.'[66]

Sir David Brewster, whose writings Cameron liked, agreed with Lady Eastlake. He wrote in 1867 to Antoine Claudet, 'I do not think *sharp definition* at all necessary; on the contrary, I think it is an evil.'[67] Ten years before, Eastlake had said that the early imperfections of the calotype had been truer to the way we experience the world. 'Mere broad light and shade . . . give artistic pleasure of a very high kind; it is only when greater precision and detail are superadded that the eye misses the further truths which should accompany the further finish.'[68] The burr, the blur, the impression of movement, were as important to him as to Eastlake and Sir William Newton, who also wrote against 'sharp articulation'.[69] They required of art that it should achieve effects of sublimity not naturalism, even though the photographic medium was inherently realistic. The row between Henry Peach Robinson and Julia Margaret Cameron should be seen in this context. The comprehension of her work by two later photographers, Peter Henry Emerson and Alvin Langdon Coburn, came from their understanding of photography as a graphic medium of expression rather than as an instrument inherently bound to realism. They were concerned more with mass than line, distance as an effect, softness as an inducement to feeling, and the rendering of fleeting effects in facial expression and in nature.

Emerson was the first to investigate her lenses, a Jamin and a Dallmeyer:

The 'Jamin' working at F/6 had no small diaphragms, abominations introduced later on by a scientist and invaluable to such an one, but utterly *useless* to the artist – nay fatal, as I have proved scientifically. In addition, though the image appeared sharp on the screen, owing to the positive chromatic aberration, the picture would be out of focus when taken. It was therefore *impossible* for Mrs Cameron to get what is technically known as the 'sharpest focus'. Still, having learnt from this experience, in after years she did not work with the sharpest focus obtainable with the Rapid Rectilinear Lens. Having produced out-of-focus results at first by accident, she was artist enough, and so well advised, that she determined to imitate that effect; a determination fulfilled later on when she became possessed of an 18 by 22 Dallmeyer Rapid Rectilinear Lens – one of the triumphs of Photographic Optics. She used this lens at large aperture, so that her son, an experienced photographer, says it is almost impossible to distinguish the pictures taken with the two instruments as regards the quality of focus – but this I think an error. All her work was taken direct, indeed she claimed that as a merit, and she was right. Enlargements, as I first pointed out, are false in many elemental qualities. Mrs Cameron gave very long exposures, ranging in duration from one to five minutes. This method was brought up against her as a matter for raillery by jealous craftsmen. Unable, with all their appliances, to produce work comparable to hers, the photographers of commerce sought every pretext to belittle her pictures, but all in vain, for many of them possess those undying qualities of art which artists immediately recognized, and after all it is in their hands that the final judgment in such matters rests. All that can be said against her is that she used too short a focus lens for her 15 by 12 plates.[70]

in British graphic art in the nineteenth century, with its special traditions of watercolour, mezzotint, and photogravure, Cameron found herself in the mainstream. The finest nineteenth century critic in that field, Philip Gilbert Hamerton, had no difficulty with her work. Hamerton considered photography, as generally practised, 'antagonistic to the artistic spirit'. Its literalness, its incapacity to select – what Charles Cameron had called 'obtrusive aptitude' – made it less than art:

The nearest approach to fine art yet made by photography has been in the remarkable photographs by Mrs Cameron which many readers will remember or possess. Mrs Cameron deflated the obtrusiveness of photographic detail by putting her subjects out of focus, which gave them a massive breadth not unlike the gloom and obscurity of some old pictures.[71]

An anonymous critic of Cameron's work, in a magazine which reproduced one of her photographs, also praised her breadth of effect:

The breadth, to use a technical word, which she gives to her subjects is of a character that may even be called grand. The unnatural depth of the shadow on the upper lip is disguised by the softness of its outline . . . With this quality of breadth is united a wonderful richness of chiaroscuro. The great error and ignorance of the modern pre-Raffaelites in this country, the absence of aerial perspective, cannot be committed by nature. On the contrary, the effect of atmosphere is here exaggerated, but exaggerated with the happiest effect. The purity, depth, and variety of the half tones in the print before us are such as almost to drive an artist, if he should seek to imitate them, to despair. [72]

Cameron perceived that photography could compete less well with painting than with sculpture or low-relief. Her own emphasis on roundness and modelling of flesh suggests she aspired to make more nude studies beyond those of her child models and occasionally less than fully-draped Madonnas. The *Madonna lactans* was not allowable to her, let alone the male or female nude. But the softness of her outlines, the sheen of her surfaces, the modelling of her draperies, and the way her subjects thrust forward, detaching themselves from their backgrounds, suggest a comparison with the work of the sculptors John Gibson and Thomas Woolner in this period of the fame of the Elgin Marbles. Her sense of touch, as Mr Cameron had described it, was highly developed in relation to her eye.

So far as Hamerton was concerned, there had never been anything like these photographs before, even if there were objections against photography in comparison with drawing, 'an objection which far outweighs all the others, and that is the necessity for an actually existing model. You cannot photograph an intention, whilst you *can* draw an intention.'[73] Cameron, however, did photograph intentions and Hamerton may well have excepted her from his rule. It was true that the millions of

cabinet photographs of the day photographed conventions rather than intentions.

The prejudice against the lens continues to this day. It is devoid of soul, of feeling, of penetration, so the argument runs. Cameron's portraits must lose to Watts', even though they have far more in common with his method than not. Both Watts and Cameron were artists who took Titian, Tintoretto, and Rembrandt as models, and who worked against the Pre-Raphaelite tendency towards realism and finish. Both were committed to their sitters at a personal level which was neither commercial nor professional but truly amateur. John Forbes White, the Scottish photographer and critic, distinguished between hack portrait painting and that of Watts: 'Take the portrait of Tennyson, and compare it with any of the well-known photographs of the poet. How soulless are these latter beside the work of Watts, into which, while preserving an excellent likeness, the artist has infused something of the intellect of Shakespeare, and the dignity (we say it with reverence) of the representations, as given by some of the old masters, of our Lord.'[74] He clearly recognized the spiritual intention in Watts. We can see it in Cameron, too.

Lady Eastlake knew that historic interest was not enough to make portrait photography an art. Sir David Brewster knew absolute truth would not do. What Eastlake called facial maps, and what Cameron called map-making, was not art. Sir Henry Taylor, quoting his own diary of more than forty years before, remembered Coleridge saying, 'the contour of the face should be an act of the face, and not something suffered by the face'.[75]

Anna Jameson, whose father was a miniature-painter, complained that the daguerrotype infringed a basic law: 'Every object that we behold we see not with the eye only, but with the soul; and this is especially true of the human countenance, which in so far as it is the expression of mind we see through the medium of our own individual mind.'[76] Frederick Scott Archer, the English inventor of the collodion process,

despaired of achieving a synthesis of the varied expressions discernible in a sitter's face. Yet Cameron, by rejecting hard finish and obtrusive detail, by suppressing irrelevancies and unimportant information, managed to achieve the quality which Lady Eastlake praised in Rembrandt as a religious painter – the Rembrandt, 'who transfigures vulgar forms with a glory that hides every blemish'.[77] Watts had no trouble appreciating her work, but perhaps that was because his definition, 'Art is poetry manifested by science',[78] allowed the possibility of photographic as well as graphic science. He was in perfect agreement with the Camerons that high art required 'a noble theme treated in a noble manner, awakening our best and most reverential feelings, touching our generosity, our tenderness, or disposing us generally to seriousness'. The difference between Fine Art and High Art, according to the period, was that High Art was directed to moral ends, whereas Fine Art took no special account of the moral dimension of art. Watts believed that Turner's art had to be put on a lower level than Michelangelo's and Raphael's because as landscape it lacked the direct appeal of the human figure to human sympathies.

George Eliot, the great novelist, continually expressed her misgivings about photographic portraiture throughout Cameron's career: 'Women are seldom represented at all fairly by photographs',[79] a sentence echoing down the years since 1861. 'I always feel that I have to interpret a photograph, as a foreign language into which I must read more than it can directly express for me'[80] – a reversal of the common aphorism about one picture being worth a thousand words. She also complained about Mayall's photographs:

My inward representation even of comparatively indifferent faces is so vivid as to make portraits of them unsatisfactory to me. And I am bitterly repenting now that I was led into buying Mayall's enlarged copy of the photograph you mention. It is smoothed down and altered, and each time I look at it I feel its unlikeness more. *Himself as he was* is what I see inwardly, and I am

afraid of outward images lest they should corrupt the inward.[81]

It is extremely interesting to compare the Mayall portraits of Tennyson, bolt-upright in profile, with one of him wearing similar day-dress by Cameron, a half-profile (no. 3.10); and to compare both with another that Cameron took of him on the very same day as her Mayall-style picture, 3 June 1869, the picture which Tennyson called 'The Dirty Monk' (no. 3.9). The portrait style of Mayall is rigid, conventional, artificial, yet Tennyson preferred it. Cameron's is genial, elevated, and sublime in intention. Tennyson, seeing himself represented as an illustration, perhaps, to one of Jameson's *Legends of the Monastic Orders* (1850), mocked himself in order to preserve his modesty.

Consider, finally, this quotation, possibly about Carlyle, from Jameson's *Commonplace Book*:

A profound intellect is even livened and narrowed in general power and influence by a limited range of sympathies. I think this is especially true of C—: excellent, honest, gifted as he is, he does not do half the good he might do, because his sympathies are so confined. And then he wants gentleness: he does not seem to acknowledge that 'the wisdom that is from above is *gentle*'. He is a man who carries his bright intellect as a light in a dark-lantern; he sees only the objects on which he choses to throw that blaze of light: those he sees vividly, but, as it were, exclusively. All other things, though lying near, are dark, because perversely he *will* not throw the light of his mind upon them.[82]

Put it beside Cameron's portraits of Carlyle (nos. 3.21, 3.22) and recognize that his head is, indeed, a lantern, limited in its throw but terrifically impressive. It is as if Julia Margaret Cameron photographed Jameson's characterisation. The burr on the image evokes the voice of a man luminescent in his thought and lantern-jawed in his Scottish ruggedness. The author of *Heroes and Hero-Worship* found his apotheosis under the hand and eye of the photographer of the sublime.

Notes and acknowledgements

The contribution of women artists and critics to photography has been outstanding in relation to their position in the other arts except, perhaps, literature. Photography is a Cinderella art in more senses than one. It is to these women in general, and to Sara Selwood in particular, that I gratefully inscribe this essay.

1. Letter from J. M. Cameron to Sir Henry Taylor, 1 July 1876 (Bodleian Library, Oxford).

2. C. & F. Brookfield, *Mrs Brookfield and Her Circle*, London 1905, 2 vols, II: 515.

3. Richard Henry Smith, Jr. *Expositions of the Cartoons of Raphael, illustrated by photographs printed by Negretti & Zambra*, London 1860, vi.

4. Anna Jameson, *Sacred and Legendary Art*, five editions in two volumes between 1848–66, edition cited here is the ninth edition, London 1883, I: vii.

5. *Recollections of Aubrey de Vere*, London 1897, 156.

6. Tina Olivia Ledger, 'A Study of the Arundel Society', 1848–97. This is a fine doctoral thesis of 1978 (Bodleian Library, Oxford, *Ms. D. Phil c 2873, 4*), to which I am much indebted.

7. A. H. Layard, 'Publications of the Arundel Society: Fresco Painting', *Quarterly Review* CIV (October 1858), 277–325.

8. *Recollections of the Table-Talk of Samuel Rogers*, ed. Morchard Bishop, London 1952, 109–10.

9. Herschel's reply, printed in Colin Ford, *The Cameron Collection*, London and New York 1975, 142, refers to this then anonymous work. The illegible word may now be filled in from Chapter XXI 'The Law of Resentment'. The controversy aroused at the time produced three essays by W. E. Gladstone, with illustrations by John Leighton, in *Good Words*, 1 January, 1 February, 1 March, 1868. The reference to *Man and his Dwelling* is to a work by James Hinton, London 1859.

10. 'Veri Vindex' (J. F. White and Sir George Reid), *Thoughts on Art, and Notes on the Exhibition of the Royal Scottish Academy of 1868*, Edinburgh 1868, 76–7.

11. (Coventry Patmore), 'Mrs Cameron's Photographs', *Macmillan's Magazine* XIII (1866), 231. Attributed to Patmore in the *Wellesley Index to Victorian Periodicals*.

12. References sprinkled throughout this essay to books found in Tennyson's library, inscribed to him by Cameron, come from *Tennyson in Lincoln: A Catalogue of the Collections in the Research Centre*, compiled by Nancie Campbell, Lincoln 1971.

13. Sir Charles Eastlake, *Contributions to the Literature of the Fine Arts*, London 1848, 18–19.

14. W. M. Rossetti, *Fine Art, Chiefly Contemporary*, London 1867, 41, 43, 45.

15. On the print at George Eastman House, Rochester, NY.

16. Charles Hay Cameron, *Two Essays*, London: privately printed 1835, 'An Essay on the Sublime and Beautiful', and 'The British Code of Duel', 46.

17. *Ibid.*, 42.

18. Anna Jameson (completed by Lady Eastlake), *The History of Our Lord*, London 1864, 2 vols, I: 288–9.

19. *Op. cit.*, II: 379–80.

20. On the print at George Eastman House.

21. Layard, *Quarterly Review* CIV (October 1858), 287.

22. Charles Dickens, 'Beautiful Girls', *All the Year Round* XV (12 August 1865), 60–5.

23. Jameson, *Sacred and Legendary Art*, I: 343.

24. Letter from Julia Margaret Cameron to Sir John Herschel, 31 December 1864, printed in Ford, *The Cameron Collection*, 140.

25. Jameson (and Eastlake), *History of Our Lord* I: 9.

26. Charles Dickens, 'Book Illustration', *All the Year Round* XVII (10 August 1867), 151.

27. *The Works of George Eliot, Volume I: Adam Bede*, Standard edition (Blackwood), n.d., 270.

28. *Letters of Dante Gabriel Rossetti*, eds. O. Doughty and J. R. Wahl, Oxford 1965, 4 vols, I: 223.

29. *The George Eliot Letters*, ed. Gordon S. Haight, London and New Haven 1978, 9 vols, IV: 55.

30. Letter from Julia Margaret Cameron to Francis Fox, 15 December 1874, tucked into the back cover of the Metropolitan Museum, New York's copy of her *Idylls of the King*, Part One.

31. *Tennyson and His Friends*, ed. Hallam, Lord Tennyson, London 1911, 498.

32. George Birkbeck Hall, *Letters of Dante G. Rossetti to William Allingham 1854–70*, London 1897, 97–8.

33. *William Holman Hunt*, an Exhibition arranged by the Walker Art Gallery, Liverpool 1969, 62.

34. W. M. Rossetti, *op.cit.*, 259.

35. George du Maurier, 'The Illustrating of Books' (1), *The Magazine of Art*, August 1890, 352.

36. C. H. Cameron, *Two Essays*, 28–9.

37. *A Victorian Album*, ed. Graham Ovenden, London 1975, 110, where the image is not identified.

38. Jameson (and Eastlake), *The History of Our Lord*, II: 232.

39. Thomas Carlyle, *Heroes and Hero-Worship and the Heroic in History*, 'Lecture III. The Hero as Poet. Dante; Shakespeare, Tuesday, 12 May, 1840', London 1840.

40. J. M. Cameron to F. G. Stephens, 9 April 1862, (Bodleian Library, Oxford). Holman Hunt was also invited.

41. *The Works of Sir Henry Taylor : Notes from Life; The Statesman*, London 1877–8, 5 vols, IV: 138.

42. Letter from J. M. Cameron to Sir Henry Taylor, 8 March 1875 (Bodleian Library, Oxford, *Ms. Eng. Lett. d 12 fols. 396–7*).

43. *The Works of Sir Henry Taylor, Review of John Stuart Mill's Work on 'The Subjection of Women'*, first published February 1870, V: 281–304.

44. Una Taylor, *Guests and Memories*, London 1924, 229.

45. *Works of Sir Henry Taylor*, IV: 76.

46. *The Colebrooke-Cameron Papers*, ed. G. C. Mendis, London 1956, 2 vols, I: 121–89, for 'Report of Charles H. Cameron, Esq. upon the Judicial Establishments and Procedure in Ceylon'.

47. Thanks to David Wooters for this information, and to Joanne Lukitsh; and to my other friends at George Eastman House.

48. Charles Hay Cameron, *An Address to Parliament on the duties of Great Britain to India in respect of the education of the natives and their official employment*, London 1853, 3, 20, 31, 39.

49. *Sir John Herschel and Education at the Cape, 1834–40*, ed. W. T. Ferguson and R. F. M. Immelman, Cape Town 1961, 42.

50. Jameson (and Eastlake), *History of Our Lord*, I: 201.

51. *Ibid.*, 255.

52. Jameson, *Sacred and Legendary Art*, I: 40.

53. Anna Jameson, *A Commonplace Book of Thoughts, Memories, and Fancies*, London 1854, 164.

54. Anna Jameson, *Characteristics of Women*, London 1858, 2 vols, II: 117.

55. Jameson, *A Commonplace Book*, 365.

56. Jameson (and Eastlake), *History of Our Lord*, I: 251.

57. *Ibid.*, I: 255–6.

58. Letter from J. M. Cameron to Sir Henry Taylor, 1 July 1875 (Bodleian Library, Oxford, *Ms. Eng. Lett. d 13 fol. 81*).

59. Ellen C. Clayton, *English Female Artists*, London 1876, 2 vols, II: 135–7.

60. C. H. Cameron, *Two Essays*. The quotations which follow are, perhaps, too numerous to cite. The reader is referred to the copies of this 64-page essay in the Bodleian and British Libraries.

61. Helmut Gernsheim, *Lewis Carroll, Photographer*, London and New York 1969, 60.

62. Marie A. Belloc, 'Interview with Mr H. Hay Herschel Cameron', *The Woman at Home*, IV (1896–7), 586.

63. Letter to Sir John Herschel cited in Ford, *The Cameron Collection*, 141.

64. This 'lady artist and photographist' can be found in the correspondence column of *The Illustrated Photographer*, I (25 September 1868), 418–19.

65. *The Works of John Ruskin*, eds. E. T. Cook and Alexander Wedderburn, London 1912, 39 vols, XXXVII: 734.

66. Lady Eastlake, Review of *Modern Painters* by Ruskin, *Quarterly Review* XCVIII (March 1856), 412.

67. Letter cited in *Photographic News,* 14 August 1868, 387.

68. Lady Eastlake, 'Photography', *Quarterly Review,* CI (April 1857), 460.

69. Sir William J. Newton, 'Upon Photography in an Artistic View', *Journal of the Photographic Society* I (1853), 6–7.

70. P. H. Emerson, 'Mrs Julia Margaret Cameron', *Sun Artists* 5 (1890), 37. The argument about 'diffusion of focus' had raged in *The British Journal of Photography* throughout the last half of 1866, culminating in the announcement of Dallmeyer's new portrait lens, 21 December 1866, which offered a wide range of definition.

71. P. G. Hamerton, *Thoughts about Art*, London 1875, 64–5.

72. Anon. (possibly G. Wharton Simpson), 'Studies from Life by Mrs Cameron', *Art Pictorial and Industrial* III, January–June 1872, 25–6.

73. P. G. Hamerton, *The Graphic Arts*, London 1882, 9.

74. 'Veri Vindex' (J. F. White), *Thoughts on Art,* 64.

75. Sir Henry Taylor's diary, 24 February 1824, cited by him in a review of Carlyle's *Reminiscences, Nineteenth Century* IX (June 1881), 1013.

76. Jameson, *A Commonplace Book, II.*

77. Eastlake contribution to Jameson, *History of Our Lord*, I: 3.

78, Mary Seton Watts, *George Frederick Watts,* London 1912, 3 vols, III: 165, 188.

79. *The George Eliot Letters*, III: 449.

80. *Ibid.*, VII: 213.

81. *Ibid.,* VII: 233.

82. Jameson, *A Commonplace Book,* 316–317.

Selected writings
by Julia Margaret Cameron

Leonora

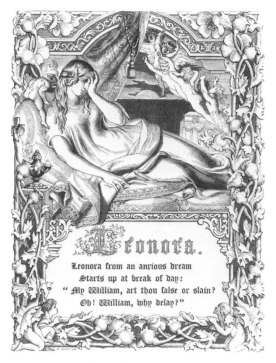

Leonora from an anxious dream
Starts up at break of day:
" My William, art thou false or slain?
Oh! William, why delay?"

vi. & vii. Steel engravings from
illustrations by Daniel Maclise, 1847.
(Bodleian Library, Oxford)

i

Leonora from an anxious dream
 Starts up at break of day:
'My William, art thou false or slain?
 Oh! William, why delay?'

ii

With Frederick's host to battle-field
 Her lover had been led;
No tidings came, no line disclosed
 If he were false or dead.

iii

The Empress and the King no more
 Engage in bloody feud;
They've signed a covenant of peace,
 With hearts now turned to good.

iv

And marching home with shout and song,
 Bedecked with laurels green,
With kettle drums and kling and klang,
 The joyous troops are seen.

v

Whilst old and young o'er path and plain
 Go forth the host to meet,
Shouting their joyous jubilee
 The comers home to greet.

vi

'The work of strife at last is done,
 Praise God!' said many a bride:
'Welcome! loved comers from the '
 Parents and children cried.

vii

But why stands Leonora there
 Alone, amongst the rest?
Whilst all embrace, to her pale lip
 No loving lip is prest.

viii

She hurriedly, now up now down,
 Questions the host in vain;
No one can tell, no one can say,
 Was William false, or slain.

ix

They have passed on, the warrior host;
 And wild is her despair;
Upon the earth she madly rolls,
 And tears her raven hair.

x

The mother to her comfort flies:
 'Oh! why this grief so wild?'
She clasps her daughter in her arms,
 And cries 'God calm my child!'

xi

'Oh! mother, mother, lost is lost!
 Ruthless is God's decree;
I bid farewell to earth and heaven;
 Oh, woe! woe is me!'

xii

'Oh! God is love, in him put trust,
 Thy Paternoster say:
All that God doth is wisely done;
 Have faith, my child, and pray.'

xiii

'Oh! mother, God hath not well done;
 Your words are idle, vain;
I've prayed in vain, what use to pray
 Now my poor William's slain!'

xiv

'Oh! help, God help, my darling child!
 The sacrament receive;
This holy rite thy grief will soothe;
 God helps those who believe.'

xv

'Oh! mother, for my bitter woe
 No rite can solace give;
Can sacrament restore the dead,
 And make my William live?'

xvi

'Hark! child: perchance he's false, not dead,
 Thy tears they flow in vain;
False are his vows, his perjured heart
 Cast back to him again.'

xvii

'Away from thee, in Hungary
 Another hath he wed;
Much his false vow shall profit him,
 He'll burn for it when dead.'

xviii

'Oh! mother, mother, lost is lost!
 Forlorn is still forlorn;
Death now is all I hope or seek,
 Would God I'd ne'er been born!

xix

'For ever quenched he life's faint spark!
 To me no mercy's given:
Come death! I seek, in its dark gloom,
 Nor life, nor hope, nor heaven.'

xx

'Oh! spare, God spare! her heart is torn;
 Pity my erring child!
Judge not her words, for reason's gone;
 Oh! be in mercy mild!

xxi

'Be calm, my child, forget thy woe,
 And think of God and heaven;
God, thy Redeemer, hath to thee
 Himself for bridegroom given.'

xxii

'Oh! mother, mother, what is heaven?
 Oh! mother, what is hell?
To be with William, that's my heaven;
 Without him, that's my hell.

xxiii

'Come death! come death! I loathe my life;
 All hope is in death's gloom.
My William's gone, what's left on earth?
 Would I were in his tomb!'

xxiv

The sun hath set with golden light,
 The stars illume the skies;
All nature's sunk in sweet repose,
 Leonora only sighs.

xxv

For her there is no blessed rest,
 She cannot 'kiss the rod;'
But wrings her hands, and beats her breast,
 And raves against her God.

xxvi

When hark! a sound, a tramp tramp tramp,
 A sound from horse's hoof;
A knight dismounts, with jingling spur,
 And stands beneath the roof.

xxvii

Now kling kling kling, the door bells ring;
 She, anxious, bends to hear
The well loved voice — yes, that it is
 Which sounds upon her ear.

xxviii

'Holla, my love! Leonora, rise!
 Art watching, or art sleeping?
Art loving me with constant soul?
 Art glad, my love, or weeping?'

xxix

'My William, thou? and riding too?
 From where so late by night?
Since dawn I've watched and waited and wept;
 My poor heart's broken quite.'

xxx

'From far Bohemia's land I come,
 I only ride by night,
And with thee thither must return
 Ere dawn of morning light.'

xxxi

'Oh! William, first come in; come close;
 Round thee my arms I'll fold;
Through hawthorn hear the whistling wind;
 Come close, heart's love, thou'rt cold.'

xxxii

'Heed not the whistling wind; my steed
 Doth paw, his mane doth bristle;
I must not here delay, my child;
 Let whistle wind, let whistle.

xxxiii

'Up! up! dress, spring behind me, mount,
 Our course be quickly sped;
Ere morn a hundred miles we ride,
 To reach the bridal bed.'

xxxiv

'Oh! William, say not so; just hark!
 The clock now chimes eleven;
A hundred miles we cannot go,
 So cold, so dark the heaven.'

xxxv

'See here! see here! the moon shines clear,
 We and the dead ride fast;
I promise thee to bridal bed
 To bring ere night hath past.'

xxxvi

'Say on; the bridal bed where is't?
 And where thy nuptial hall?'
'Six boards and two short planks our bed,
 Far, far, still, cool, and small.'

xxxvii

'Hast room for me?' 'For thee and me.
 Come, dress, and mount, and ride;
The nuptial guests impatient wait,
 The door stands open wide.'

xxxviii

The loving Leonora starts,
 She springs upon his steed,
Close round him clasps her lily hands,
 And forward on they speed.

xxxix

And now, hurrah! tramp tramp, the horse
 Snorting pursues his fiery course;
With showers of sparks the shattered flint
 Returns the horse-shoe's iron dint.

xl

And see, to left, to right, with speed
 Fly past them hamlet, town, and mead;
They pass heath, valley, mountain ridge,
 And thundering cross o'er many a bridge.

xli

'Fearest thou, sweet love? the moon shines clear,
 The dead they ride in full career.
Dost fear, sweet love?' 'Oh! no, ' she said;
 'But why, my William, name the dead?'

xlii

Hark! why that sound? who, solemn, sing?
 Why dismal flaps the raven's wing?
A funeral chaunt arrests the ear,
 Here comes a hearse, there moves a bier.

xliii

Now nearer draws the funeral train,
 Like croak of frogs resounds the strain.
Why tolls the bell? who, solemn, say
 'Dust unto dust, and clay to clay?'

xliv

'Follow me; follow, train and Priest;
 Come, follow to the nuptial feast.
We want you there; and at midnight
 You may resume your funeral rite.

xlv

'Come, Choir and Sacristan, along;
 Follow, and chaunt our bridal song.
Come, Priest; and be thy blessing said,
 Ere we do lie on bridal bed.'

xlvi

Vanished the hearse and ceased the song,
 And at his word they rush along;
With whirr whirr whirr, the funeral train
 Close in his track all panting strain.

xlvii

And still, hurrah! tramp tramp, the horse
 Snorting pursues his fiery course;
With showers of sparks the shattered flint
 Returns the horse-shoe's iron dint.

xlviii

Fast flew to left, fast flew to right,
 Each object as it came in sight;
The mountains, bushes, hedges flew,
 All mingled in the hurried view.

xlix

'Dost fear, sweet love? the moon shines clear,
 The dead they ride in full career.
Dost fear, my child?' 'Oh! no,' she said:
 'But why not leave in peace the dead?'

l

See here! see there! a ghastly sight
 But dimly seen by pale moonlight,
A felon to the wheel is bound,
 An airy rabble dance around.

li

'Ho, Rabble, here! with me advance;
 Come dance for us the nuptial dance;
Close in our flying footsteps tread,
 Till we do mount the bridal bed.'

lii

And true enough; for, hoosh hoosh hoosh,
 As if a gust in hazel bush
Through withered leaves and branches blew,
 Rustling was heard this airy crew.

liii

Still faster now, tramp tramp, the horse
 Snorting pursues his fiery course;
With showers of sparks the shattered flint
 Returns the horse-shoe's iron dint.

liv

The moon-lit scene, so fast it flew,
 All nature seemed beneath their view
On every side to fly, and far
 Above their heads flew moon and star.

lv

'Dost fear, sweet love? the moon shines clear,
 The dead they ride in full career.
My love, dost fear?' 'Oh! no,' she said;
 'But why not leave in peace the dead?'

lvi

'Haste! haste! The cock crows, night is worn;
 I smell the freshening breeze of morn;
Our sand is run, and done our course,
 Strain every nerve, my raven horse.'

lvii

'Hurrah! hurrah! the dead ride fast,
 Hurrah! hurrah! we're here at last;
The nuptial bed is open wide,
 We've reached it now, my lovely bride.'

lviii

At utmost speed he rushes straight,
 With loose rein, on an iron gate;
Its beauty folds, with crash of thunder,
 And bars and bolts are burst asunder.

lix

And onward still the furious horse,
 Trampling o'er graves, pursues his course;
In the pale moonlight, all around,
 White tombstones glimmer on the ground.

lx

Now see! now see! Where is the knight?
 What is this horrid ghastly sight?
All shivering falls the warrior's steel,
 A skeleton from head to heel!

lxi

And as his flesh, so doth his hair,
 All mouldering, leave a death skull bare;
His bony fingers, lean and lithe,
 Clasp round an hourglass and a scythe.

lxii

Now reared the horse, while sparks and flame
 From his spread nostril flashing came.
He sinks! the earth doth open yawn!
 Leonora's left! the horse is gone!

lxiii

The heavens with yelling cries resound,
 And earth's deep bosom groans around;
Leonora's heart, amidst the strife,
 Doth aching beat 'twixt death and life:

lxiv

Whilst round and round, with airy prance,
 The ghosts enchained in circle dance;
And, as they dance, they slowly groan
 These solemn words with solemn tone:

lxv

'Endure! endure! though break the heart,
 Yet judge not God's decree.
Thy body from thy soul both part,
 Oh! may God pardon thee!'

Gottfried August Bürger, *Leonora*. Translated
by Julia Margaret Cameron, with illustrations
by Daniel Maclise, London 1847

151

Dearest Halford

Ashburton Cottage,
Putney Heath,
SW0.

Ap. 5th 59 –

Dearest Halford

I have been longing to write to you all these past days yet my heart has kept uttering to itself 'What can I who have never yet been called upon to part with a precious child say to him who has been called upon to part with so precious and so perfect a child. His only Child too – his one little Ewe Lamb the light and life of his Soul—'

One thing I can most confidently say dear Halford that that same Child is now more than ever, & will be so to all eternity more than ever the Light and Life of your Soul.

Oh let that Light shine upon you through sepulchral darkness – his little Grave seems to me transparent with Eternal Light & lined with Eternal Love. Oh let that Love mingle with the Heavenly Love that gave and that has now with equal Love taken away – altho' the mystery of this dispensation may stagger you now – it is so heavy and so *seemingly* crushing a blow in its first weighty fall—

Sweet little one – ! might we not all have seen that it had an angel's soul already blessed – I was always struck with the majesty of that child-beauty — I did not then read the meaning of it as now I do – & yet I felt all its preciousness to you in unfolding the many mysteries of Earth — of Baby Life – of Parent Life – and Parent Love – of innocence – mysteries your beautiful & ardently impressible nature loved to dwell upon, but that was a part only — and a very small part of its relations with you — The mysteries of Heaven it had to teach unto you, thro' the memories of the sacred kisses, your hand, and your foot can never forget — for I know his sweet habits and ways of caress — its life of fruitful love.

That life is not over – it is & will be more fruitful than ever – bearing fruit that will never turn to ashes, as has seemed to perish this first fair fruit of your body — The shell will perish – the corruptible part you consigned to its little mossy bed last Saturday – & I know the agony of that consignment, but your Child is less dead now than when in full health on Earth — Then it was surrounded by mortal influences, and had it continued on Earth its immortal nature might have been *dimmed* and *obscured* by sin – by assault by temptation — now it lives in its own native air of Heaven in bright realms where it will watch over you, and pray for you, and see and feel those tears you all three (Parents and Grand Parent) shed daily for its long absence and your utter loss of present bliss —

Having winged away its flight to a Kingdom of Eternal peace, and unfading light it will eternally beseech God that that Light may shine with full force of Love upon you, and when your own hour comes dear Halford and in a little *twinkling of time* this last hour will come to every one of us – you will hear your Child's voice once again even as you heard his last words calling you & you will say 'I come' if you have been enabled thro' this passage of darkness to feel the way to him and to Eternal life, and you will then feel I die more in peace than if I left him on this busy stage of life struggling — it is well — and even now at this present dreadful moment of visitation you *must* say to yourself It is some comfort that my Boy can *never* endure the agony I am enduring now –

The cup of which I now drink these bitter dregs he can never *taste*.

Sweet little Lamb – one brief period of bright life he had and then, oh you must feel sure of this, he was called to the service of Heaven – and to you the blessed company of Angels –

I have often felt that it was no small destiny if that is the word – no small reward or solace – rather, to have yielded to God an unspotted Angel and to feel for ever that so large a portion of one's life already lives eternally in Heaven.

I am thankful that I saw what that blessed little one was to you – altho' this makes me share your present pain more vividly. Ah me! if when I parted with my little Juley on a sea voyage her empty garments were more than I could bear to see, can I not understand what is and will be for ever your aching memory — and ever increasing blank —

I don't think Time softens these losses— I am not tempted to offer to you meaningless consolation – but I know out of my own heart what *does* console – what *does* inspire – what does more than reconcile one so bereaved – and *it is* this only certain truth that your child is not dead— Lost to sight for a little time –

'Heaviness endureth for a night but joy cometh in the Moil –' you will never see him a full grown man on Earth – you will meet him a full grown Angel in Heaven if you will turn your full face of Love towards him even as you always turned it when you heard his soft pattering footstep and felt his soft balmy breath and if you will now let those little hands that still belong to you help, by God's bidding to open to you the golden gates of Eternal Life wide— wide so that you his Father may like a King of Glory enter in & be at rest and wear the crown of righteousness and redemption.

Every time you think of that child it will be a prayer – every thought is a prayer— link prayer to prayer (with him) till prayer becomes yr. Life with him – till Baby utterances have eternal meaning and he teaches you as you used to teach him – because he has been the first perfected to that perfectness you are both born unto – and both will attain for God so loved you most tenderly to give you that precious Child and still more tenderly did he love you when he removed it for a season to draw you all the nearer to Him and Heaven— I believe all these things most deeply— More shame to me that I often in conduct wander from the rooted belief I have – but God knows I believe it – and God knows that at every conception as at every birth I prayed ardently for life eternal for my offspring and every daily event that befalls every precious child I have felt equally that they belong to God – and that I at best can do but little for them if unaided by His mighty Power.

I have often lately wondered why I held this present life so dear a thing for them & even now if I did not pray perpetually that they might be granted strength & faith to weather the storms of temptation and of trial I should I am quite sure suffer as much in having, as you have suffered in losing a Child & who knows what is reserved to a Parent who has children living of suffering for them and in them – & with them yet I believe all is finally blessed so long as we commend all to God.

It is because I *love* you dear Halford and reverence you and honour you that I write thus in confidence to you giving you the best of my Love the undying and unfading side of our poor beating breaking bereaved hearts – We all have our losses & cares – those of Earth weigh us down – those in Heaven will lift us up with Angels Wings and bear us on high – above the storm. Your Babe was like a Cherub & Seraph Babe – We did not see his Angel Wings but they were there and now the divine Energies & Offices of Heaven are upon him and he is strong eno' to help you upwards all those who so devotedly loved him and so deeply grieve for him –

His sweet mother & my best beloved Mia know what I feel with my Mother Heart –

May God restore their strength which is at a low ebb with both I too well know.

Yours in perfect sympathy pity – tenderness and sadness of love

Julia Margaret Cameron

A letter from Julia Margaret Cameron to H. H. Vaughan, 5 April 1859, published by permission of the Bodleian Library, Oxford (*Ms. Eng. Lett. c 457, Fols. 64–73*)

On receiving a copy of Arthur Clough's poems at FreshWater Bay

But eighteen months ago – and here he stood
Warm as the summer air in fullest June
Pouring all learning like a golden flood –
Now — all is vanished – too soon – too soon –

Who has not marked, who ever saw him oft –
The music of his sad and serious eye
Winning the listener with persuasion soft
Thro' fields of asphodel, and pathless sky —

And the home picture, — that with sacred touch
Can be but sketched, tho' faithful to the life
His children for his leisure coaxing much
His labour shared, and sweeten'd by his Wife

She, like an echo, by his side would sit
And as a bird catches mid-air, and flies
With treasure caught to line its nest found fit
So with sweet instinct, she, did all the Wise

And fugitive fancies fix – and now the Nest
To us the mourners – us his friends is given
The tender questionings of a wild unrest
Of noble soul – soaring towards Home and Heaven –

Sent to Clough's widow, 20 July 1862.
Published by permission of the Bodleian Library,
Oxford. (*Ms. Eng. Lett. d 178, Fol. 75*)

Annals of My Glass House

'Mrs Cameron's Photography,' now ten years old, has passed the age of lisping and stammering and may speak for itself, having travelled over Europe, America and Australia, and met with a welcome which has given it confidence and power. Therefore, I think that the 'Annals of My Glass House' will be welcome to the public, and, endeavouring to clothe my little history with light, as with a garment, I feel confident that the truthful account of indefatigable work, with the anecdote of human interest attached to that work, will add in some measure to its value.

That details strictly personal and touching the affections should be avoided, is a truth one's own instinct would suggest, and noble are the teachings of one whose word has become a text to the nations –

> 'Be wise: not easily forgiven
> Are those, who setting wide the doors that bar
> The secret bridal chamber of the heart
> Let in the day.'

Therefore it is with effort that I restrain the overflow of my heart and simply state that my first lens was given to me by my cherished departed daughter and her husband with the words, 'It may amuse you, Mother, to try to photograph during your solitude at Freshwater.'

The gift from those I loved so tenderly added more and more impulse to my deeply seated love of the beautiful, and from the first moment I handled my lens with a tender ardour, and it has become to me as a living thing, with voice and memory and creative vigour. Many and many a week in the year '64 I worked fruitlessly, but not hopelessly –

> 'A crown of hopes
> That sought to sow themselves like wingéd lies
> Born out of everything I heard and saw
> Fluttered about my senses and my soul.'

I longed to arrest all beauty that came before me, and at length the longing has been satisfied. Its difficulty enhanced the value of the pursuit. I began with no knowledge of the art. I did not know where to place my dark box, how to focus my sitter, and my first picture I effaced to my consternation by rubbing my hand over the filmy side of the glass. It was a portrait of a farmer of Freshwater, who, to my fancy, resembled Bolingbroke. The peasantry of our island is very handsome. From the men, the women, the maidens and the children I have had lovely subjects, as all the patrons of my photography know.

This farmer I paid half-a-crown an hour, and, after many half-crowns and many hours spent in experiments, I got my first picture, and this was the one I effaced when holding it triumphantly to dry.

I turned my coal-house into my dark room, and a glazed fowl-house I had given to my children became my glass house! The hens were liberated, I hope and believe not eaten. The profit of my boys upon new laid eggs was stopped, and all hands and hearts sympathised in my new labour, since the society of hens and chickens was soon changed for that of poets, prophets, painters and lovely maidens, who all in turn have immortalized the humble little farm erection.

Having succeeded with one farmer, I next tried two children; my son, Hardinge, being on his Oxford vacation, helped me in the difficulty of focussing. I was half-way through a beautiful picture when a splutter of laughter from one of the children lost me that picture, and less ambitious now, I took one child alone, appealing to her feelings and telling her of the waste of poor Mrs Cameron's chemicals and strength if she moved. The appeal had its effect, and I now produced a picture which I called 'My First Success.'

I was in a transport of delight. I ran all over the house to search for gifts for the child. I felt as if she entirely had made the picture. I printed, toned, fixed and framed it, and presented it to her father that same day: size 11 by 9 inches.

Sweet, sunny haired little Annie! No later prize has effaced the memory of this joy, and now that this same Annie is 18, how much I long to meet her and try my master hand upon her.

Having thus made my start, I will not detain my readers with other details of small interest; I only had to work on and to reap rich reward.

I believe that what my youngest boy, Henry Herschel, who is now himself a very remarkable photographer, told me is quite true – that my first successes in my out-of-focus pictures were a fluke. That is to say, that when focussing and coming to something which to my eye, was very beautiful, I stopped there instead of screwing on the lens to the more definite focus which all other photographers insist upon.

I exhibited as early as May, '65. I sent some photographs to Scotland – a head of Henry Taylor, with the light illuminating the countenance in a way that cannot be described; a Raphaelesque Madonna, called 'La Madonna Aspettante.' These photographs still exist, and I think they cannot be surpassed. They did not receive the prize. The picture that did receive the prize, called 'Brenda,' clearly proved to me that detail of table-cover, chair and crinoline skirt were essential to the judges of the art, which was then in its infancy. Since that miserable specimen, the author of 'Brenda' has so greatly improved that I am content to compete with him and content that those who value fidelity and manipulation should find me still behind him. Artists, however, immediately crowned me with laurels, and though 'Fame' is pronounced 'The last infirmity of noble minds,' I must confess that when those whose judgement I revered have valued and praised my works, 'my heart has leapt up like a rainbow in the sky,' and I have renewed my zeal.

The Photographic Society of London in their *Journal* would have dispirited me very much had I not valued that criticism at its worth. It was unsparing and too manifestly unjust for me to attend to it. The more lenient and discerning judges gave me large space upon their walls which seemed to invite the irony and spleen of the printed notice.

To Germany I next sent my photographs. Berlin, the very home of photographic art, gave me the first year a bronze medal, the succeeding year a gold medal, and one English institution – the Hartley Institution – awarded me a silver medal, taking, I hope, a home interest in the success of one whose home was so near to Southampton.

Personal sympathy has helped me on very much. My husband from first to last has watched every picture with delight, and it is my daily habit to run to him with every glass upon which a fresh glory is newly stamped, and to listen to his enthusiastic applause. This habit of

running into the dining room with my wet pictures has stained such an immense quantity of table linen with nitrate of silver, indelible stains, that I should have been banished from any less indulgent household.

Our chief friend, Sir Henry Taylor, lent himself greatly to my early efforts. Regardless of the possible dread that sitting to my fancy might be making a fool of himself, he, with greatness which belongs to unselfish affection, consented to be in turn Friar Laurence with Juliet, Prospero with Miranda, Ahasuerus with Queen Esther, to hold my poker as his sceptre, and do whatever I desired of him. With this great good friend was it true that so utterly

'The chord of self with trembling
Passed like music out of sight',

and not only were my pictures secured for me, but entirely out of the Prospero and Miranda picture sprung a marriage which has, I hope, cemented the welfare and well-being of a real King Cophetua who, in the Miranda, saw the prize which has proved a jewel in that Monarch's crown. The sight of the picture caused the resolve to be uttered which, after 18 months of constancy, was matured by personal knowledge, then fulfilled, producing one of the prettiest idylls of real life that can be conceived, and, what is of far more importance, a marriage of bliss with children worthy of being photographed, as their mother had been, for their beauty; but it must also be observed that the father was eminently handsome, with a head of the Greek type and fair ruddy Saxon complexion.

Another little maid of my own from early girlhood has been one of the most beautiful and constant of my models, and in every manner of form has her face been reproduced, yet never has it been felt that the grace of the fashion of it has perished. This last autumn her head illustrating the exquisite Maud –

'There has fallen a splendid tear
From the passion flower at the gate,'

is as pure and perfect in outline as were my Madonna Studies ten years ago, with ten times added pathos in the expression. The very unusual attributes of her character and complexion of her mind, if I may so call it, deserve mention in due time, and are the wonder of those whose life is blended with ours as intimate friends of the house.

I have been cheered by some very precious letters on my photography, and having the permission of the writers, I will reproduce some of those which will have an interest for all.

An exceedingly kind man from Berlin displayed great zeal, for which I have ever felt grateful to him. Writing in a foreign language, he evidently consulted the dictionary which gives two or three meanings for each word, and in the choice between these two or three the result is very comical. I only wish that I was able to deal with all foreign tongues as felicitiously:–

'Mr. — announces to Mrs. Cameron that he received the first half, a Pound Note, and took the Photographies as Mrs. Cameron wishes. He will take the utmost sorrow* to place the pictures were good.

'Mr. — and the Comitie regret heavily† that it is now impossible to take the Portfolio the rooms are filled till the least winkle.‡

'The English Ambassude takes the greatest interest of the placement the Photographies of Mrs. Cameron and M — sent his extra ordinarest respects to the celebrated and famous female photographs. — Your most obedient, etc.'

The kindness and delicacy of this letter is self-evident and the mistakes are easily explained:–

* Care – which was the word needed – is expressed by 'Sorgen' as well as 'Sorrow.' We invert the sentence and we read – To have the pictures well placed where the light is good.
† Regret – Heavily, severely, seriously.
‡ Winkle – is corner in German.

The exceeding civility with which the letter closes is the courtesy of a German to a lady artist, and from first to last, Germany has done me honour and kindness until, to crown all my happy associations with that country, it has just fallen to my lot to have the privilege of photographing the Crown Prince and Crown Princess of Germany and Prussia.

This German letter had a refinement which permits one to smile *with* the writer, not *at* the writer. Less sympathetic, however, is the laughter which some English letters elicit, of which I give one example:–

'Miss Lydia Louisa Summerhouse Donkins informs Mrs. Cameron that she wishes to sit to her for her photograph. Miss Lydia Louisa Summer-

house Donkins is a carriage person, and therefore, could assure Mrs. Cameron that she would arrive with her dress uncrumpled.

'Should Miss Lydia Louisa Summershouse Donkins be satisfied with her picture, Miss Lydia Louisa Summerhouse Donkins has a friend who is *also* a Carriage person who would *also* wish to have her likeness taken.'

I answered Miss Lydia Louisa Summerhouse Donkins that Mrs. Cameron, not being a professional photographer, regretted she was not able to 'take her likeness,' but that had Mrs. Cameron been able to do so she would have very much preferred having her dress crumpled.

A little art teaching seemed a kindness, but I have more than once regretted that I could not produce the likeness of this individual with her letter affixed thereto.

This was when I was at L. H. H. [Little Holland House], to which place I had moved my camera for the sake of taking the great Carlyle.

When I have had such men before my camera my whole soul has endeavoured to do its duty towards them in recording faithfully the greatness of the inner as well as the features of the outer man.

The photograph thus taken has been almost the embodiment of a prayer. Most devoutly was this feeling present to me when I photographed my illustrious and revered as well as beloved friend, Sir John Herschel. He was to me as a Teacher and High Priest. From my earliest girlhood I had loved and honoured him, and it was after a friendship of 31 years' duration that the high task of giving his portrait to the nation was allotted to me. He had corresponded with me when the art was in its first infancy in the days of Talbot-type and autotype. I was then residing in Calcutta, and scientific discoveries sent to that then benighted land were water to the parched lips of the starved, to say nothing of the blessing of friendship so faithfully evinced.

When I returned to England the friendship was naturally renewed. I had already been made godmother to one of his daughters, and he consented to become godfather to my youngest son. A memorable day it was when my infant's three sponsors stood before the font, not acting by proxy, but all moved by real affection to me and to my husband to come in person, and surely Poetry, Philosophy and Beauty were never more fitly represented than when Sir John Herschel, Henry Taylor and my own sister, Virginia Summers, were encircled round the little font of the Mortlake Church.

When I began to photograph I sent my first triumphs to this revered friend, and his hurrahs for my success I here give. The date is September 25th, 1866:—

'MY DEAR MRS. CAMERON, —

'This last batch of your photographs is indeed wonderful in two distinct lines of perfection. That head of the "Mountain Nymph, Sweet Liberty" (a little farouche and egarée, by the way, as if first let loose and half afraid that it was too good), is really a most astonishing piece of high relief. She is absolutely alive and thrusting out her head from the paper into the air. This is your own special style. The other of "Summer Days" is in the other manner – quite different, but very beautiful, and the grouping perfect. Proserpine is awful. If ever she was "herself the fairest flower" her "cropping" by "Gloomy Dis" has thrown the deep shadows of Hades into not only the colour, but the whole cast and expression of her features. Christabel is a little too indistinct to my mind, but a fine head. The large profile is admirable, and altogether you seem resolved to out-do yourself on every fresh effort.'

This was encouragement eno' for me to feel myself held worthy to take this noble head of my great Master myself, but three years I had to wait patiently and longingly before the opportunity could offer.

Meanwhile I took another immortal head, that of Alfred Tennyson, and the result was that profile portrait which he himself designates as the 'Dirty Monk.' It is a fit representation of Isaiah or of Jeremiah, and Henry Taylor said the picture was as fine as Alfred Tennyson's finest poem. The Laureate has since said of it that he likes it better than any photograph that has been taken of him *except* one by Mayall; that '*except*' speaks for itself. The comparison seems too comical. It is rather like comparing one of Madame Tussaud's waxwork heads to one of Woolner's ideal heroic busts. At this same time Mr. Watts gave me such encouragement that I felt as if I had wings to fly with.

Written in 1874; published in *Photographic Journal* Ll (N.S.) (July 1927), 296–301

On a Portrait

Oh, mystery of Beauty! who can tell
 Thy mighty influence? who can best descry
How secret, swift, and subtle is the spell
 Wherein the music of thy voice doth lie?

Here we have eyes so full of fervent love,
 That but for lids behind which sorrow's touch
Doth press and linger, one could almost prove
 That Earth had loved her favourite over much.

A mouth where silence seems to gather strength
 From lips so gently closed, that almost say,
'Ask not my story, lest you hear at length
 Of sorrows where sweet hope has lost its way.'

And yet the head is borne so proudly high,
 The soft round cheek, so splendid in its bloom,
True courage rises thro' the brilliant eye,
 And great resolve comes flashing thro' the gloom.

Oh, noble painter! more than genius goes
 To search the key-note of those melodies,
To find the depths of all those tragic woes,
 Tune thy song right and paint rare harmonies.

Genius and love have each fulfilled their part,
 And both unite with force and equal grace,
Whilst all that we love best in classic art
 Is stamped for ever on the immortal face.

Dated *September*, 1875; published *Macmillan's Magazine,* XXXIII (February 1876), 372

Select bibliography

Julia Margaret and Charles Hay Cameron

ANON (possibly G. Wharton Simpson) 'Studies from Life by Mrs. Cameron', *Art Pictorial and Industrial* III, January–June 1872, 25–26

CAMERON, CHARLES HAY *An Address to Parliament on the duties of Great Britain to India in respect of the education of the natives and their official employment,* London 1853

CAMERON, CHARLES HAY *Two Essays,* privately printed, London 1835

CAMERON, JULIA MARGARET *Illustrations to Alfred Tennyson's Idylls of the King and Other Poems,* London: Henry S. King, Part One, Christmas 1874; Part Two, May 1875

COBURN, ALVIN LANGDON 'The Old Masters of Photography', *The Century* XC, 6 (October 1915), 909–920

EMERSON, PETER HENRY 'Mrs. Julia Margaret Cameron', *Sun Artists* 5 (1890), 33–42

EVANS, FREDERICK H. 'Exhibition of Photographs of Julia Margaret Cameron', *Amateur Photographer* XL, (21 July 1904), 43–4

FORD, COLIN *The Cameron Collection* (the Sir John Herschel album), London and New York 1975

FORD, COLIN *The Herschel Album* (a brief version of the above published by the National Portrait Gallery), London 1975

GERNSHEIM, HELMUT *Julia Margaret Cameron: Her Life and Photographic Work,* Millerton, N.Y. 1975

HARKER, MARGARET *Julia Margaret Cameron,* London 1983

HILL, BRIAN *Julia Margaret Cameron, A Victorian Family Portrait,* London 1973

MILLARD, CHARLES W. 'Julia Margaret Cameron and Tennyson's "Idylls of the King" ', *Harvard Library Bulletin* XXI, 2 (April 1973), 187–201

MOZLEY, ANITA VENTURA Catalogue to the exhibition, *Mrs. Cameron's Photographs from the Life,* Stanford University, Palo Alto 1974

OVENDEN, GRAHAM, ed. *A Victorian Album: Julia Margaret Cameron and Her Circle* (her sister Mia's album), London 1975

(PATMORE, COVENTRY) 'Mrs. Cameron's Photographs', *Macmillan's Magazine* XIII, January 1866, 230–1

POWELL, TRISTRAM ed. *Victorian Photographs of Famous Men and Fair Women,* reprint 1973 of an edition of 1926 with contributions from Virginia Woolf and Roger Fry

RITCHIE, ANNE THACKERAY *Alfred, Lord Tennyson, and his friends. A Series of 25 Portraits . . . in photogravure from the negatives of Mrs. J. M. Cameron and H. H. H. Cameron,* London 1893

TAYLOR, UNA *Guests and Memories: Annals of a Seaside Villa,* London 1924

The Arundel Society

LAYARD, A. H. 'Publications of the Arundel Society: Fresco Painting', *Quarterly Review* CIV (October 1858), 277–325

LEDGER, TINA OLIVIA *A Study of the Arundel Society 1848–97,* D.Phil thesis, Oxford 1978 (*Ms. D.Phil c 2873,4*)

The Moxon Tennyson

PENNELL, JOSEPH (ed.) *Some Poems by Alfred Lord Tennyson,* with an introduction by Holman Hunt, London 1901

REID, FORREST *Illustrators of the Sixties,* London 1927

TENNYSON, ALFRED LORD *Poems* with illustrations by Thomas Creswick, John Everett Millais, William Holman Hunt, William Mulready, John Calcott Horsley, Dante Gabriel Rossetti, Clarkson Stanfield and Daniel Maclise, London and New York 1857

WHITE, GLEESON *English Illustration: 'The Sixties',* London 1897

GEORGE FREDERICK WATTS

CHESTERON, G. K. *G. F. Watts*, London 1904, reprinted 1975
CATALOGUE TO THE EXHIBITION, *G. F. Watts: The Hall of Fame*, National Portrait Gallery, London 1975
SYMONS, ARTHUR 'The Art of Watts', *Fortnightly Review* N.S. LXVIII (August 1900), 188–97
WATTS, MARY SETON *George Frederick Watts*, 3 vols., London 1912

GENERAL

CAMPBELL, NANCIE (compiler) *Tennyson in Lincoln: A Catalogue of the Collections of the Research Centre*, Lincoln 1971
DICKENS, CHARLES 'Book Illustration', *All the Year Round* XVII (10 August 1867) 151–5
EASTLAKE, SIR CHARLES *Contributions to the Literature of the Fine Arts*, London 1848
FERGUSON, W. T. and R. F. M. IMMELMAN *Sir John Herschel and Education at the Cape, 1834–40*, Cape Town 1961
HAMERTON, P. G. *Thoughts about Art*, London 1875
HAMERTON, P. G. *The Graphic Arts*, London 1882
JAMESON, ANNA *Characteristics of Women, moral, poetical, and historical*, 2 vols., London 1832
JAMESON, ANNA *Sacred and Legendary Art*, 2 vols., 9th edition, London 1848
JAMESON, ANNA *Legends of the Monastic Orders, as represented in the Fine Arts*, London 1850; 2nd edition, enlarged 1852
JAMESON, ANNA *Legends of the Madonna, as represented in the fine Arts*, London 1852; 2nd edition, enlarged 1857
JAMESON, ANNA *A Commonplace Book of Thoughts, Memories, and Fancies, Original and Selected*, London 1854
JAMESON, ANNA continued and completed by Lady Eastlake, *The History of Our Lord as exemplified in works of art: with that of his types . . .*, 2 vols., London 1864
(KINGSLEY, CHARLES) 'The Poetry of Sacred and Legendary Art' (review of Anna Jameson's work), *Blackwood's Magazine* LXV (February 1849) 175–89
LANDOW, GEORGE P. *Victorian Types Victorian Shadows: Biblical Typology in Victorian Literature, Art, and Thought*, Boston, London and Henley 1980
ROSSETTI, W. M. *Fine Art, Chiefly Contemporary*, London 1867
SMITH, SIR WILLIAM (ed.), *Dictionary of Greek and Roman Antiquities*, 2nd edition, London 1851
SMITH, SIR WILLIAM *Classical Dictionary of Greek and Roman Biography and Mythology*, London, c. 1858
SMITH, SIR WILLIAM (ed.), *A Dictionary to the Bible, comprising its Antiquities, Biography, Geography and Natural History*, 3 vols., London 1851
TAYLOR, SIR HENRY *The Works*, 5 vols., London 1877–8
TAYLOR, SIR HENRY *Autobiography . . . 1800–1875*, 2 vols., London 1885
TENNYSON, HALLAM LORD *Alfred, Lord Tennyson: a memoir*, 2 vols., London 1897
TENNYSON, HALLAM LORD (ed.) *Tennyson and His Friends*, London 1911
WITEMEYER, HUGH *George Eliot and the Visual Arts*, New Haven and London 1979
WHITE, JOHN FORBES, and SIR GEORGE REID ('Veri Vindex') *Thoughts on Art, and Notes on the Exhibition of the Royal Scottish Academy of 1868*, Edinburgh 1868